BRUNO ENGLER PHOTOGRAPHY

PHOTOGRAPHS CELEBRATING
OVER SIXTY YEARS IN THE
CANADIAN ROCKIES

Rocky
Mountain Books
Calgary–Victoria–Vancouver

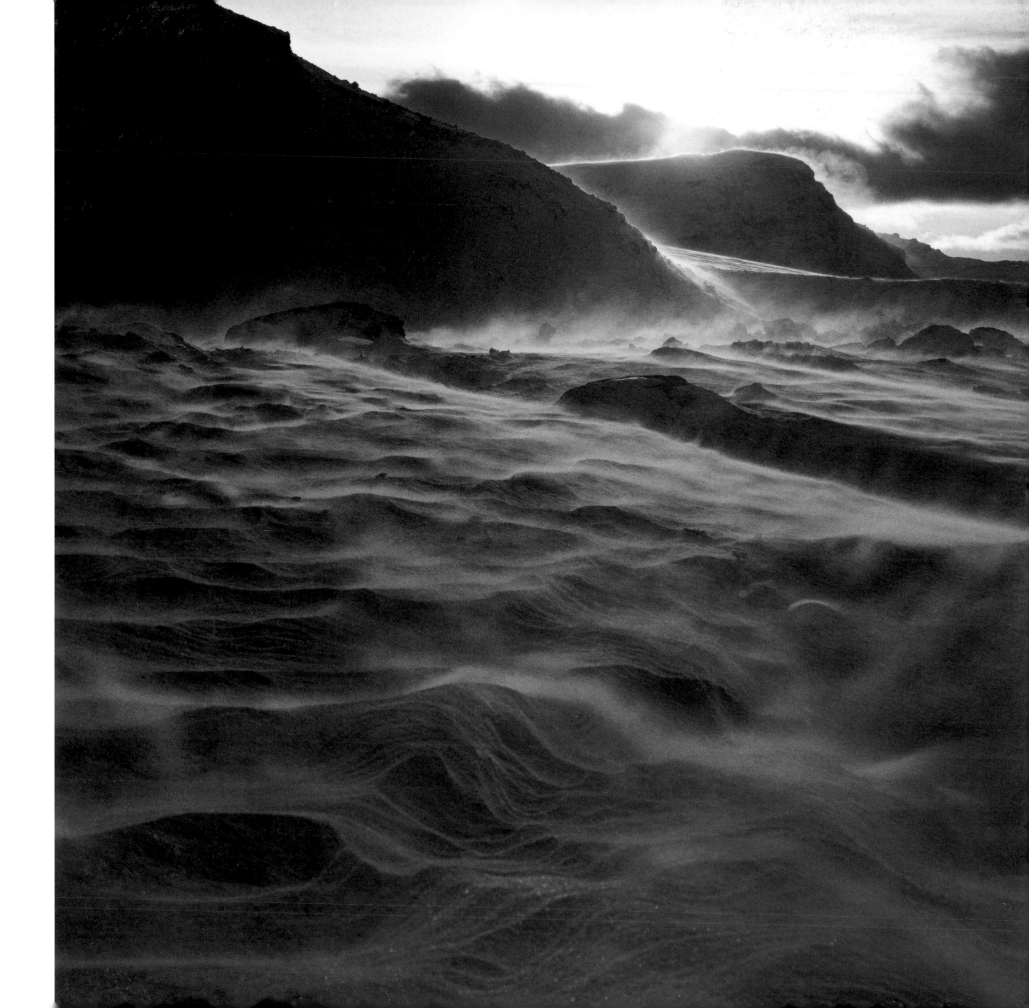

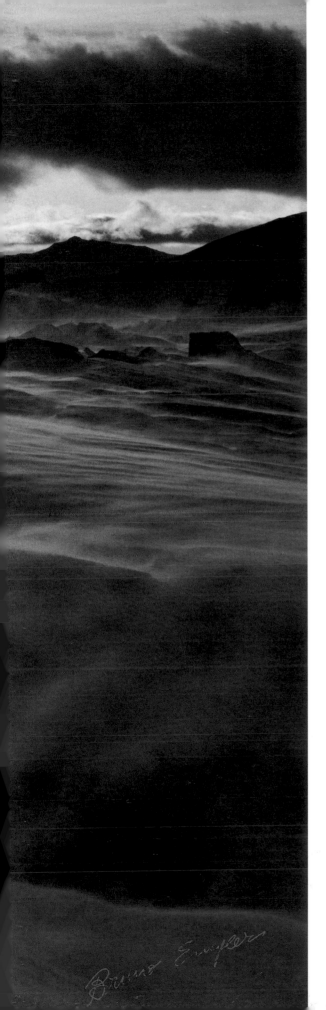

This book is dedicated to the
memory of Bruno

from

VERA MATRASOVA-ENGLER
AND SUSAN ENGLER POTTS

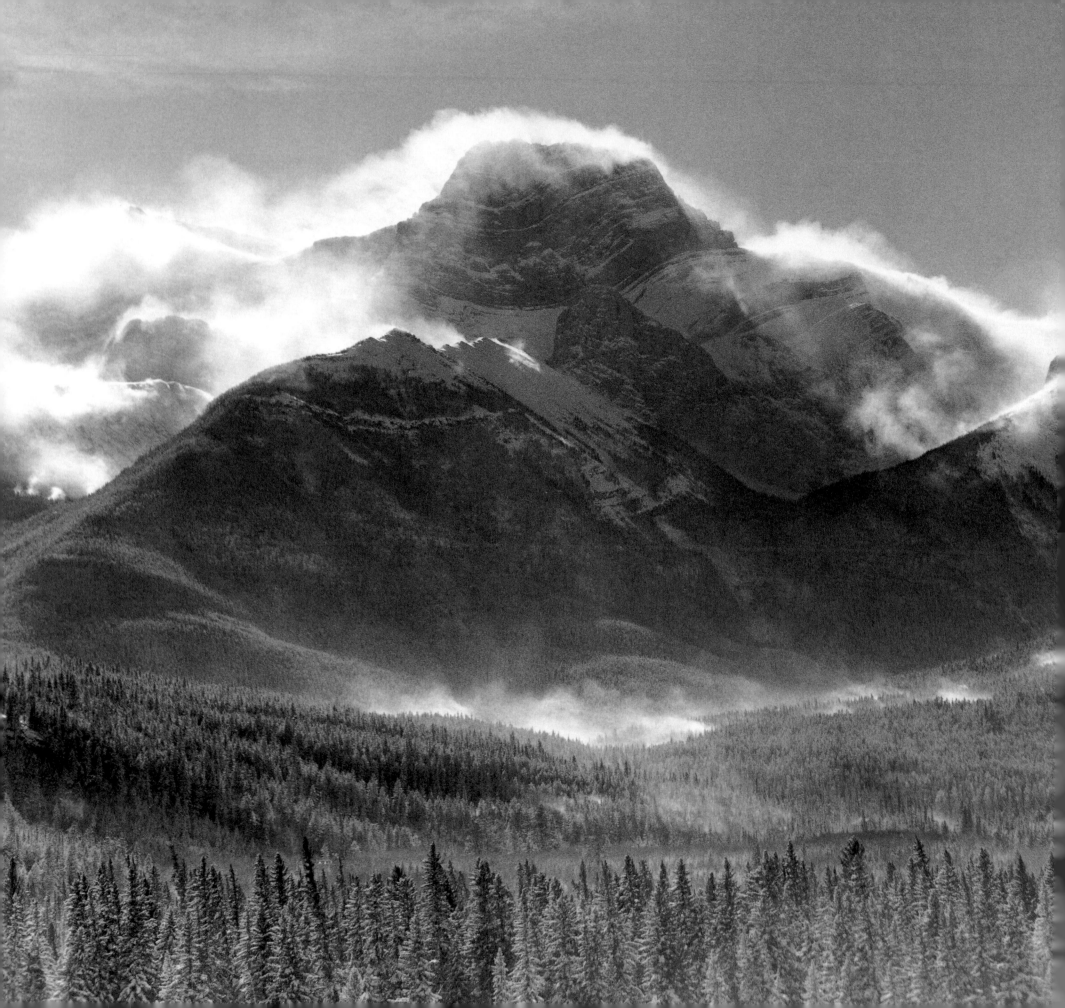

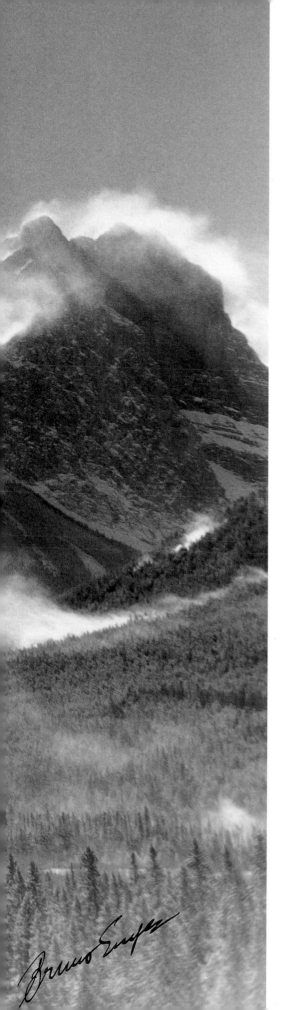

BRUNO ENGLER

PHOTOGRAPHY

We acknowledge the financial support of the Government of Canada through the Book Publishing Industry Development Program (BPIDP) and the support of the Alberta Foundation for the Arts for our publishing program.

Printed and bound in Canada by
Friesens, Altona, Manitoba

 Published by
Rocky Mountain Books
108, 17665-66A Avenue
RMB Surrey, BC V3S 2A7

National Library of Canada Cataloguing in Publication Data

Engler, Bruno, 1915-
 Bruno Engler photography

ISBN 0-921102-85-2

 1. Rocky Mountains, Canadian (B.C. and Alta.)--Pictorial works. 2. Engler, Bruno, 1915- . I. Matrasova-Engler, Vera. II. Potts, Susan Engler. III. Title.
FC219.E543 2001 779'.9971104 C2001-910955-5
F1090.E53 2001

FRONT COVER PHOTOGRAPH: TANGLE FALLS
PHOTOGRAPH ON PAGE 2: BALFOUR PASS IN A STORM
PHOTOGRAPH ON TITLE PAGE: WINDSTORM ON MOUNT LOUGHEED

Foreword by Vera

My life with this extraordinary man taught me to see the world of nature in a totally different way, in that I was able to see form and beauty, light and shade, previously unrecognized.

Bruno was enchanted by the mountains to such an extent that each new day brought a new image. Although he was physically unable to reach the peaks in the last few years, his camera provided the way to see the peaks from the foothills. He continued his mountain photography that in earlier times had made him renowned as one of the few high altitude professional photographers.

During his career, Bruno produced an estimated 25,000 photographs. His work in film included the roles of still photographer, location scout, mountain safety advisor, second unit camera man and even, on occasion, as actor. Bruno was involved in approximately 40 feature films made by Canadian and American productions, in TV series and in many documentaries made for the National Film Board of Canada as an independent cameraman.

The author of this book is Bruno Engler, my loving husband. His last wish was that this book of photographs be completed by me with the assistance of his daughter Susan. This book was begun two years previously. Bruno and I spent much time choosing appropriate photos, the choices resulting in Bruno spending many hours in the darkroom, from which he would later emerge tired with an enigmatic expression on his face. Next day, study of the new photograph would once again result in evaluation for the new book. This process was repeated day after day for about fourteen months. Ninety-five percent of this work was produced by hand processing in the darkroom of our house in Harvie Heights. In spite of so much darkroom work, Bruno was able to make his beloved trips to the mountains to photograph new images that as usual were unconventional, but captured a variety of atmospheres such as melancholy and drama.

Only Bruno's legendary stories are missing. Bruno was impatiently waiting for the spring sun and the warm sunny days to be spent on the balcony of our house that would inspire him to write the stories he called "The Unbelievable Truth"—that were, in reality, fact. He was able to spice up a story so perfectly that interpretation from someone else could never be so interesting. This is the reason why Susan and I found it impossible to tell our version of the stories. We have, therefore, included only stories written by Bruno. The photographs have mainly the same working titles used in Bruno's personal catalogue. This catalogue contains material that is really Bruno's photobiography: art, mountains, horses, climbing, skiing, personalities, history, winter, waterfalls, wildlife, scenic views and many specific

historic collections, such as histories of Norquay, Lake Louise and Sunshine ski areas, the warden service, rescue and avalanches. Bruno was usually present with camera in hand at the right moment to capture, permanently, exciting and memorable experiences.

Bruno had a variety of cameras, but his favourites were a Pentax 6X7 and a Mamiya C330. He also had in reserve a Minolta and Nikon. Bruno's passion was black and white photography, but his colour pictures, though not well known, are also excellent.

One time Bruno said, "I was a little frustrated guiding. To take pictures, to wait for the proper time, just to sit there and wait until the light was right. I had to guide. I knew that and it was a battle in me between photography and my duty as a guide. Of course, I did my duty. But I told my people, 'this is beautiful, you take the picture.' They had cameras, let them take the picture. And they wrote back and said, 'Bruno, thanks for the advice. I got beautiful picture.' So that also I passed on as a guide. That's what you're supposed to do as a guide, show the people a little bit of everything, the beauty of the mountains. The memory of that mountain stays. It's an adventure, and adventure you do together. If you don't reach the summit, so what?"

The idea for this book was born in 1999, Bruno and I cherishing "our child" with the hope that one day we would together launch this book. On March 23, 2001, after the cruel interference of fate, everything changed. I have lived with Bruno's spirit a few months more by means of his fascinating look on the world through his eyes. Finishing this book was for me a big gift from him.

Thank you, Bruno! I was living in this work with your gentle soul and kind heart. Continually I feel what an extraordinary person you were—and not only for me. Forever you will remain a beautiful memory of our five years of marriage. Your loving friendship and care for me will endure. Your love of the Canadian mountains will remain with me as will your charming Swiss accent.

Vera Matrasova-Engler

Vera Matrasova-Engler, June 2001

Foreword by Susan

The biography, "A Mountain Life," related my father's life through stories and photographs. From a different angle this book tells the story of his love and fascination with the mountains that molded his life for over six decades. We are looking through his lens, seeing through his eyes, and if we are lucky we will be brushed by the same feelings of mystery and joy that coloured his life. The ever changing mountain landscapes tell their own stories in striking black and white. Like a silent movie we must rely on the images to tell the tale. We can no longer hear his voice except through the echoes of memory.

To many he was a mountain legend, but to me he was "Dad." I will never forget his sense of humour, and how much we laughed as he related yet another incredible adventure. It didn't matter if I had heard the story before, the art was in the telling. Any of you who saw his slide shows would know this to be true.

How many miles did he trek and how many vertical feet did he climb? How many hours did he wait with his camera poised, anticipating the perfect shot, the elusive blending of light and shadow that sparked his photographer's soul? How many days did he spend just enjoying the peace and solitude of the high elevations, breathing in the mountain air that gave him life and purpose? How many nights did he entertain people with his stories and laughter? Not enough. A higher peak called him home. His pen was stilled and his stories stopped, almost in mid-sentence it seemed to me.

Working on this book has been a journey for me, sometimes painful, always bittersweet. I have shed tears as I watched and listened to him in videos while transcribing his words. I have laughed out loud as I read through his notes and stories or sat with his friends as they shared their memories.

I hope you like this Dad. We tried to keep it just as you had envisioned. And now, it's a good day to go climbing. À bientôt, Papa. I'll look for you.

Susan Engler Potts, June 2001

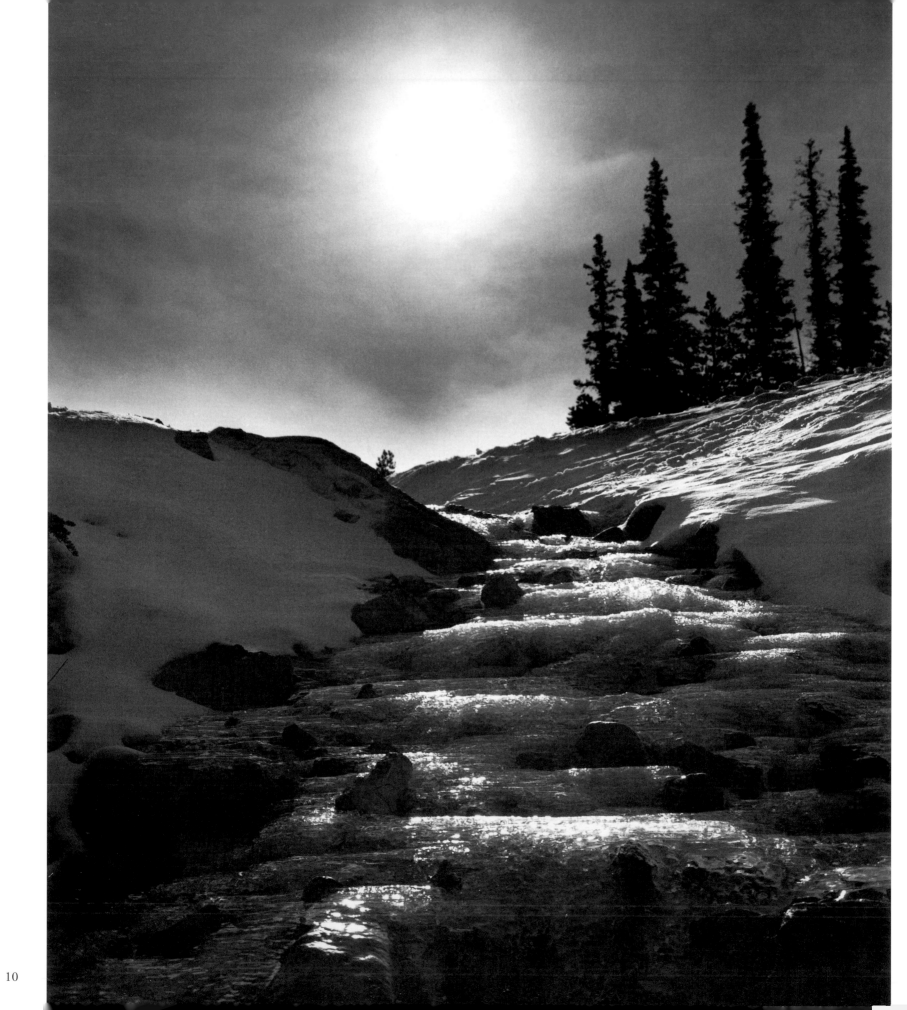

An Appreciation

The Mountains bear a secret. Amongst all those precipices, the buttresses, couloirs and valleys, there lies a stairway. At the end you find a gate. This gate is locked and to pass through it you need to have a key. It is a scarce key and also a perspicacious one, limited to but a few.

Behind the gate the sunbeams dance amongst the shades, clouds drift by, the little pika carries the nourishment to the den. Flowers open their blossoms to catch the sun rays. The ptarmigan guards her fragile chicks along the cool brook and the eagle keeps his watchful eye. You hear a rock falling; the snow white goat is contemplating your path. Unless you have the key to open the gate, this world of magic and mysticism will be only a fleeting illusion.

Bruno carried this key. He opened the door for so many who travelled with him. He introduced them to the magic and the mysticism of the grand peaks and valleys. This precious gravity he manifested in his photographs, capturing the diffused endless dreams on the horizons of peaks and the sharp details of activity. He caught the sparkle in the eye exposing the secrets of the soul.

To some he passed on the key. It was his precious gift so that they also may travel in this world of endless magic amongst the eternal Mountains.

Friend and rope companion,
Peter Fuhrmann,
Honorary President,
The Alpine Club of Canada

OPPOSITE: SUNSHINE SKI AREA IN 1939
"The first time I went into Sunshine, that's how it looked."

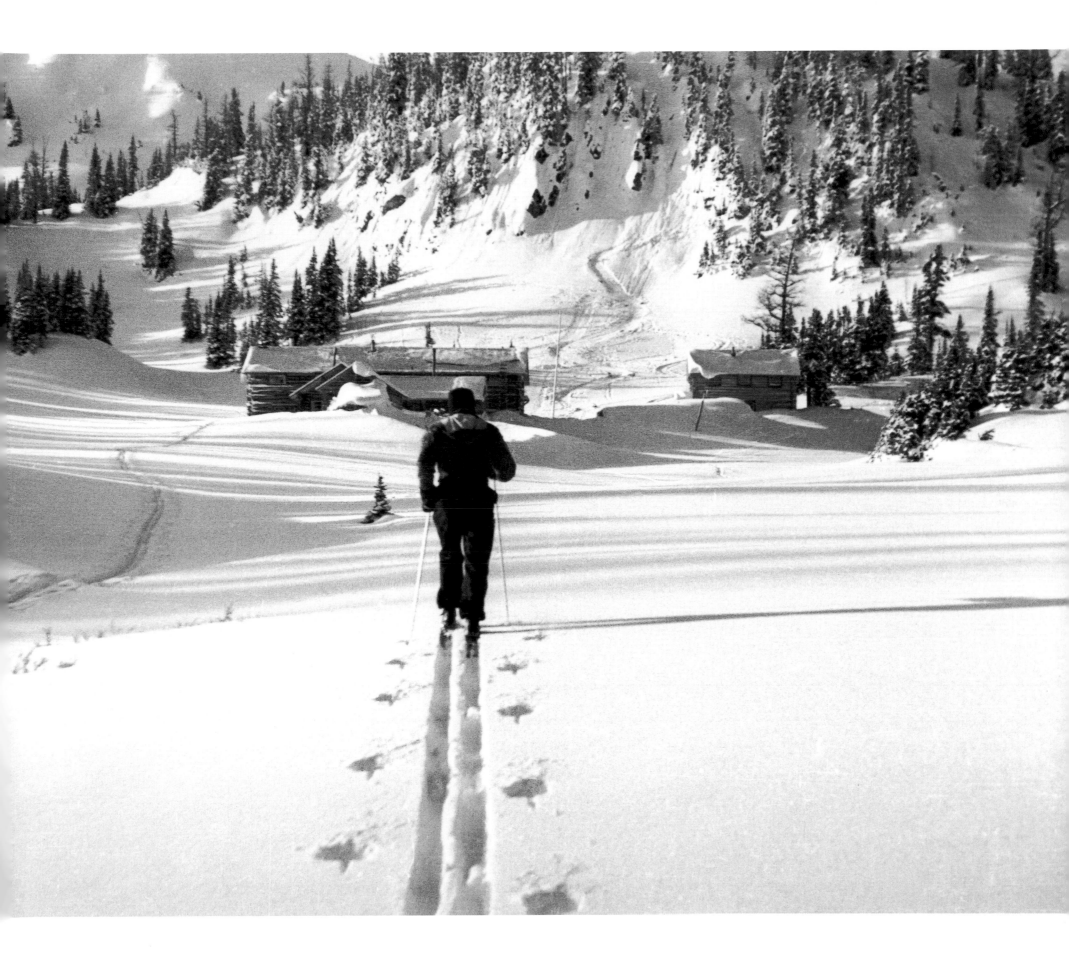

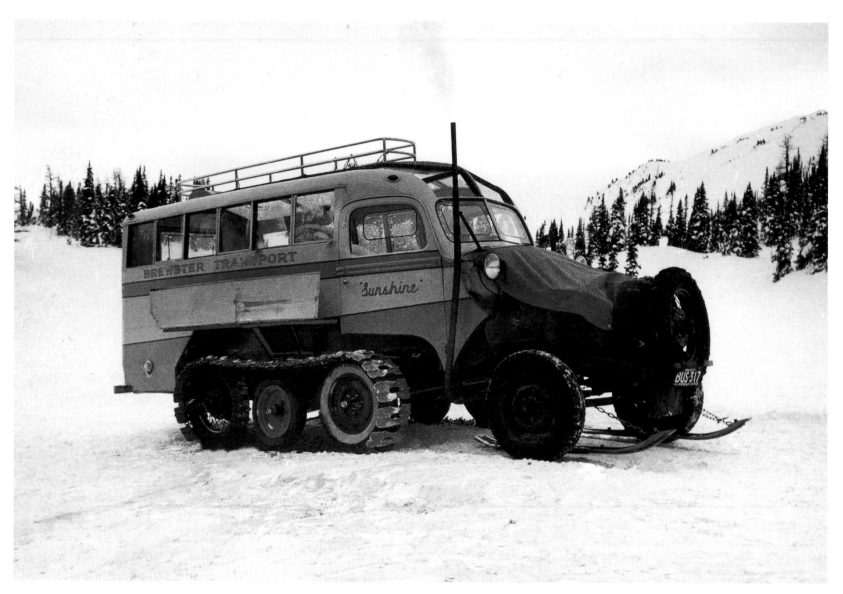

Sunshine Susie No. 2

Every morning at 10:00 a.m., Brewster Transportation's "Sunshine Susie" would pick up skiers at the Mount Royal Hotel in Banff. After a quick stop at the liquor store, up to twelve passengers would start the long trip to Sunshine Ski Area. Bruno would often ride on top of the bus with the skis to avoid motion sickness.

Getting to Sunshine was an adventure. The trip took about one hour at best, but if the road hadn't been plowed it could take two or even three hours to get to the hill. From Banff, "Susie" would have to rumble across three avalanche slopes to reach the "Ford," the present day parking lot for the gondola. The climb from here to the ski area was about three and a half miles and sometimes heavy snow bogged her down. (Eddie Hunter)

Opposite: Sunshine Ski Lodge in 1939

"Sunshine Ski Camp accommodated 35 skiers, 40 at a pinch. It cost $5.20 per day, including meals."

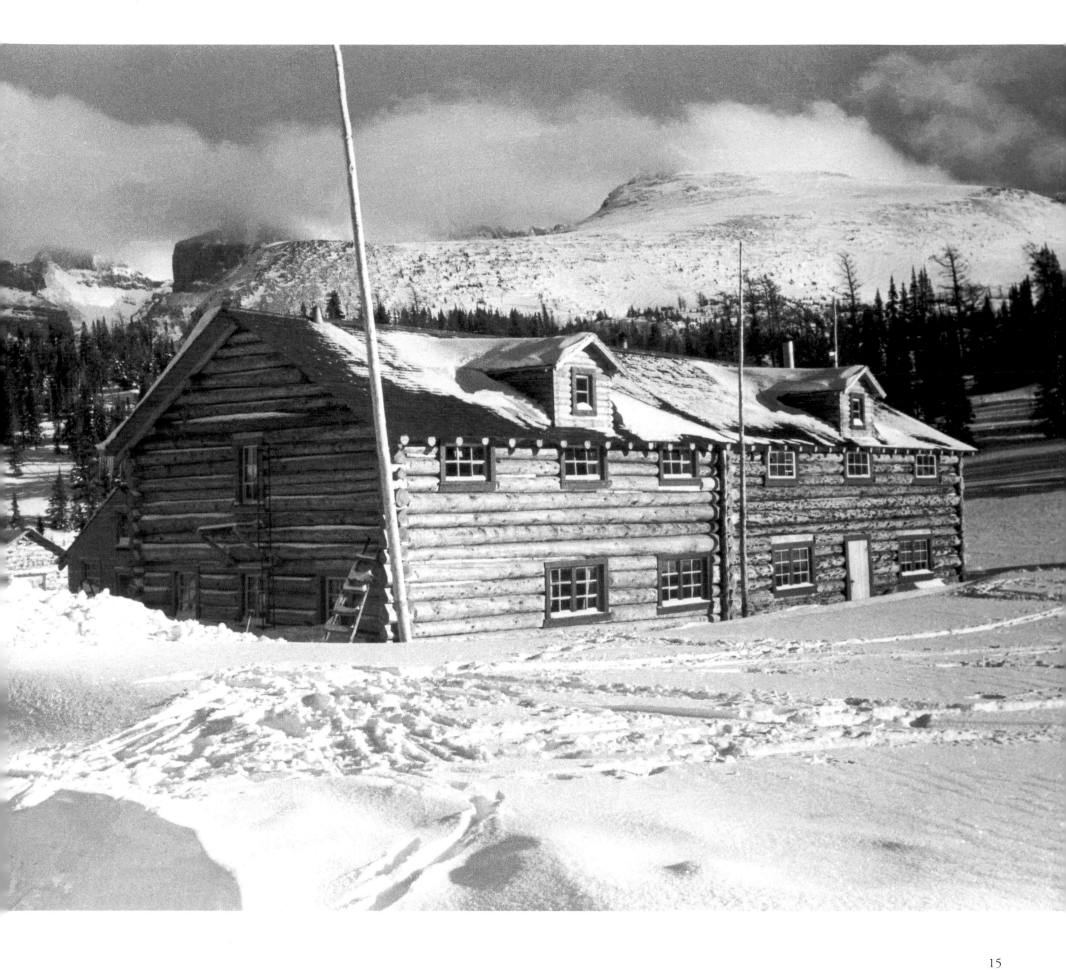

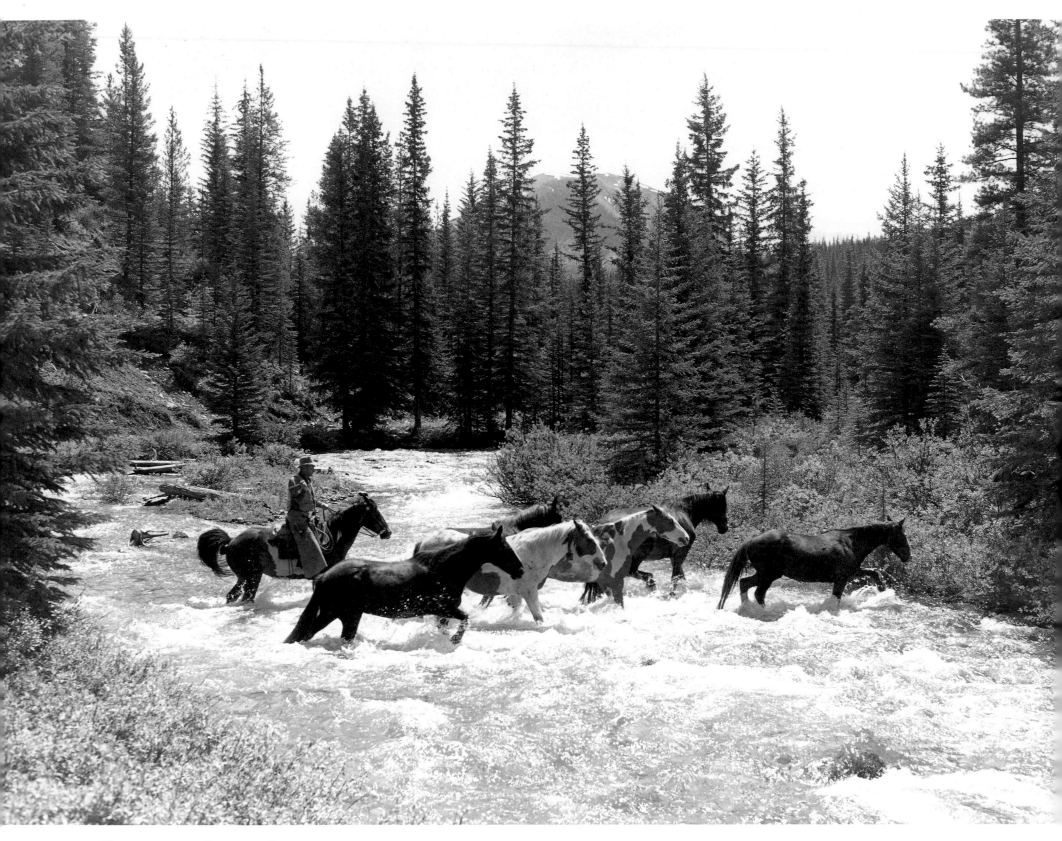

Horses crossing Brewster Creek

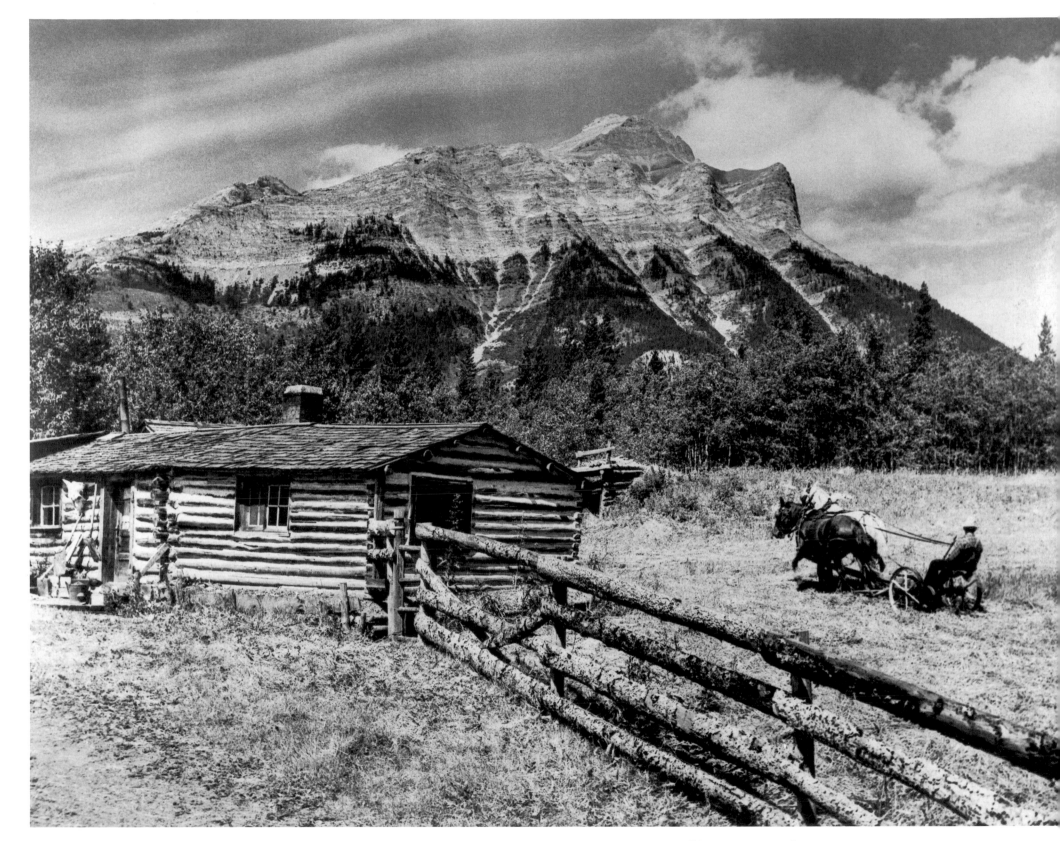

"OLD HOMESTEAD"
Ray Bagley was a pioneer rancher in the Crowsnest region.
He homesteaded and ranched while guiding for the Trail
Riders of the Canadian Rockies.

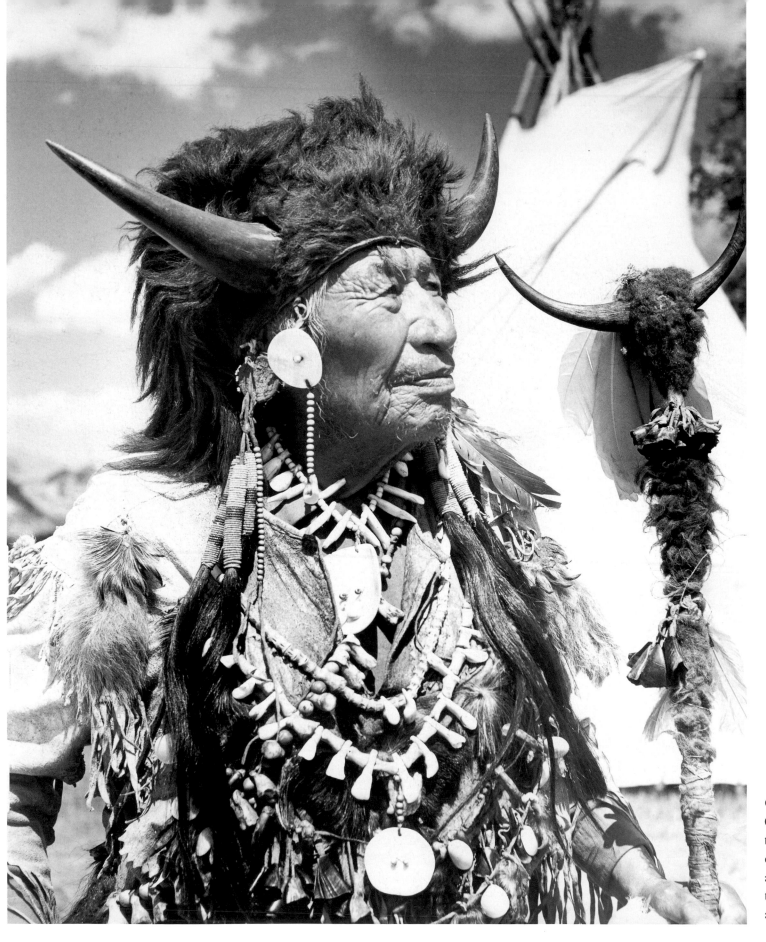

CHIEF WALKING BUFFALO
Chief Walking Buffalo is immortalized in this classic portrait taken in 1954. He was chief of the Stoney Indians for 15 years, and an advisor for many more years after that. He died in Banff in December, 1966, at the age of 98.

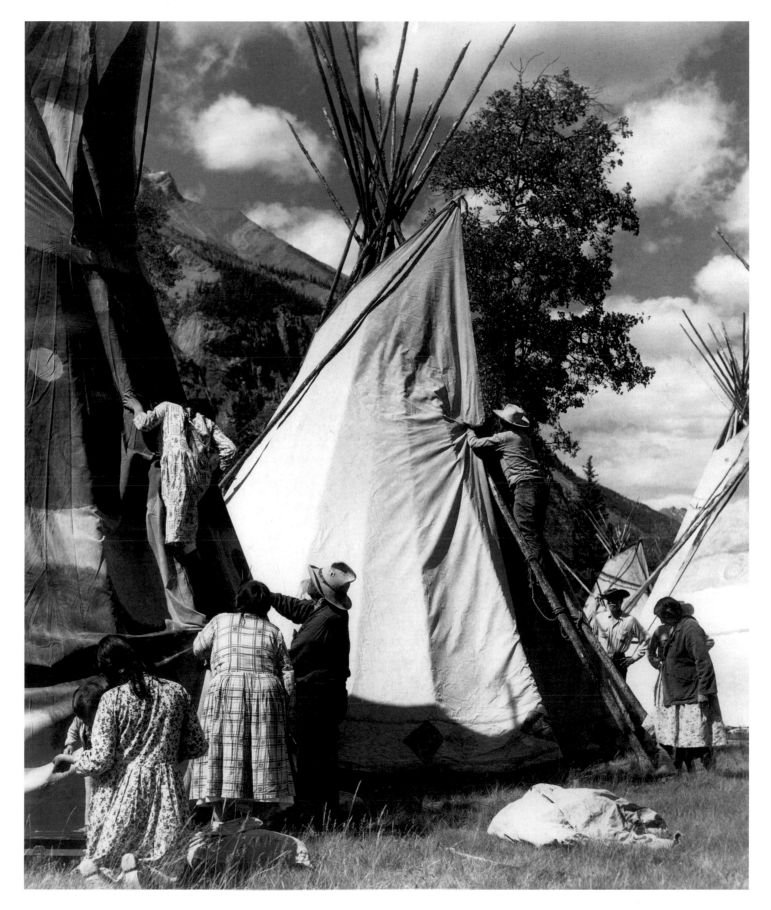

INDIANS SETTING UP TEEPEES
Banff Indian Days started in the 1890s
and lasted until 1978.

19

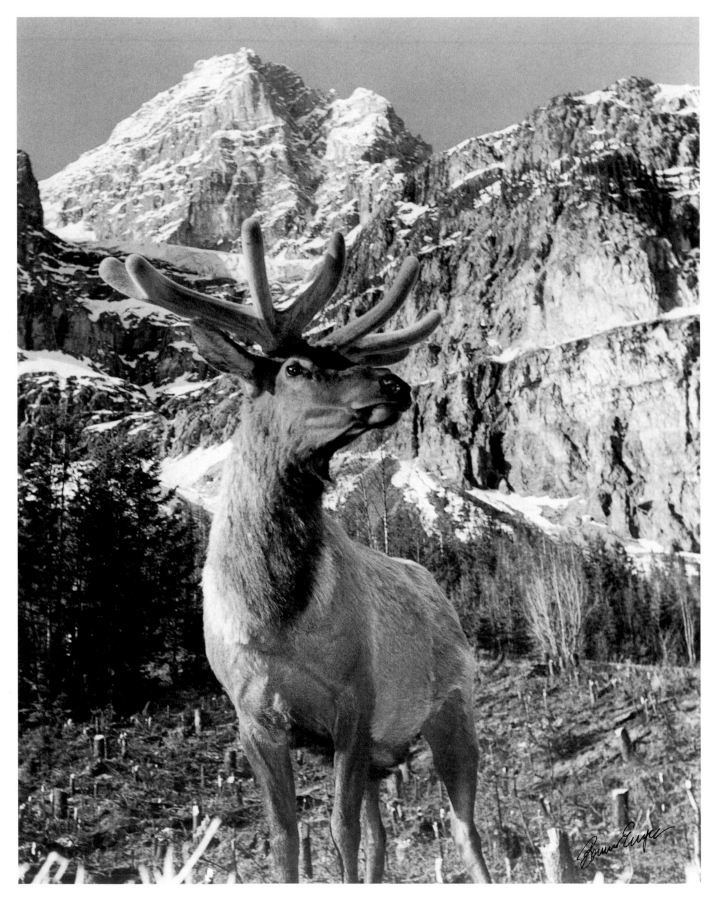

LEFT: ELK AND MOUNT STEPHEN

OPPOSITE: THE SENTINEL
A lone tree, like a sentinel, seems to
guard Crowsnest Mountain.

20

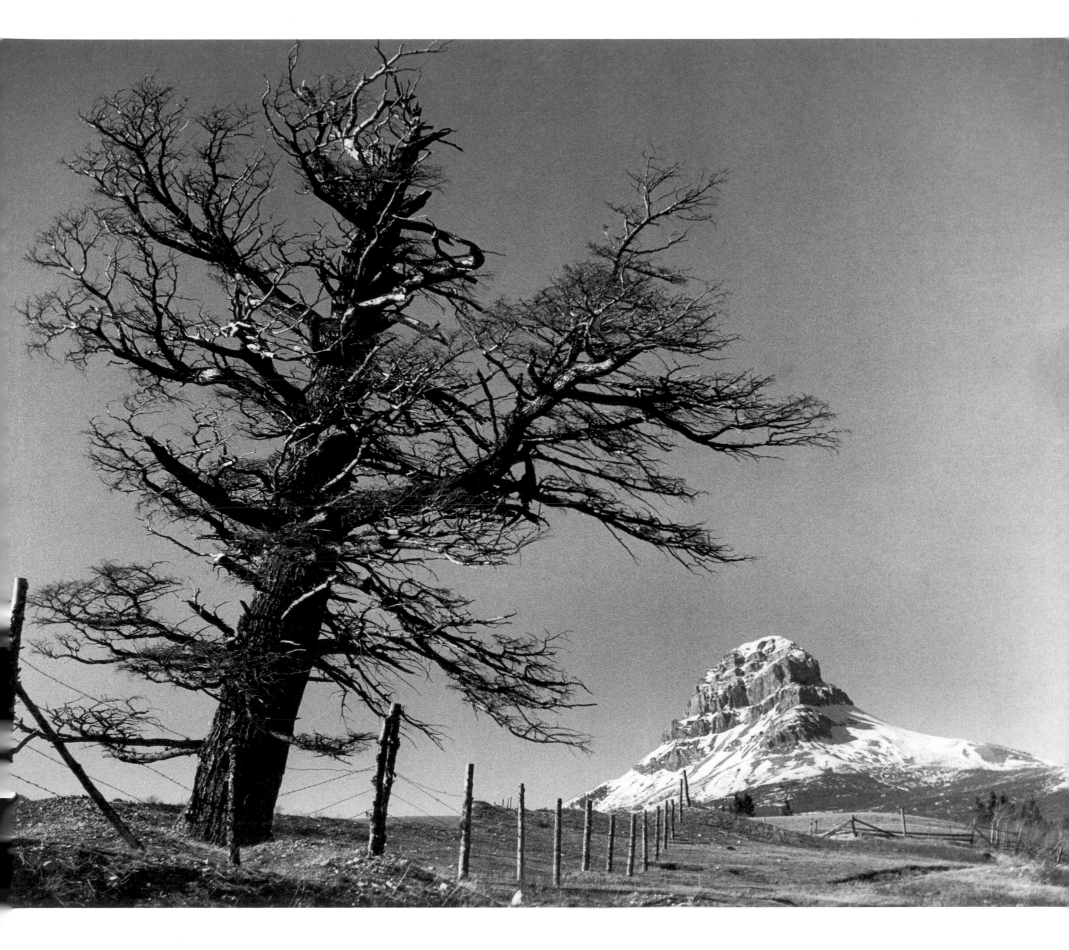

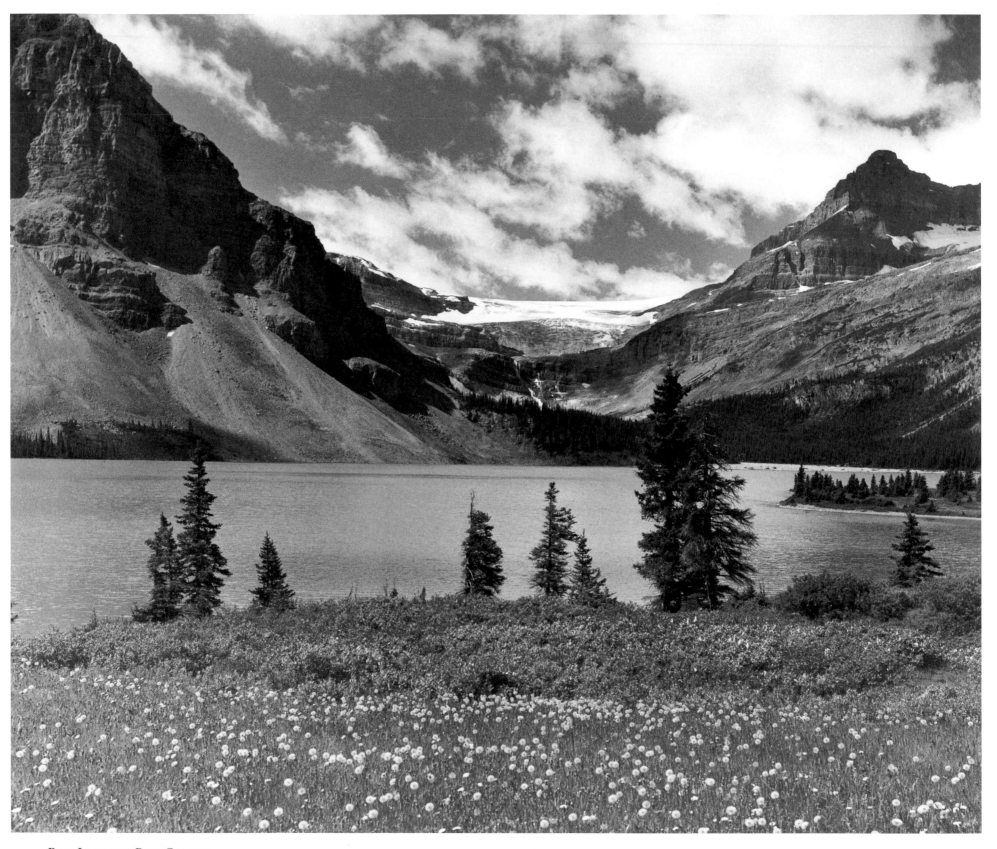

Bow Lake and Bow Glacier

Opposite: Mount Lefroy from the Needles
Only when the photo was printed did Bruno discover two goats on the ridge.

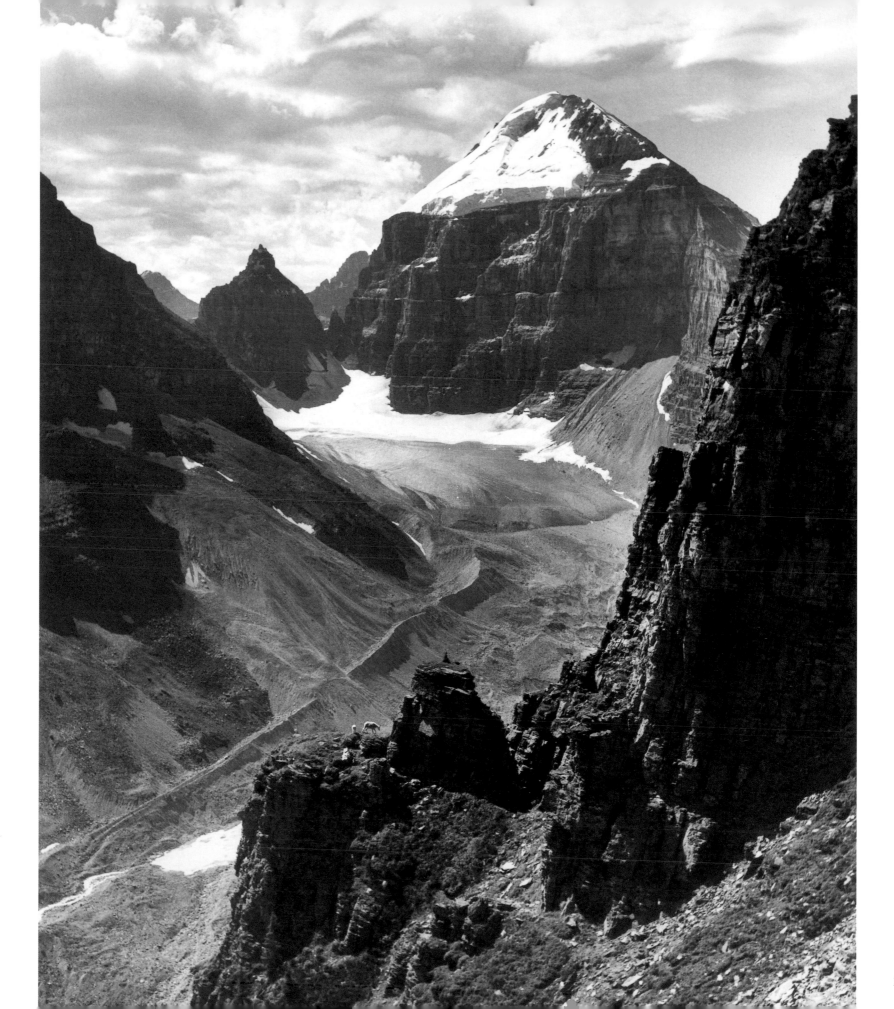

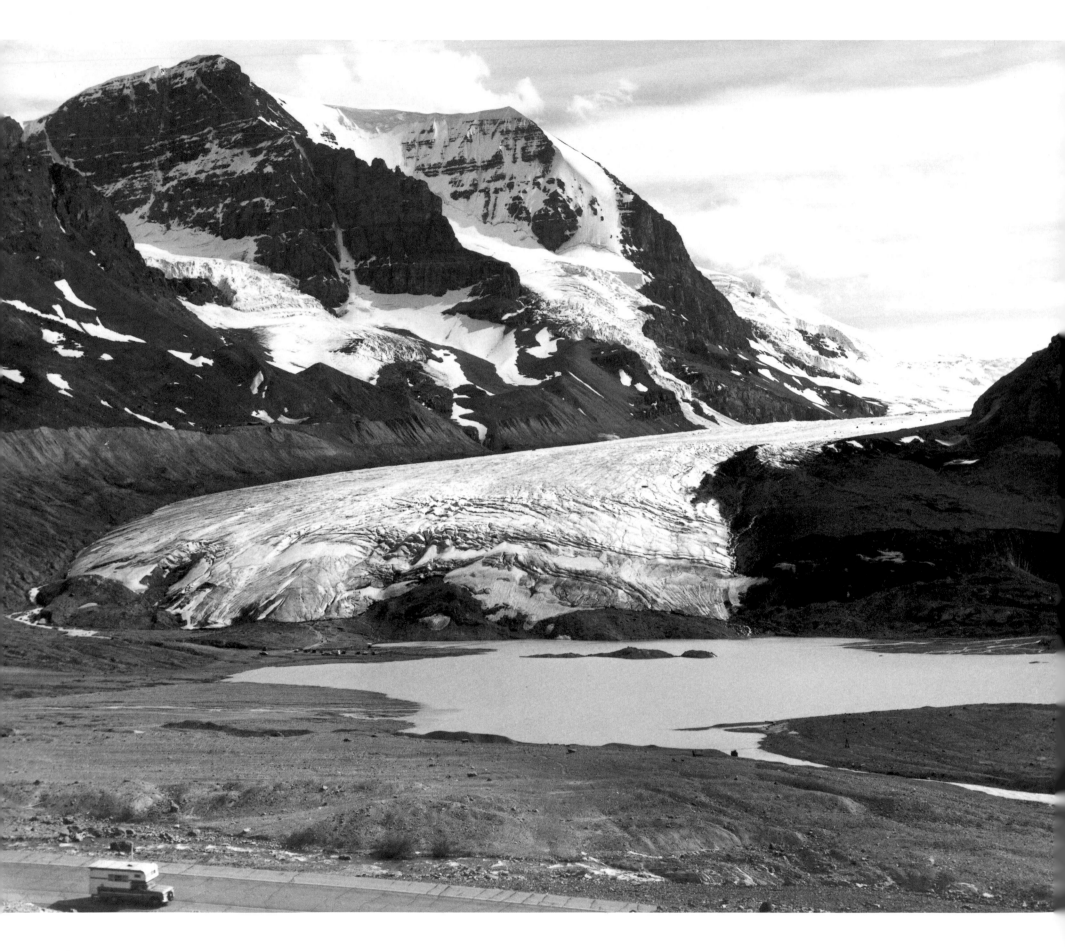

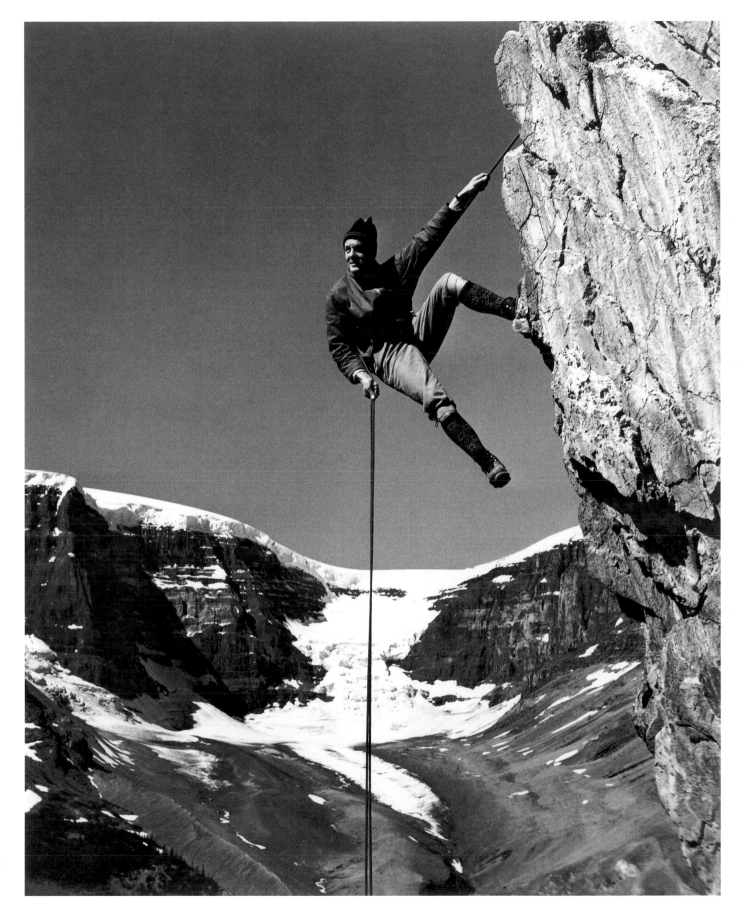

OPPOSITE: MOUNT ANDROMEDA
AND THE COLUMBIA ICEFIELD

RIGHT: DON VOCKEROTH, 1954
The Dome Glacier spills over from the
Columbia Icefield.

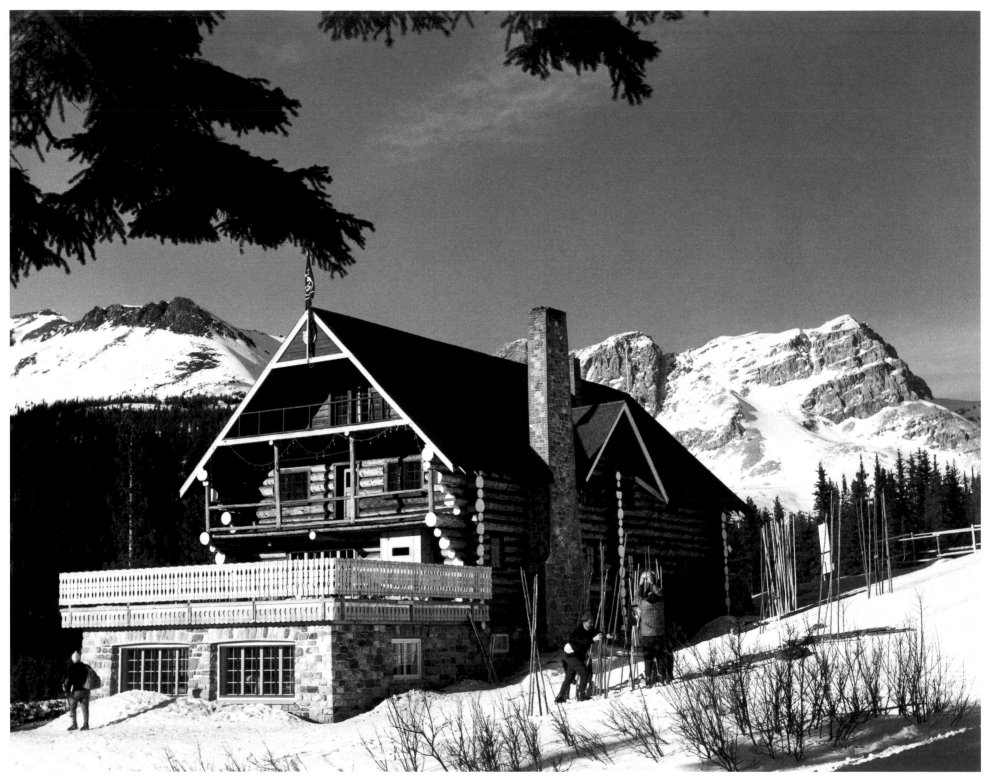

TEMPLE CHALET, 1958
The original Temple Chalet at Lake Louise Ski Area was built by
Sir Norman Watson in 1938-39. It burnt down in 1976.

OPPOSITE: "FOREST FIRE SURVIVORS"

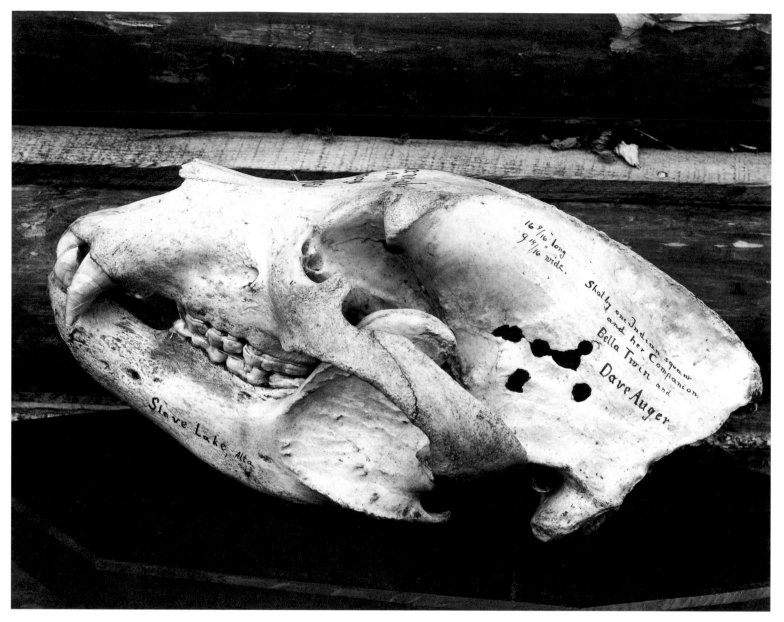

GRIZZLY SKULL

In 1953, at 63 years of age, Bella Twin claimed the world record when she shot and killed a grizzly bear at Slave Lake with a .22 calibre rifle. "The first shot was in the brain, so the bear was paralysed. He was just quivering. And she pumped in all these shots with a single action."

OPPOSITE: BELLA TWIN

"She was dressed very simply. When she thought I was going to take a picture of her she said, 'No, I have to go home first.' And she came back with a dress and put some cornstarch on her face for makeup. I said, 'Bella Twin, you looked much better before.'"

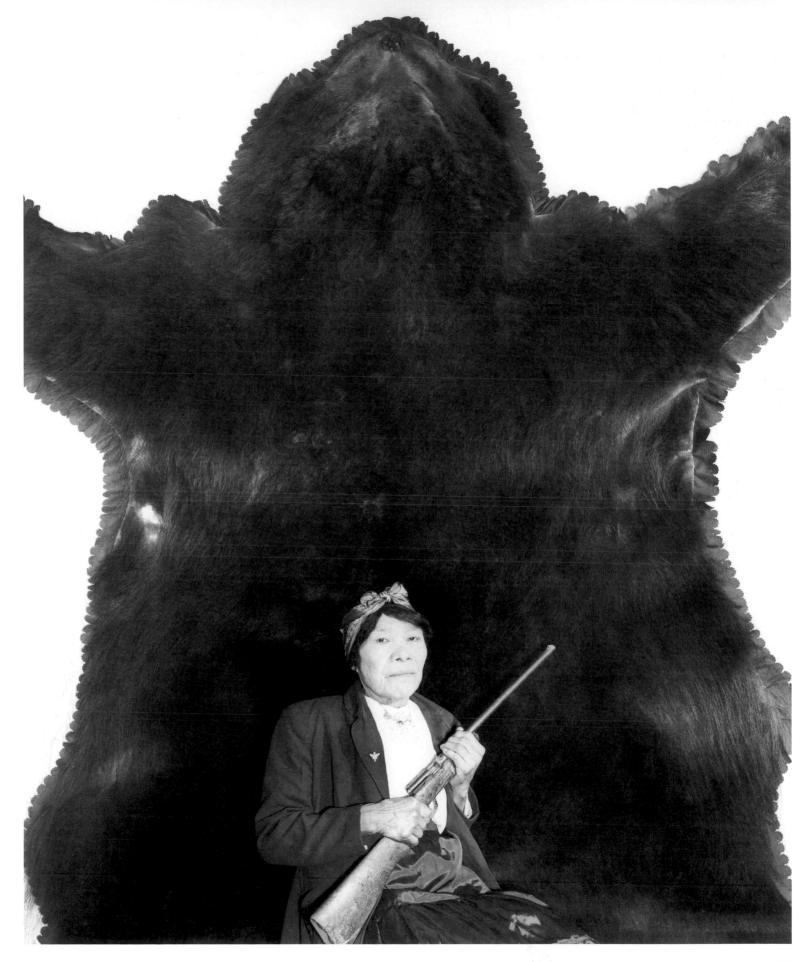

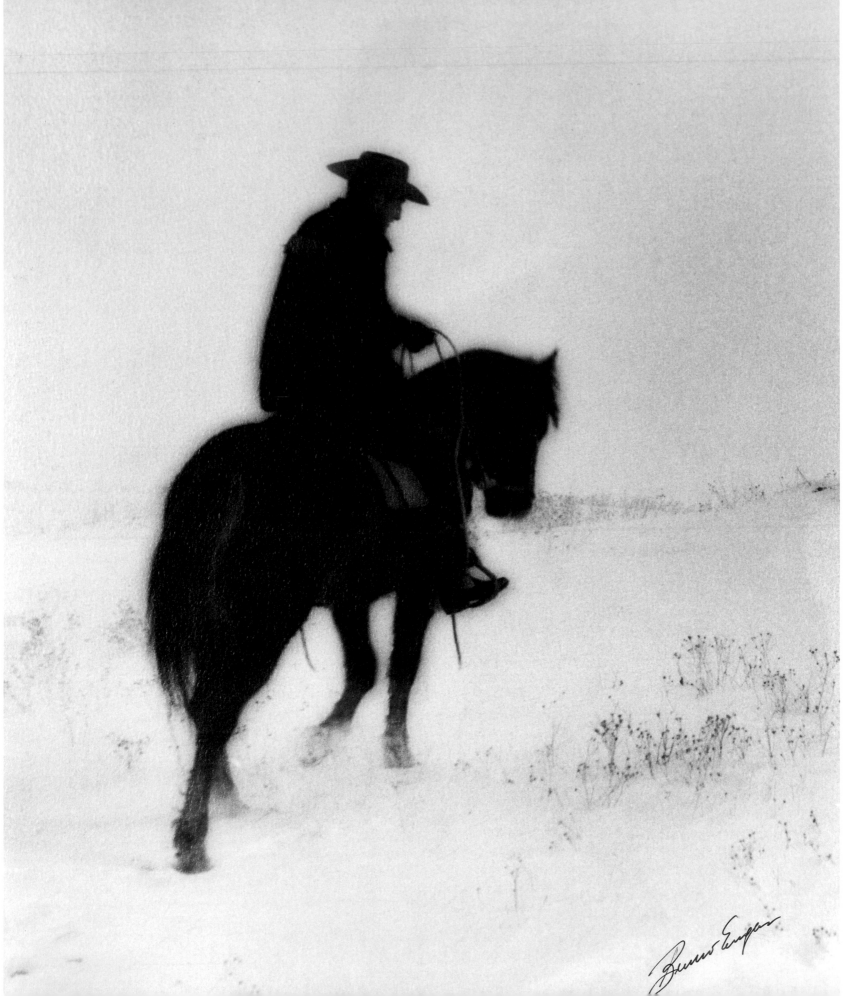

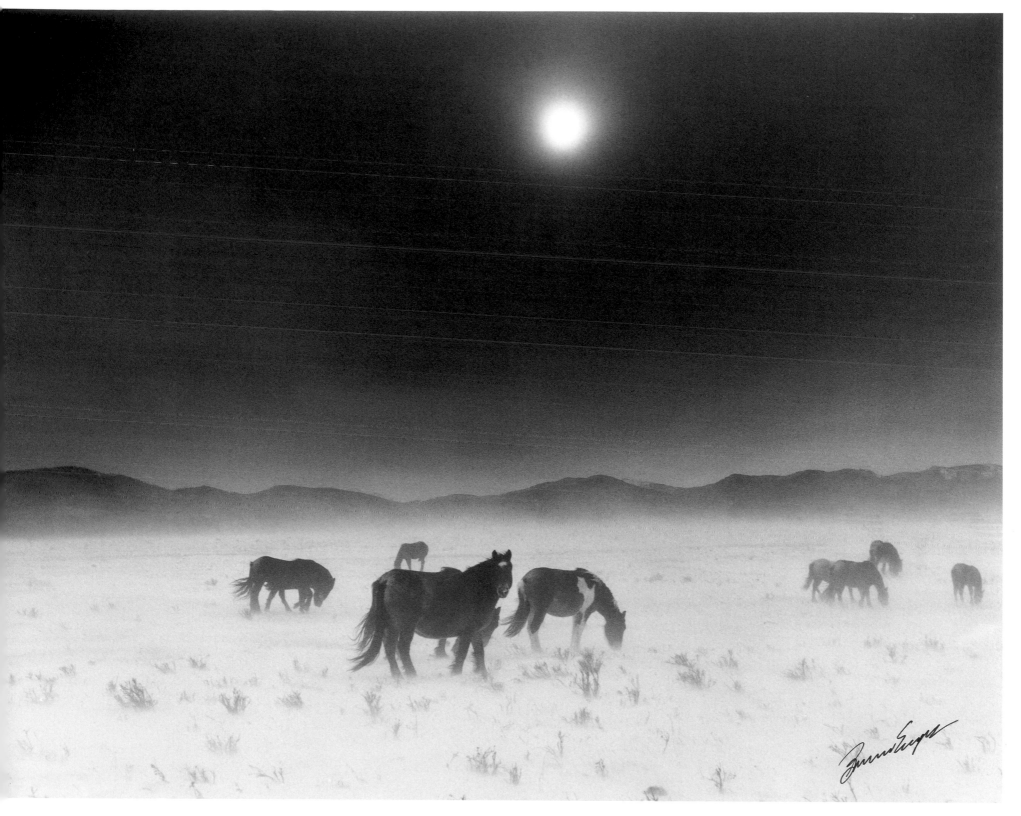

"WINTER PASTURE"

OPPOSITE: "TRACKING STRAYS"
Chief Goodstriker looks for stray cows in blizzard.

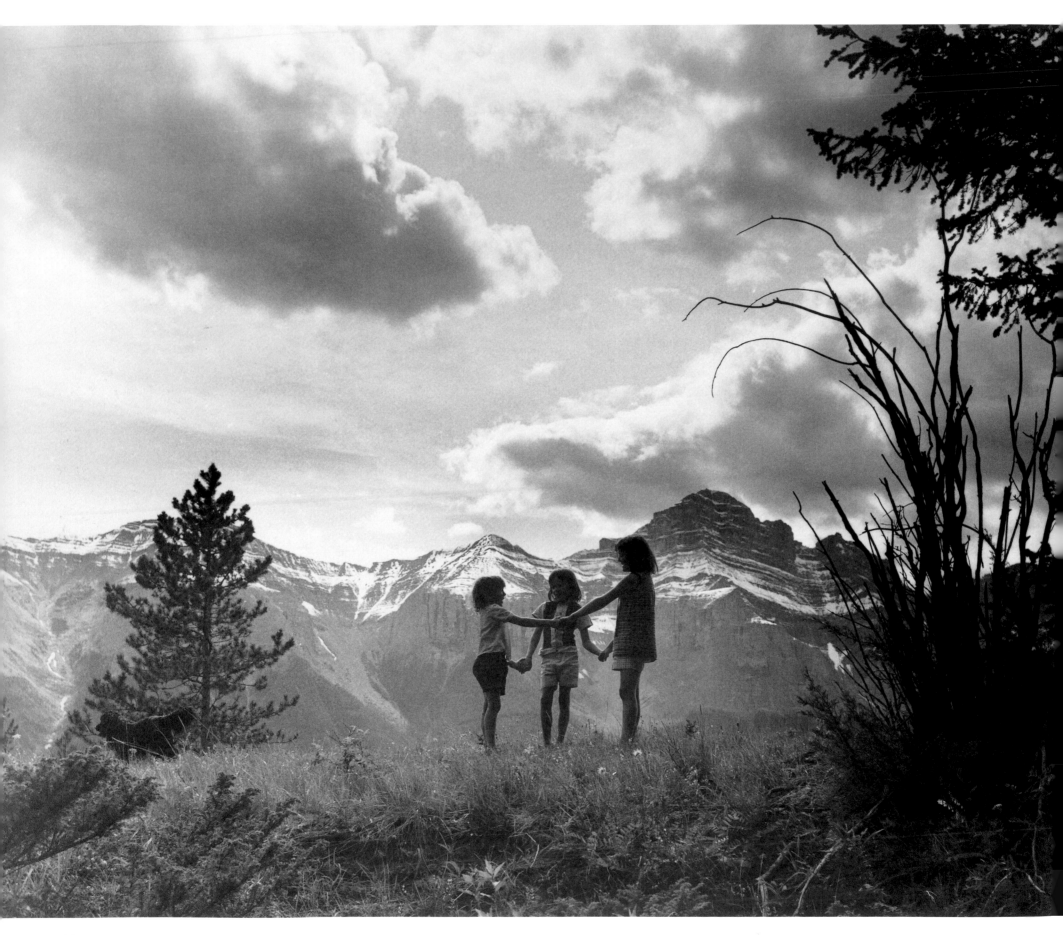

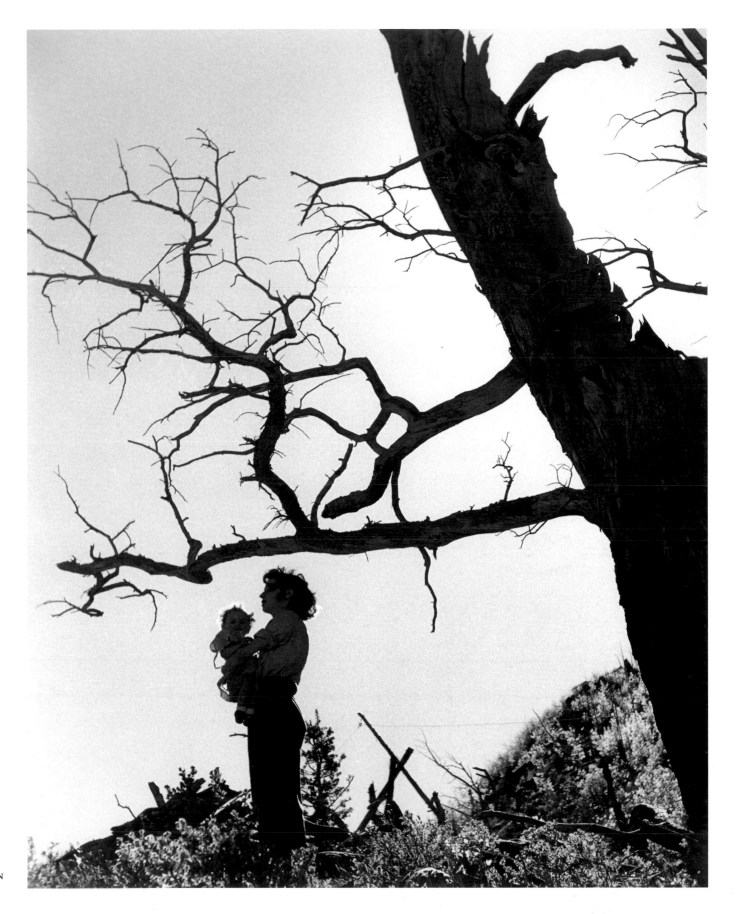

OPPOSITE: CHILDREN DANCING

RIGHT: WAITING FOR THE RETURN

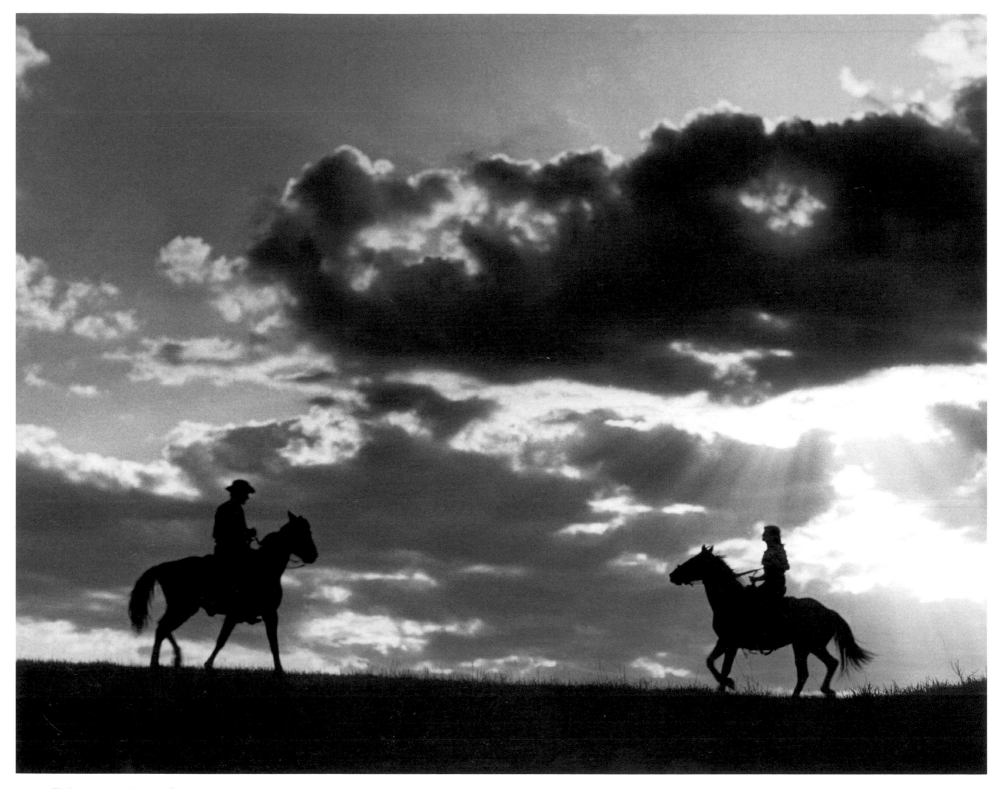

"Meeting at Sunset"

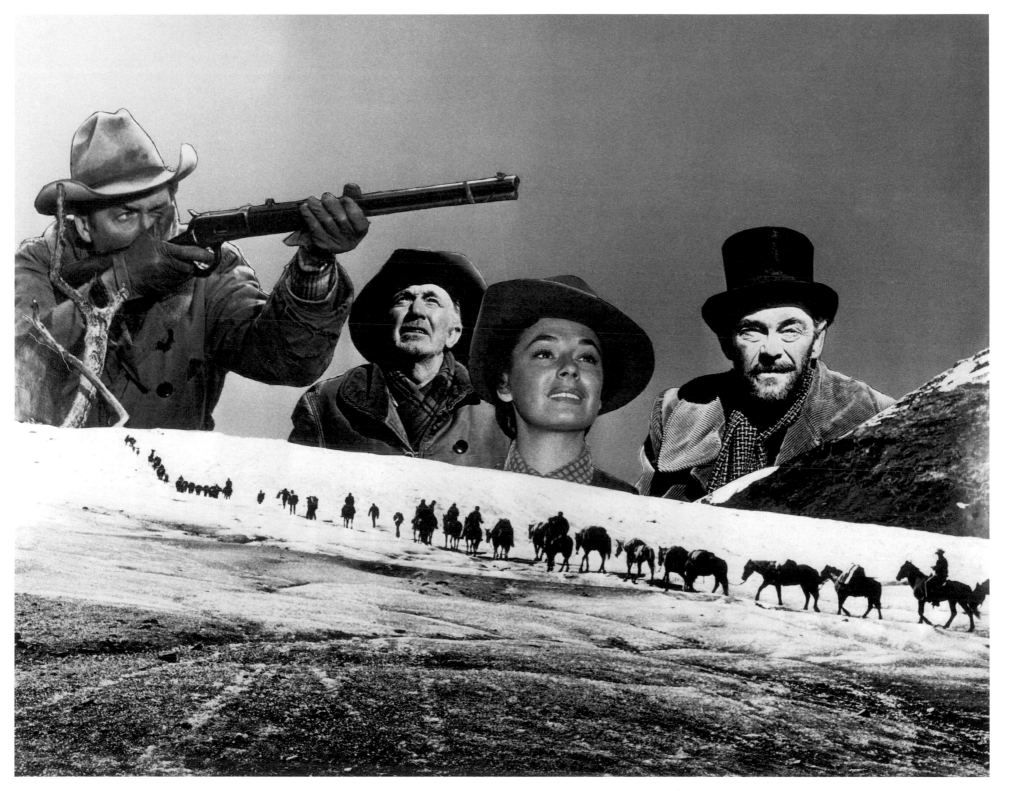

Bruno's photomontage for "The Far Country"
Left to right: Jimmy Stewart, Walter Brennan, Ruth Roman and John McIntire. This 1953 movie's locations included the Athabasca Glacier, shown here. Director, Anthony Mann.

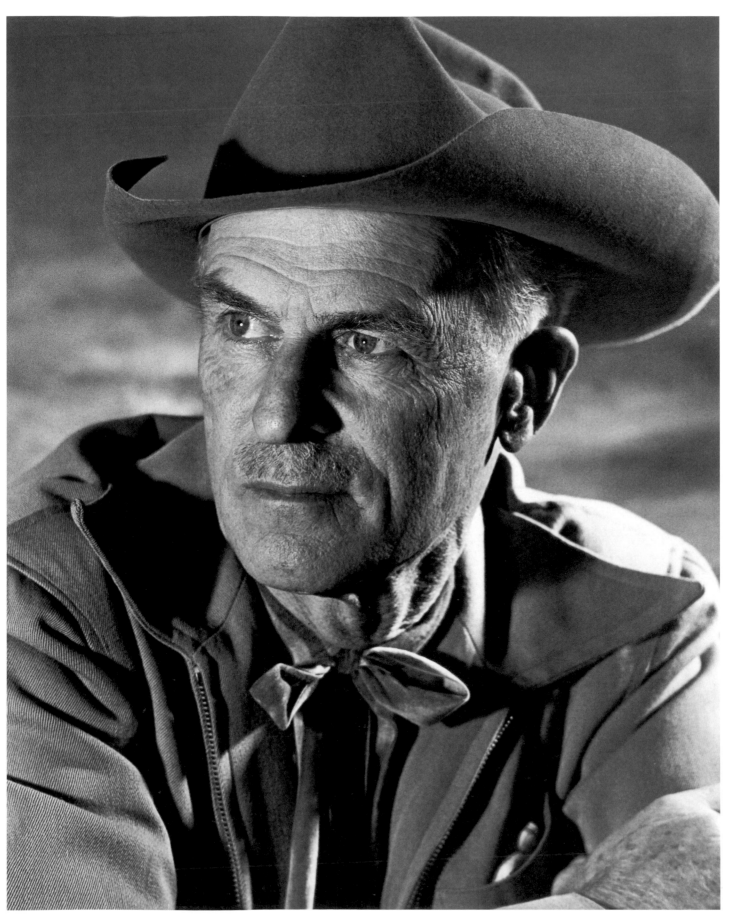

CAPTAIN FFRENCH

Marquis de Castel Thomond preferred to be called Captain O'Brien ffrench. A former British intelligence officer, he was the inspiration for Ian Fleming's James Bond. He built the fourteen-room Fairholme Ranch in 1948 on the last parcel of freehold land in Banff National Park, calling it "a little bit of heaven away from a war-torn world."

Fairholme Ranch

Fairholme Ranch, located between Two Jack Lake and Johnson Lake, was the residence of Princess Margaret during her three day visit to Banff in 1958. All that remains on the original site today are the memories and echoes of a bygone era.

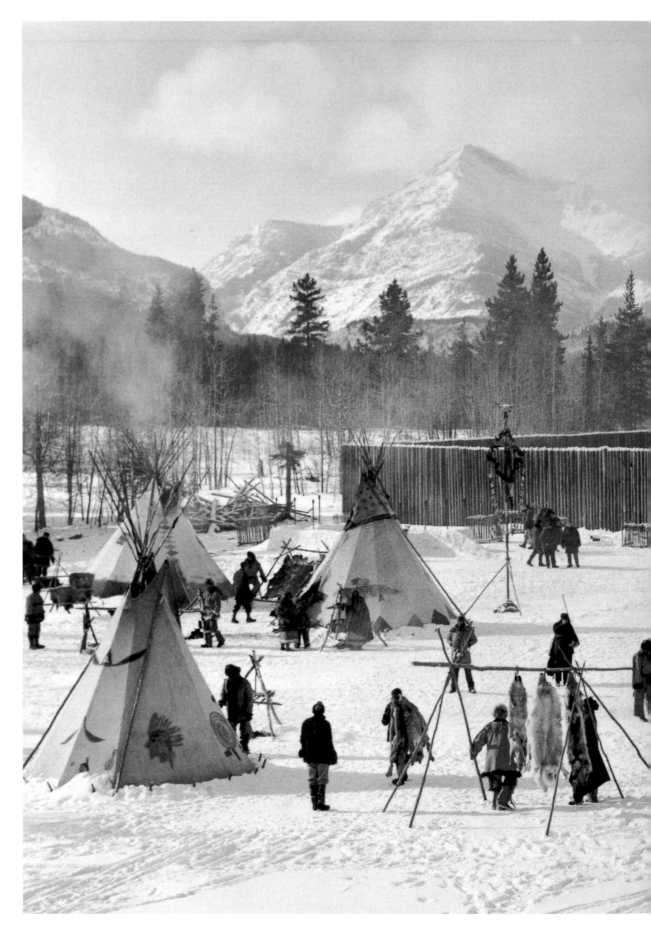

SCENE FROM "NIKKI, WILD DOG OF THE NORTH"
This movie was shot in Kananaskis Country in 1958.
Director, Jack Couffer.

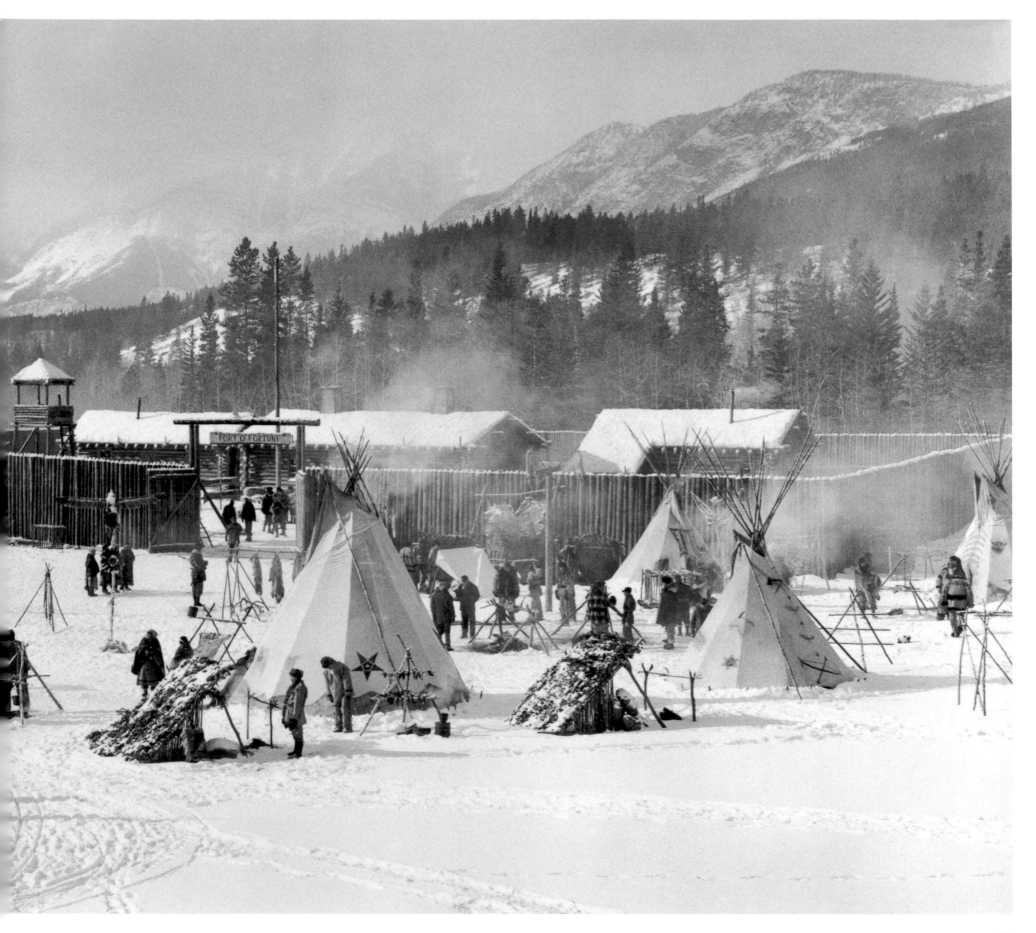

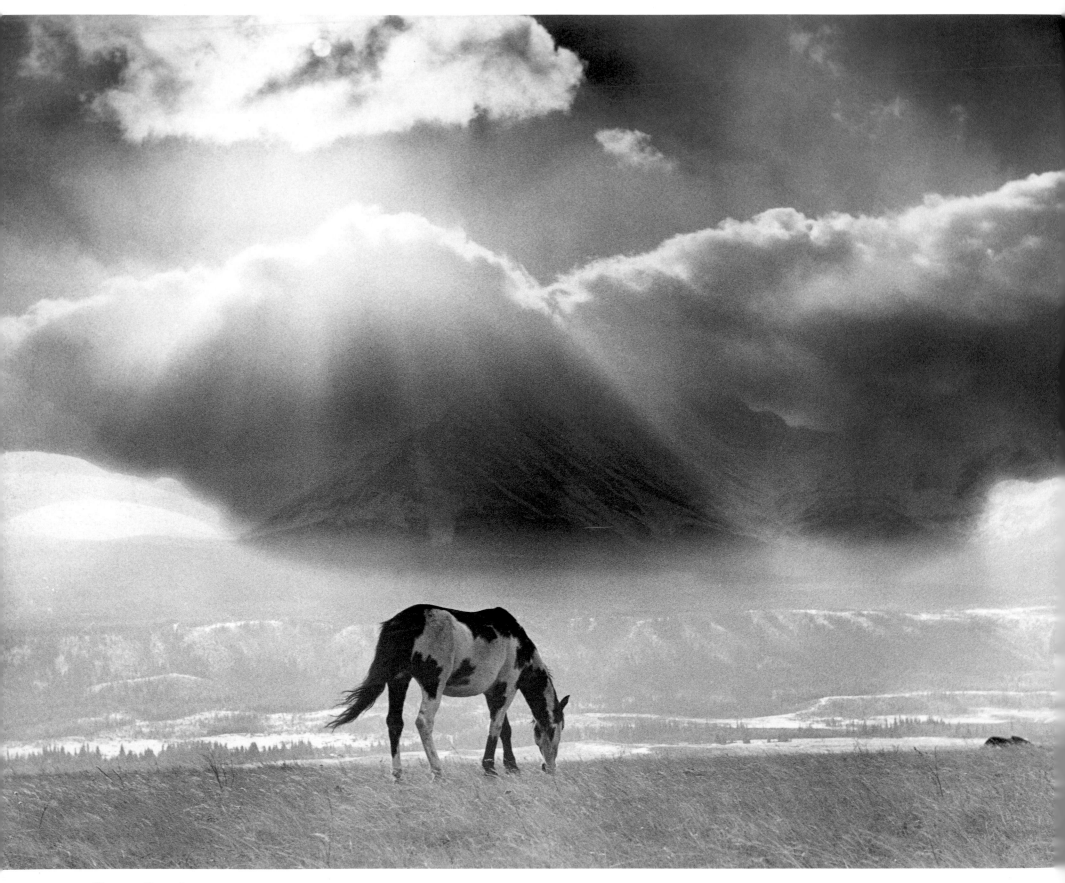

"Lonely Pinto"

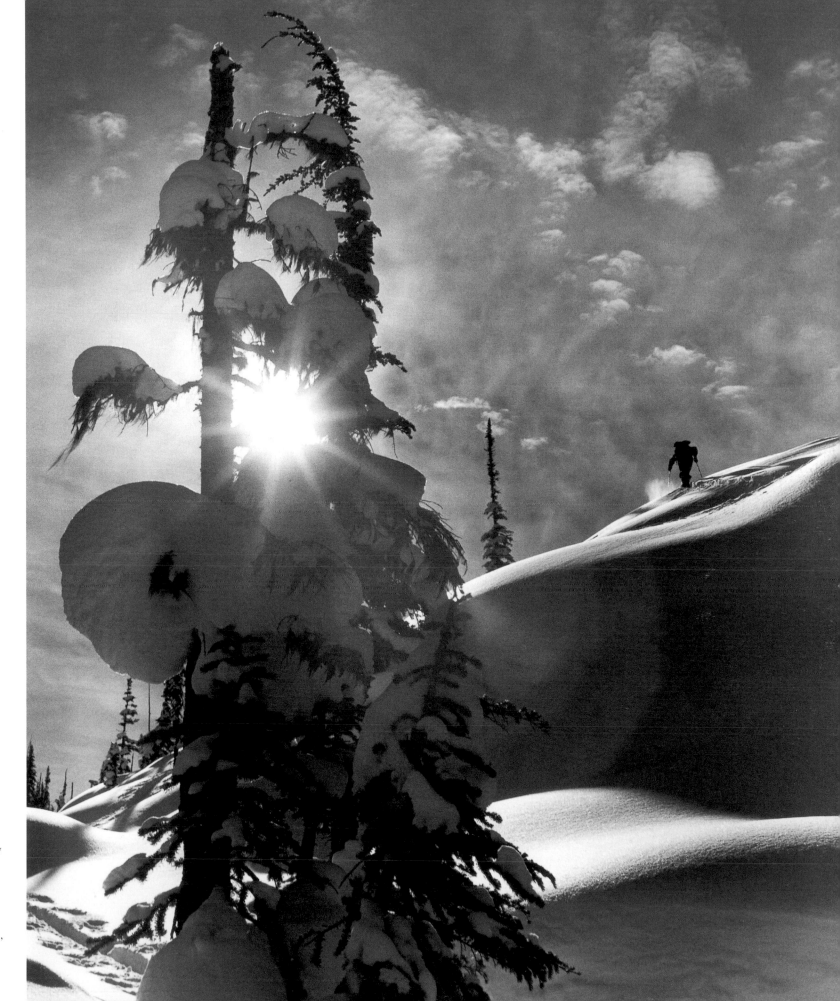

"Silent Trail"

"The heavy snow cover has molded the environment of Glacier National Park into a winter landscape. The low winter sun shimmering through the trees casts a long shadow on the undulating blanket of snow. A lone skier leaves behind a 'silent trail' that will soon disappear under new snow."

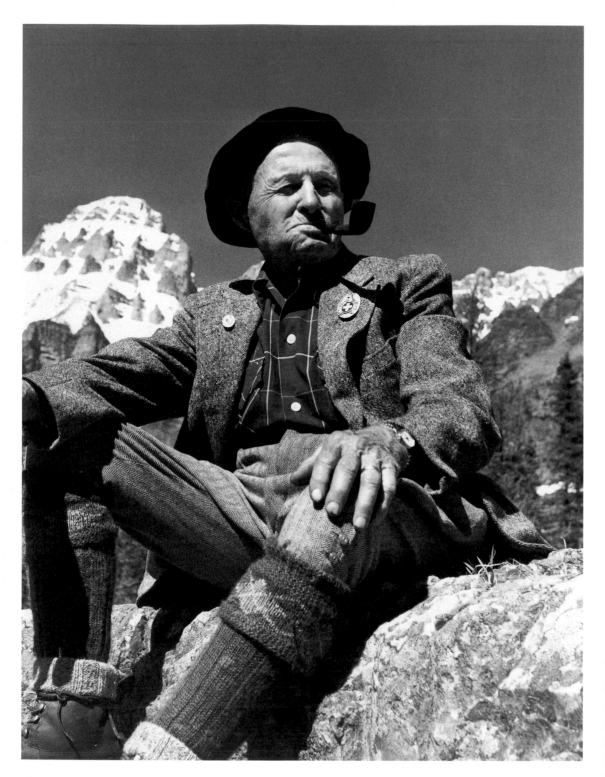

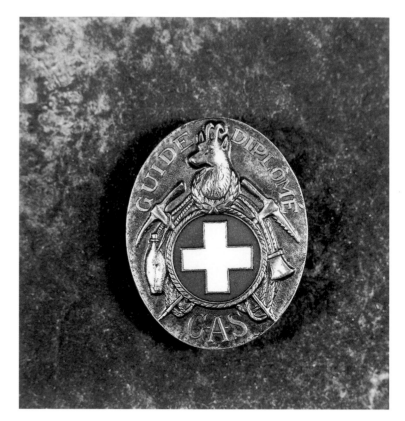

OFFICIAL SWISS GUIDE BADGE
"Respected all over the world."

EDWARD FEUZ JR.

"Ed Feuz was one of the Swiss guides that came over in 1903. His father was here before him and I had the opportunity to spend two summers with him in Lake Louise as a guide. Edward made more than 100 first ascents. I had a great respect for Edward, but he was also a proud man. Edward, he always thought he was the best, maybe he was, but there were many good ones. I made a film on him ("This Land" in 1971). I had a tough time convincing him to do it, but I'm glad I did it. It was a very nice little film on a man who said goodbye to the mountains. When he was 82 he climbed the pinnacle at Abbot Pass wearing his nailed boots. When he stood up there on top of the pinnacle, I couldn't keep the tears out of my eyes. He said, 'Goodbye Hungabee, goodbye Wenkchemna, Biddle.' He named them all. He said goodby to the mountains. 'It's the last time I'll see you from this point.' ...And this is what a mountain man is."

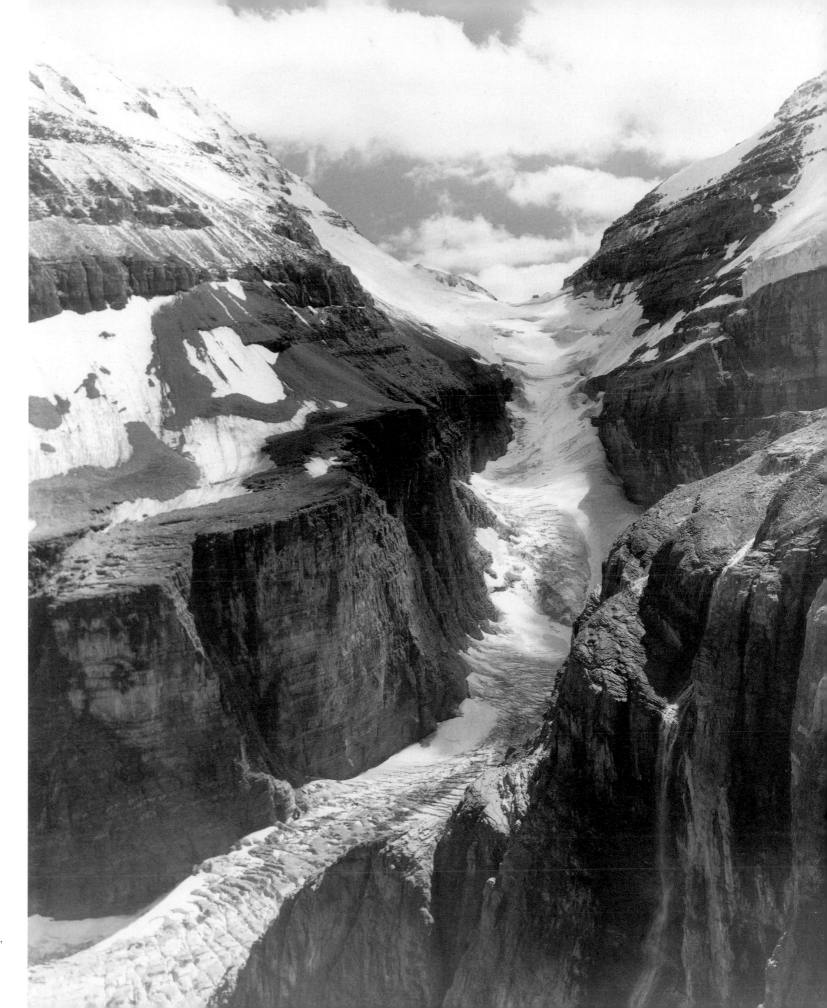

Abbot Pass

"On August 3, 1896, Philip Stanley Abbot fell to his death from Mount Lefroy (on the left side of the picture).

If you look closely, you will see a small square spot at the top of the glacier. That is Abbot Hut. Built by the CPR as a climbers' shelter, the hut is built from solid stone and is as permanent as the mountain itself. The crest of the roof is in line with the Great Divide. The rain water from the north side of the roof will eventually reach the Atlantic Ocean. From the south side, it will travel to the Pacific. The hut was officially christened in 1922."

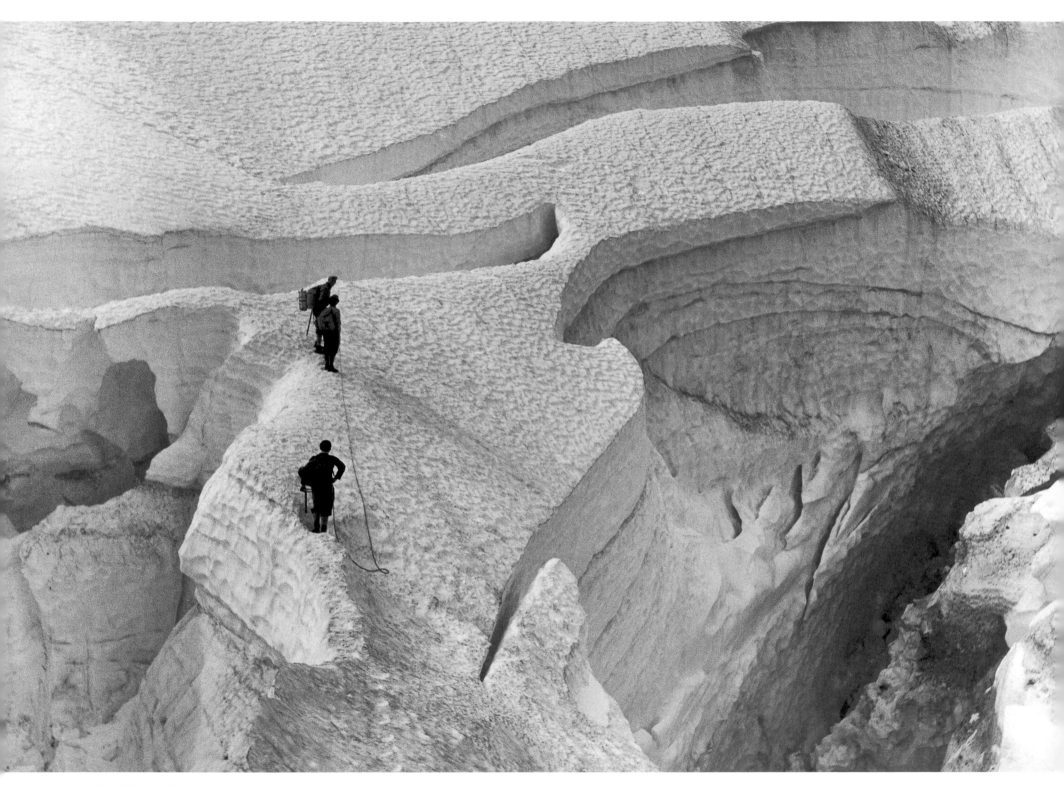

THE DEATH TRAP
Climbers ascending from the lower Victoria
Glacier to Abbot Pass.

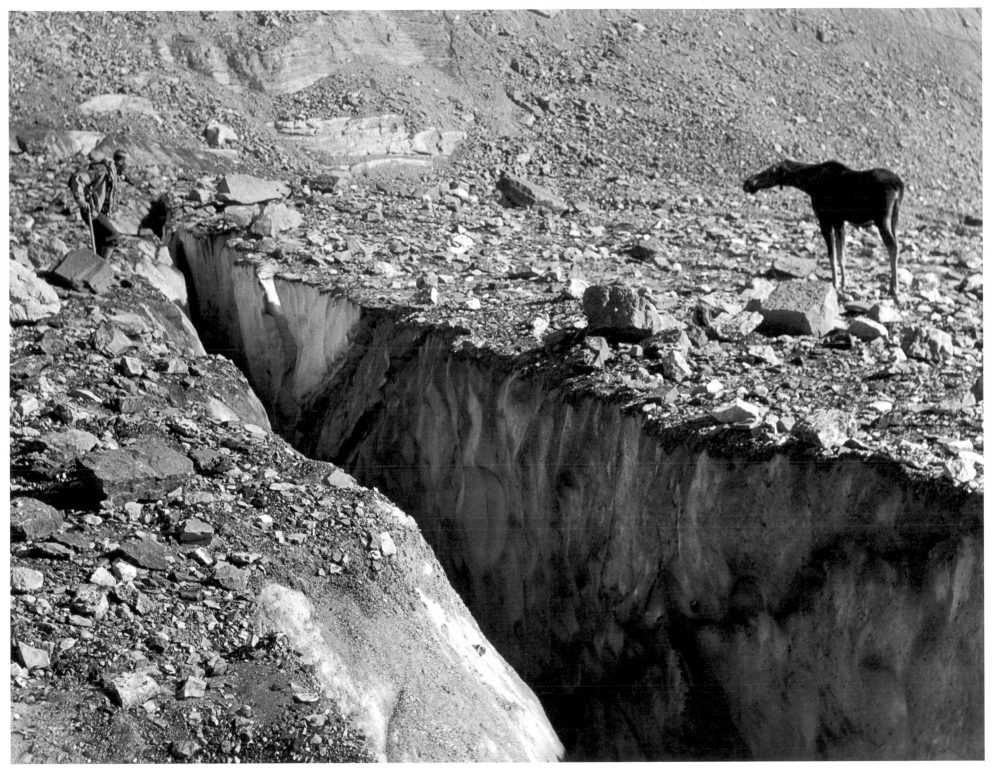

Close Encounter
Unexpected companions eye each other across
a crevasse on the lower Victoria Glacier.

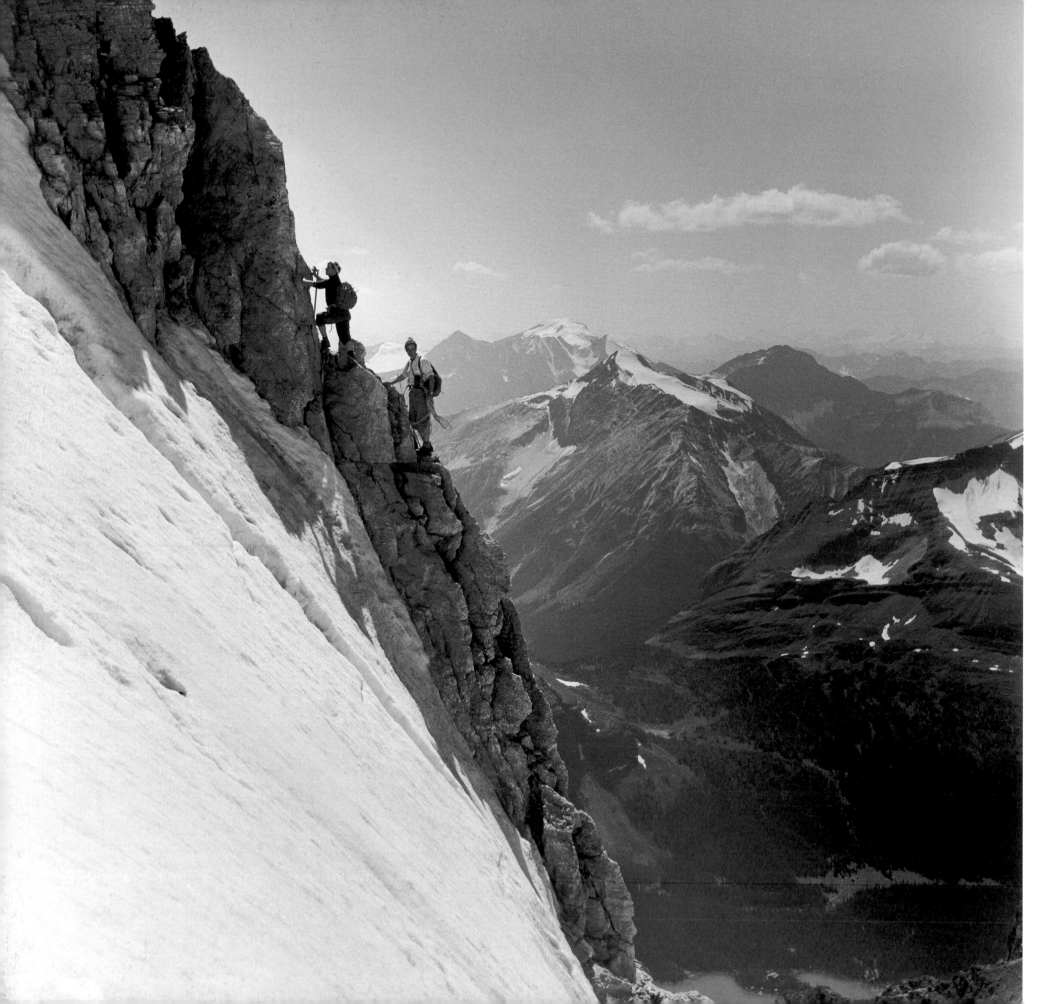

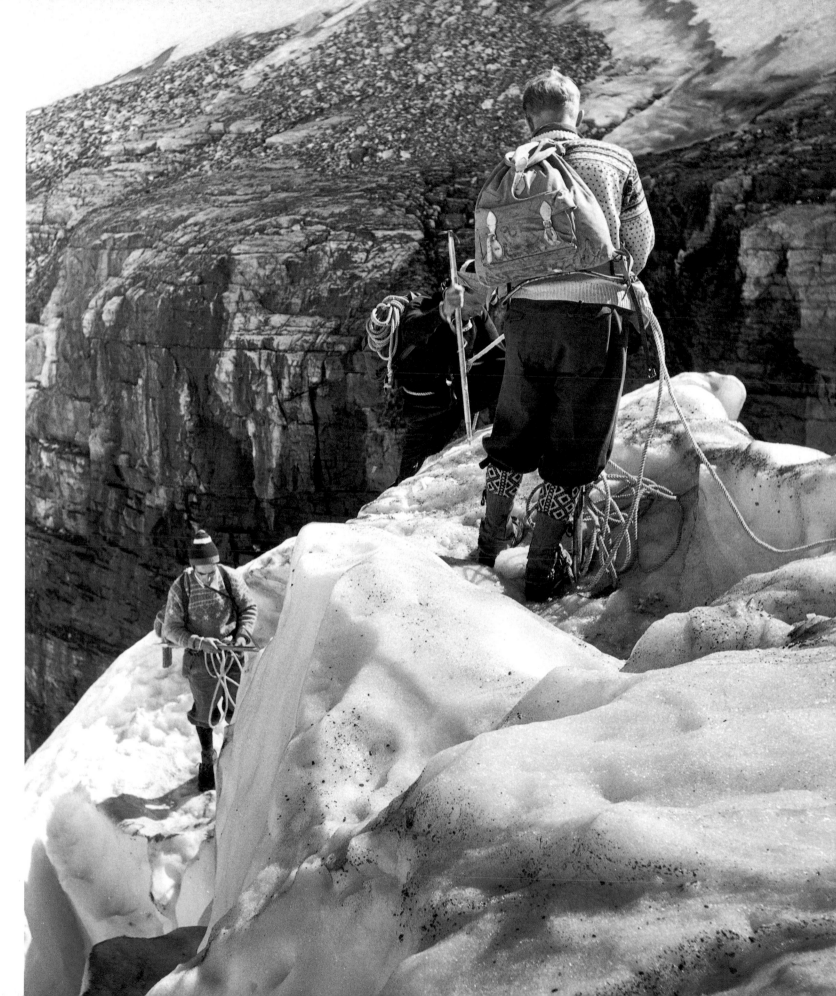

OPPOSITE: ASCENDING MOUNT
VICTORIA FROM LAKE O'HARA

RIGHT: CLIMBERS ON NORTH
VICTORIA GLACIER IN 1956
Below Mount Victoria's centre peak.

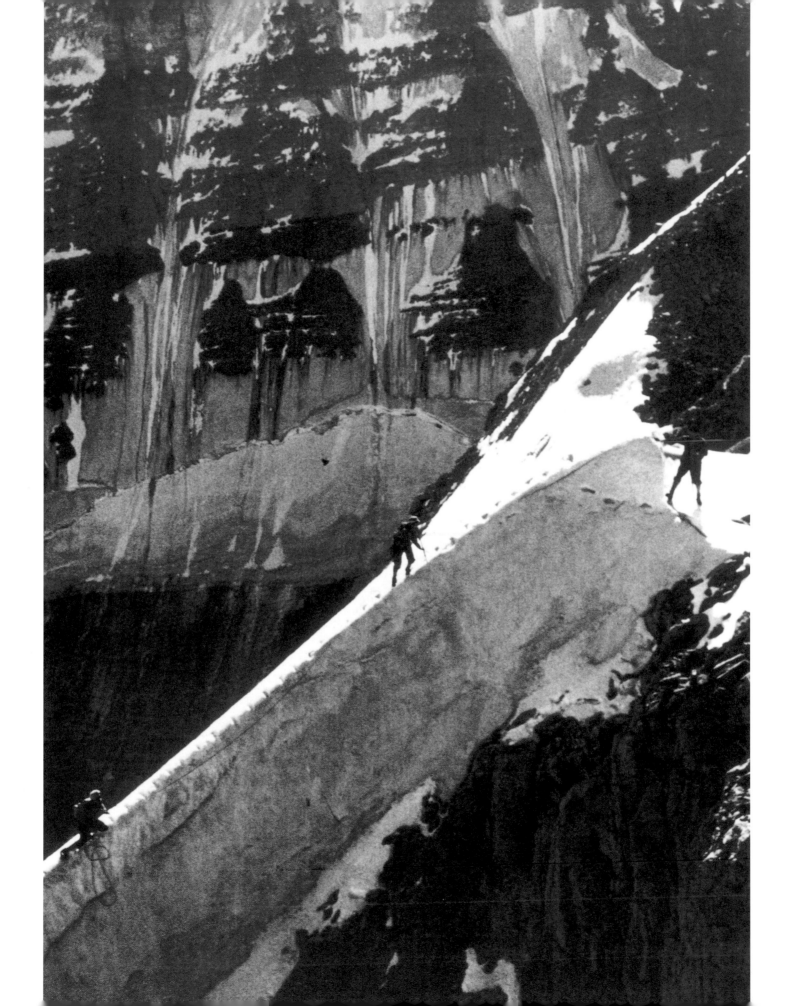

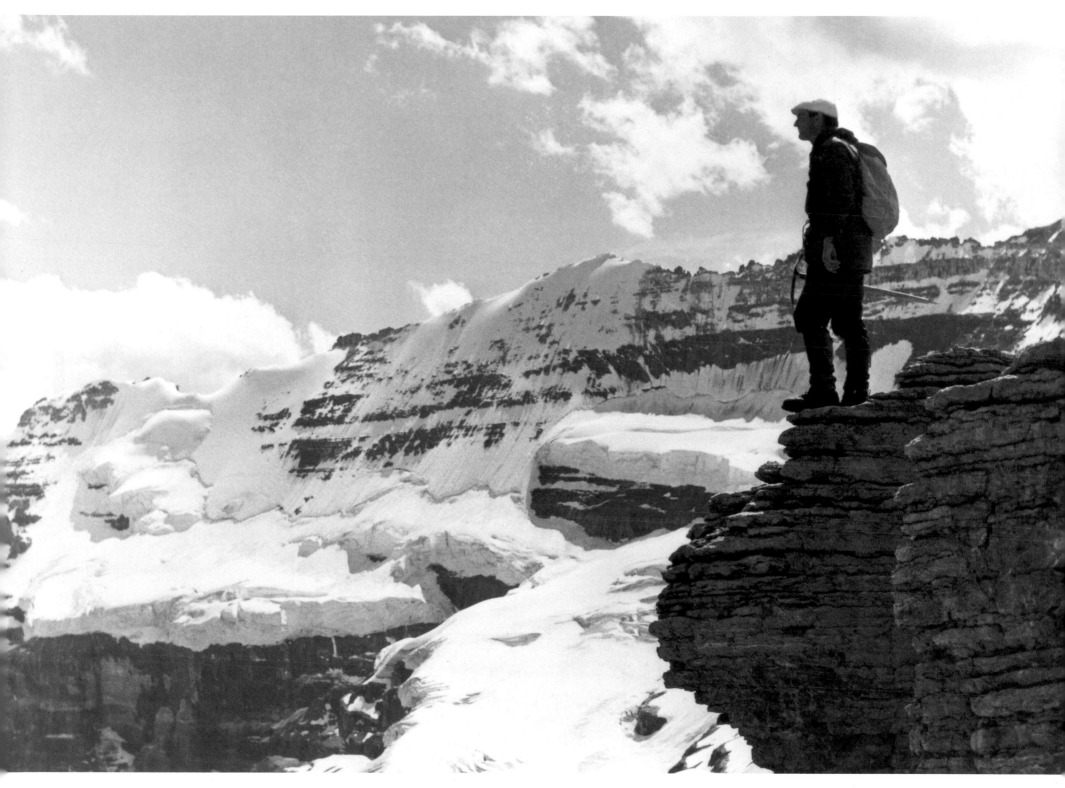

MOUNT VICTORIA FROM MOUNT WHYTE

OPPOSITE: THE SICKLE ON MOUNT VICTORIA
The ascent by Georgia Engelhard (centre), ca. 1946. Mountaineer, photographer and
writer, she made a total of 32 first ascents in the Canadian Rockies and Purcell
Mountains. Bruno took this photo using his client's camera.

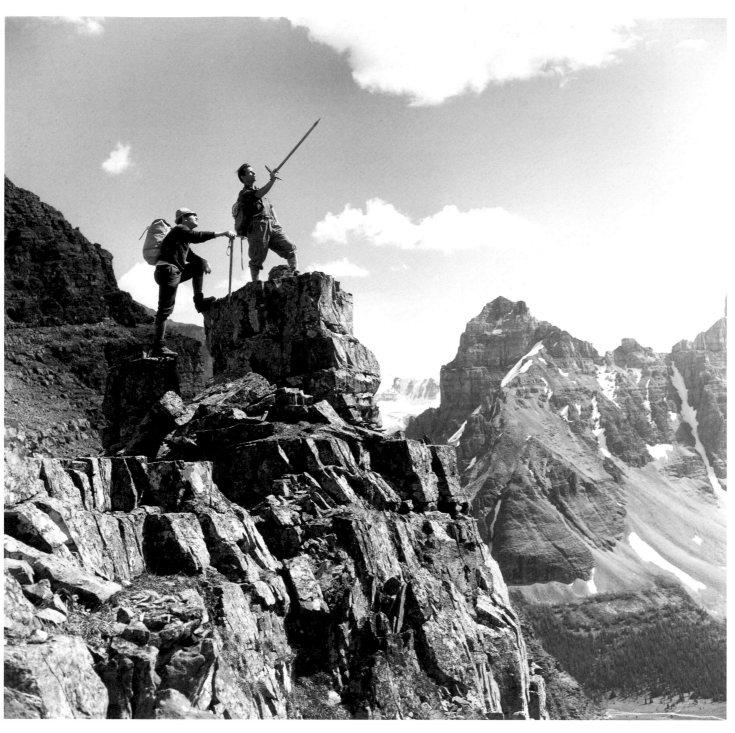

THE MITRE COL, 1956

RIGHT: MOUNT VICTORIA SOUTH, SUMMIT RIDGE
Mount Victoria was Bruno's favourite mountain. He reached the summit about thirty times.

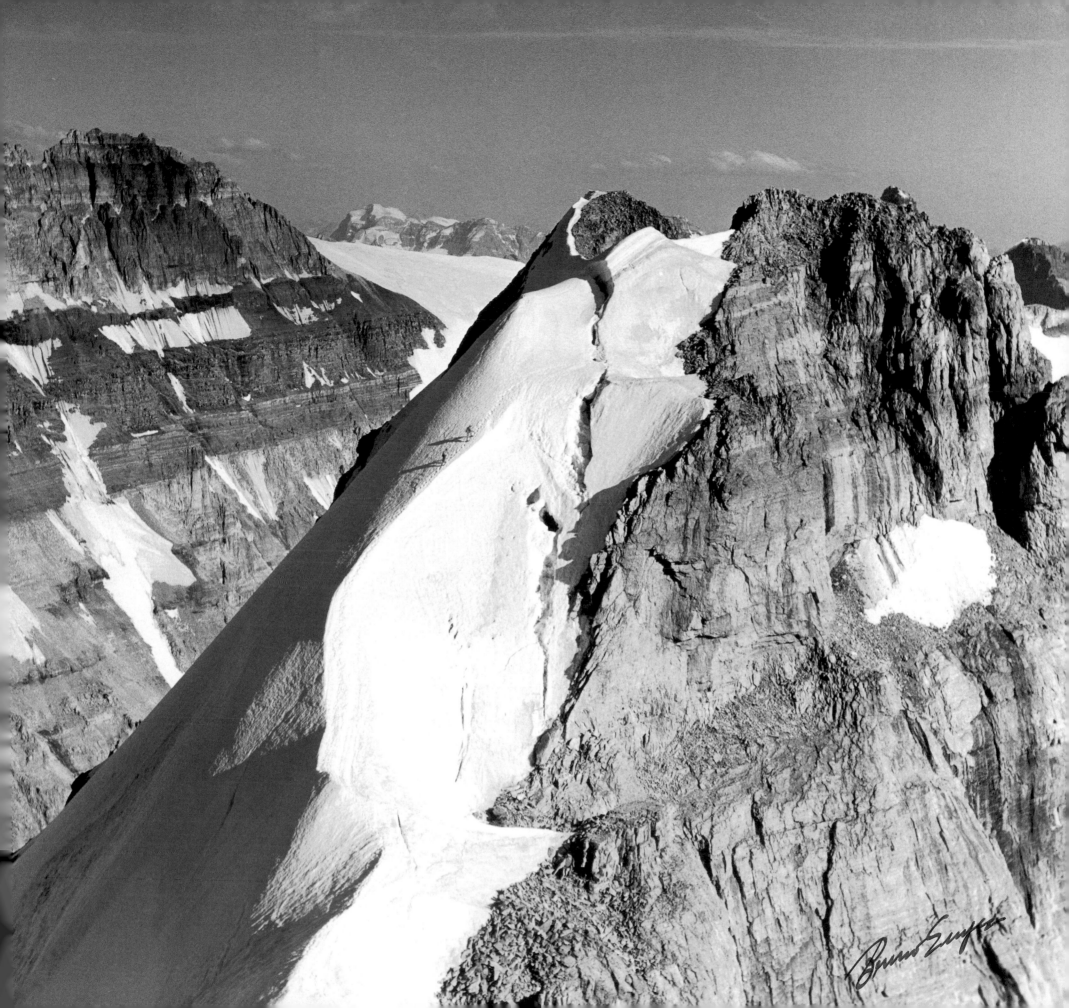

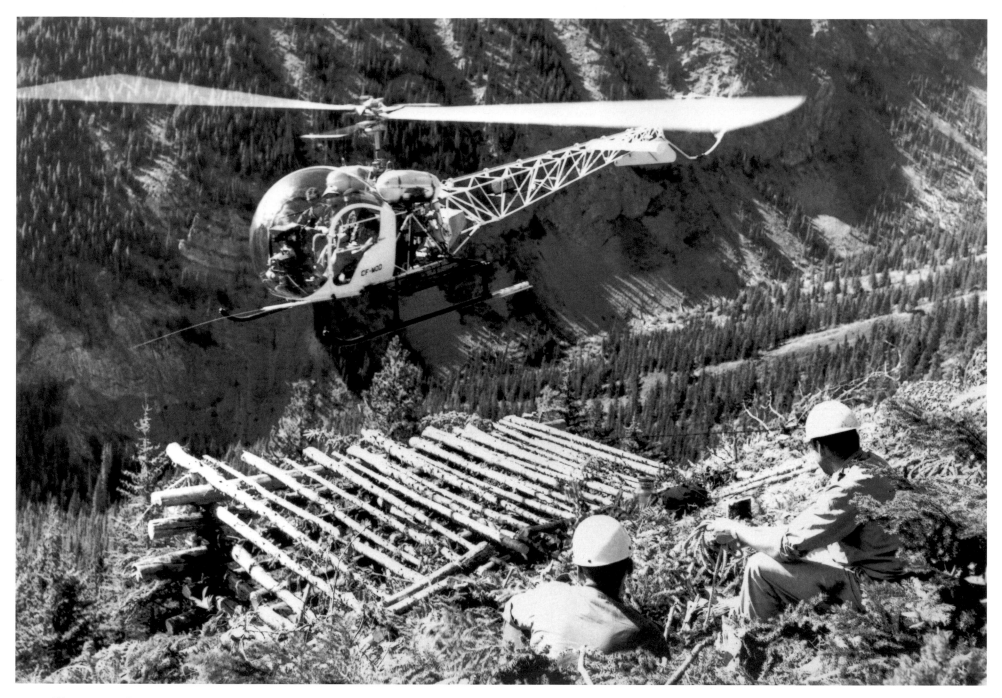

HELICOPTER RESCUE, 1956
Improvised helipad on Mount Blane being prepared by
the support rescue party.

OPPOSITE: WARDEN MOUNTAIN RESCUE TRAINING, 1955

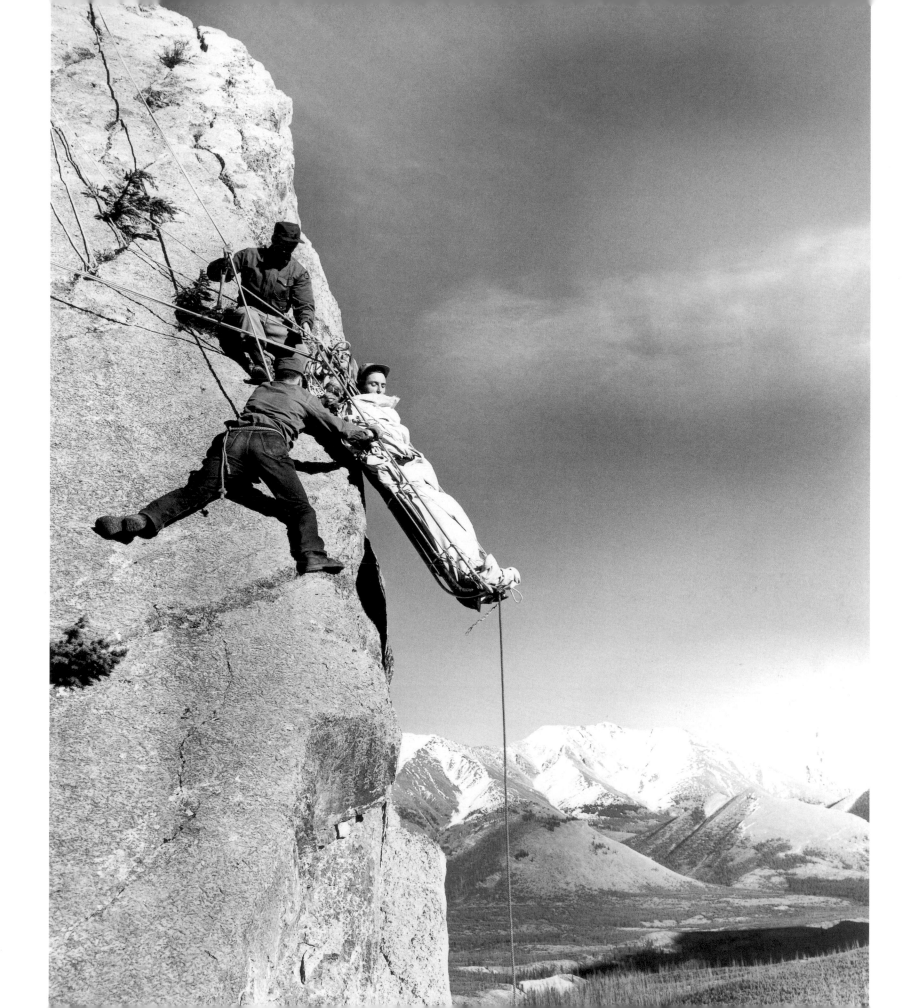

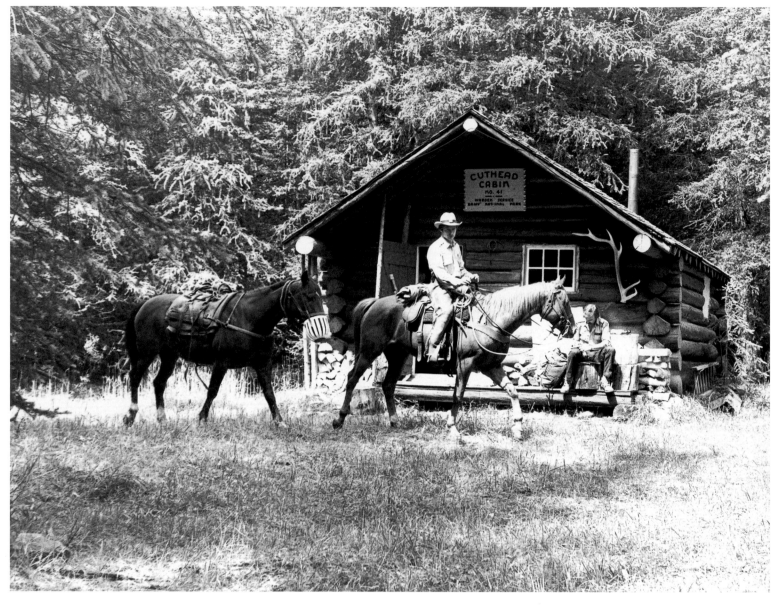

CUTHEAD WARDEN CABIN NO. 41

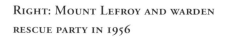

RIGHT: MOUNT LEFROY AND WARDEN
RESCUE PARTY IN 1956

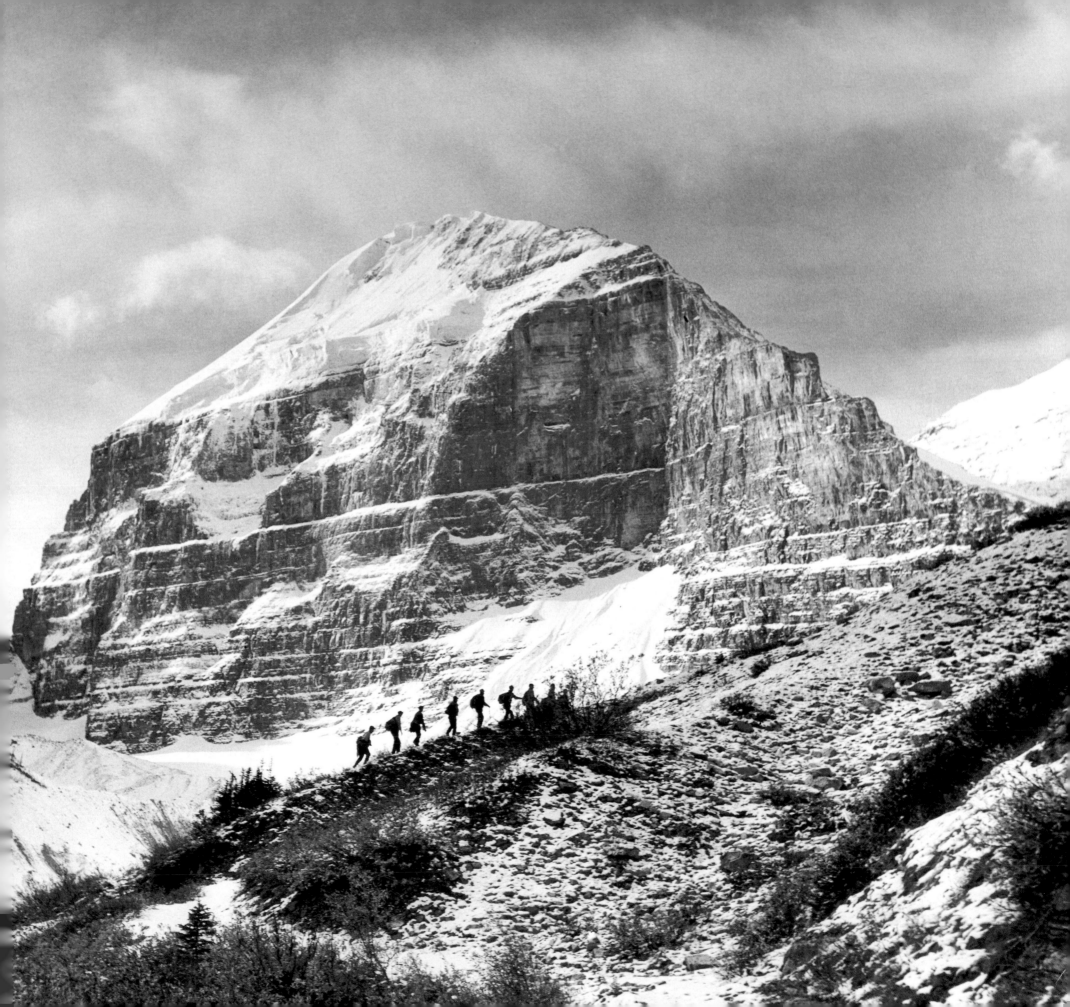

SKIING THE BOW GLACIER

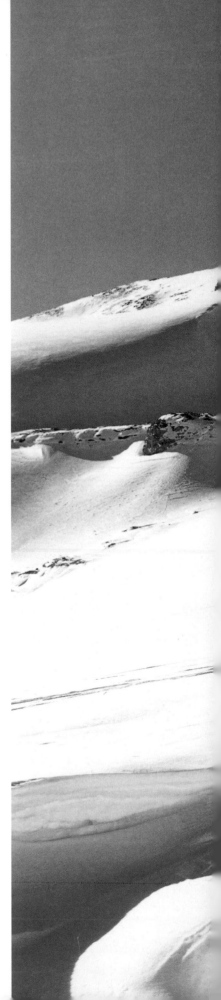

RIGHT: SKI MOUNTAINEERING
The Bow Glacier and St. Nicholas Peak.

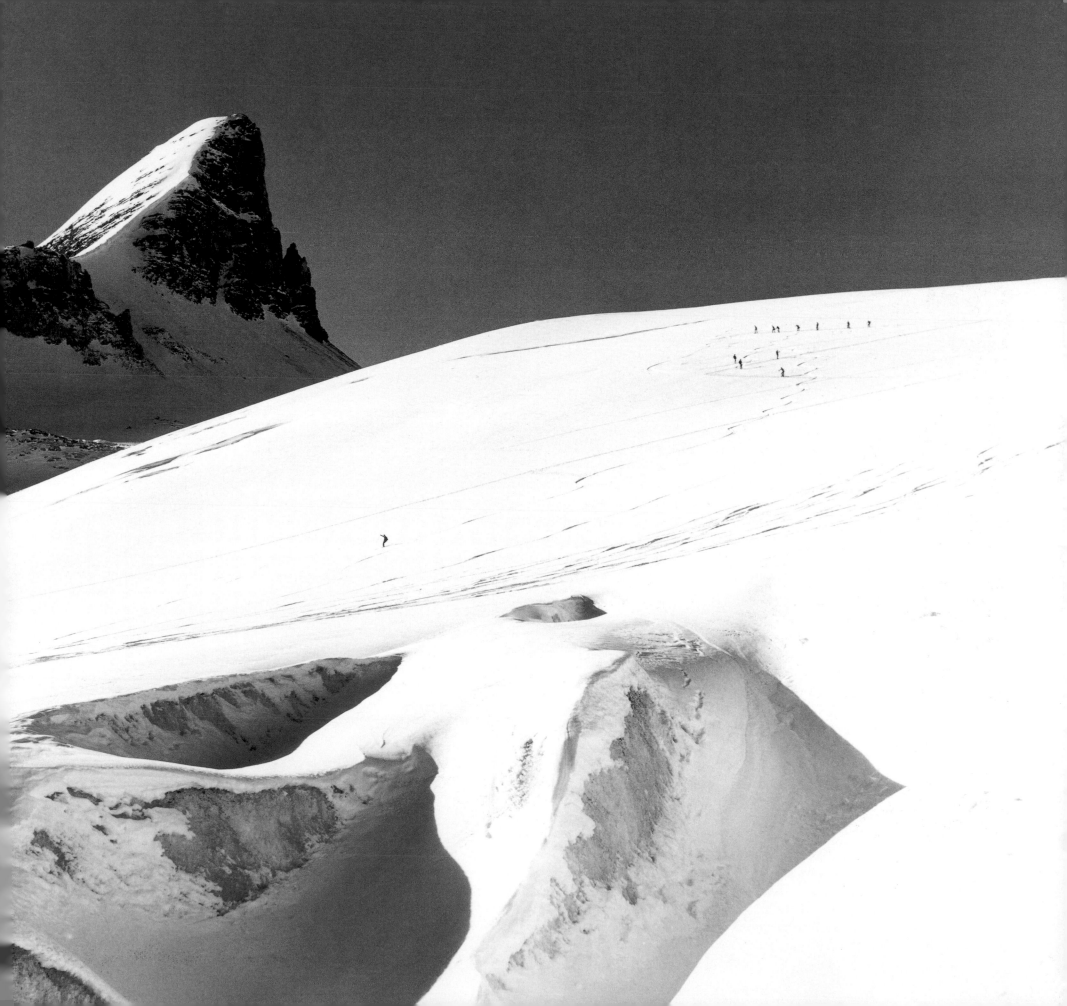

"The perennial ice on upper Mount Victoria melts slowly during the summer. For a short period this water will contribute to Lake Louise, then continue to the Bow River, eventually travelling thousands of miles to Hudson Bay. The Indians named the glacier 'Mother of the Waters.'"

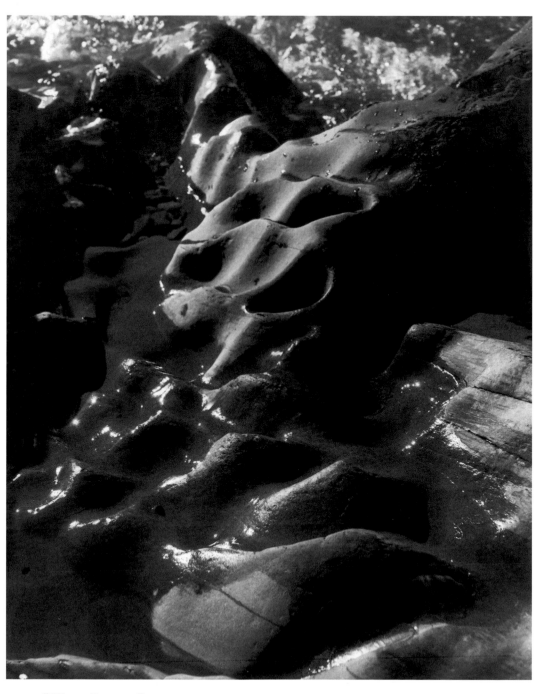

"Water Erosion"

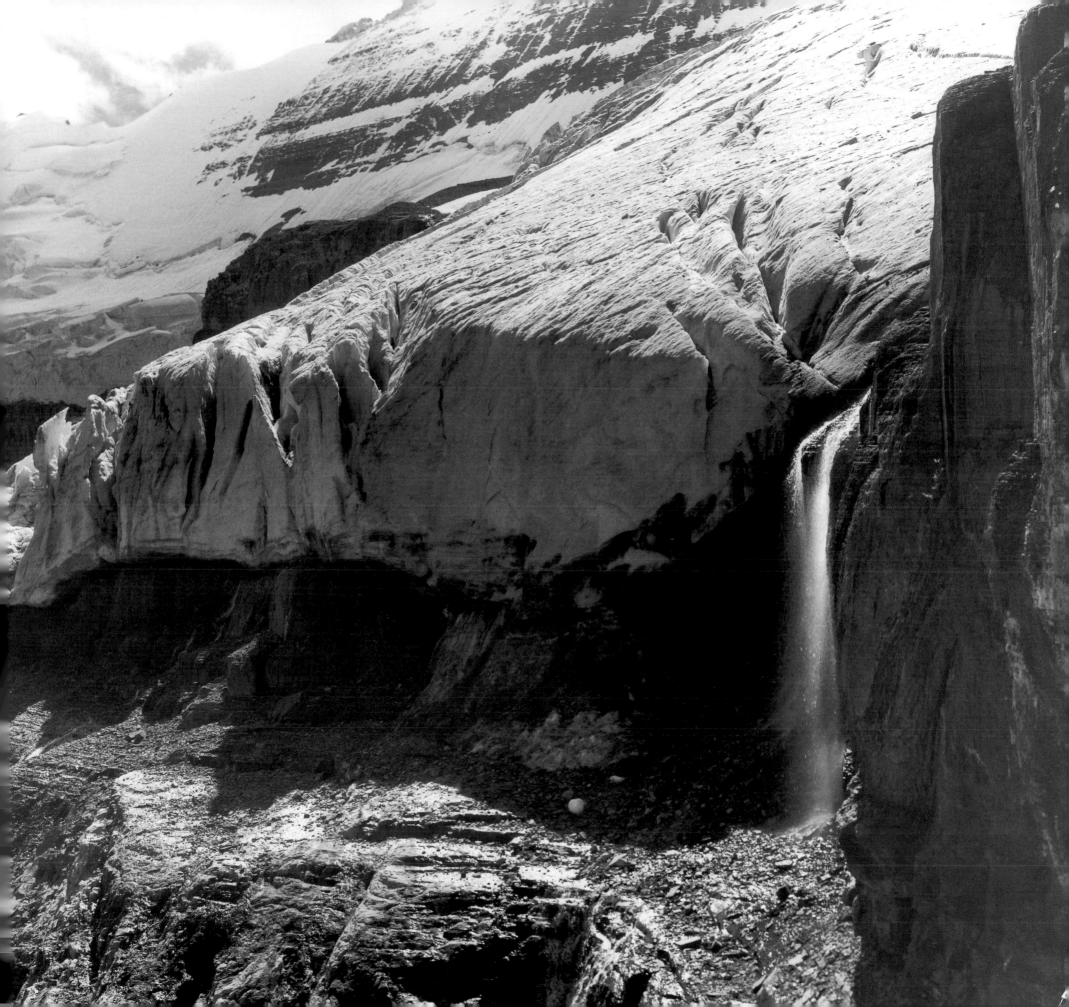

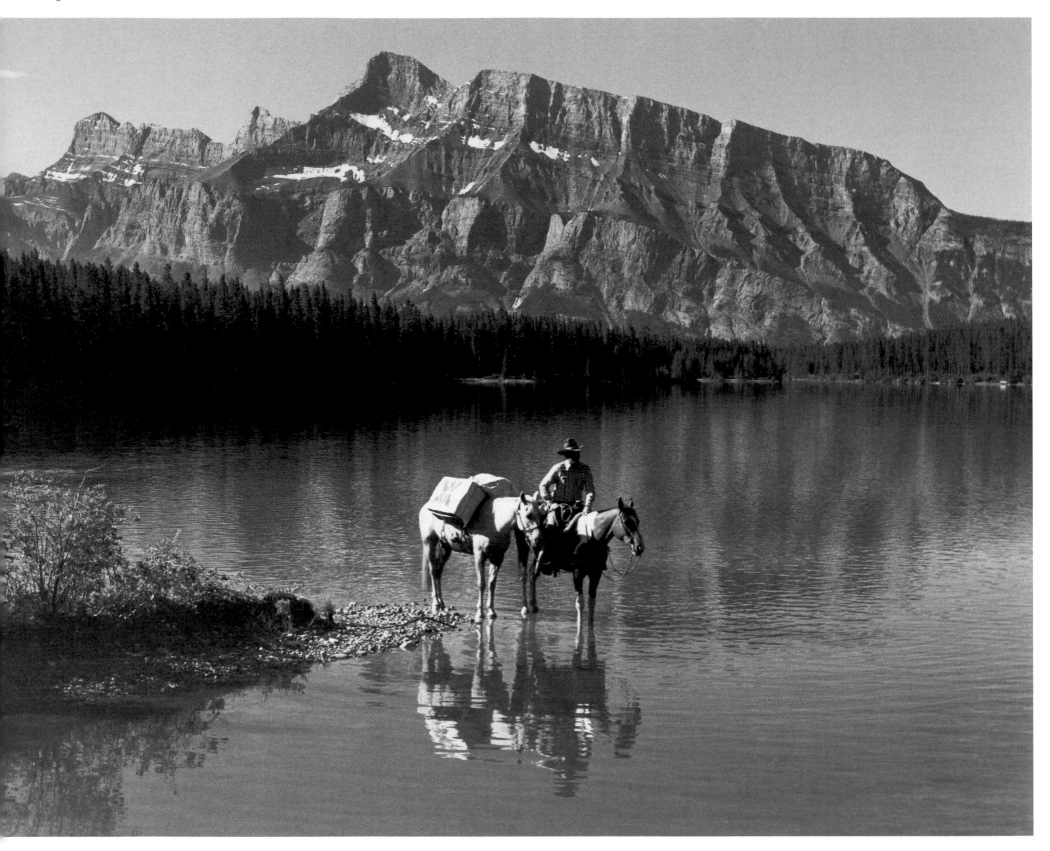

HORSES AND RIDER AT TWO JACK LAKE
Mount Rundle in the background.

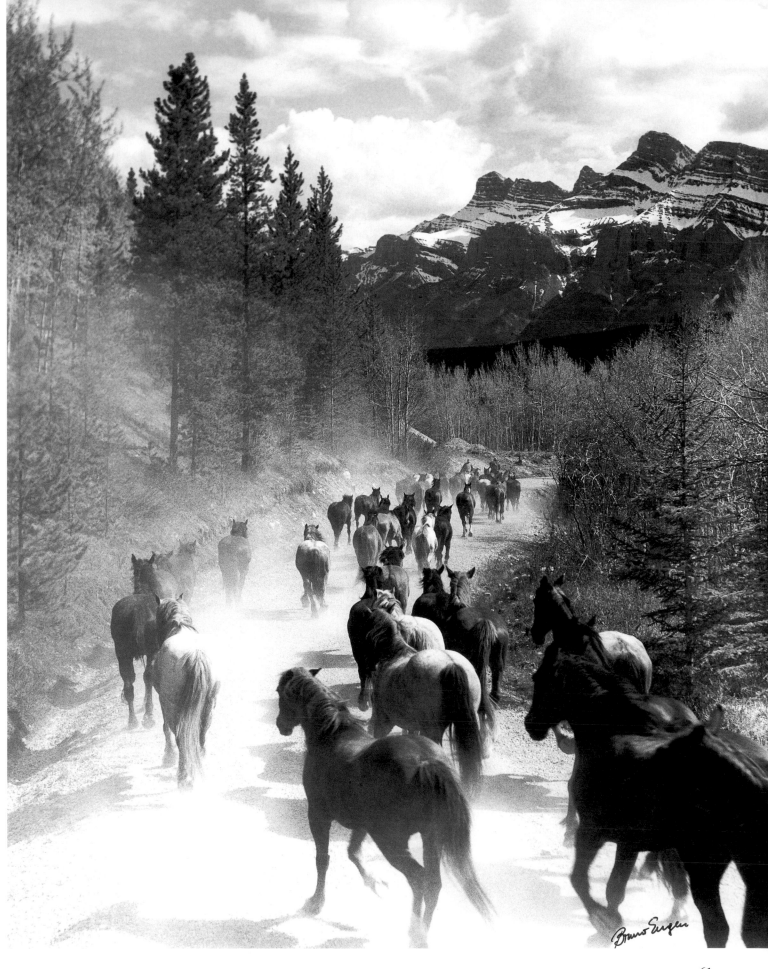

"Horse Drive"

"Every year the wardens would drive the horses from their winter pasture in Ya-Ha-Tinda and herd them down the Cascade fire road. In Banff everybody waited for the warden horses to come. That meant it was summer. In the fall they would do the same trip in reverse. That meant winter was coming."

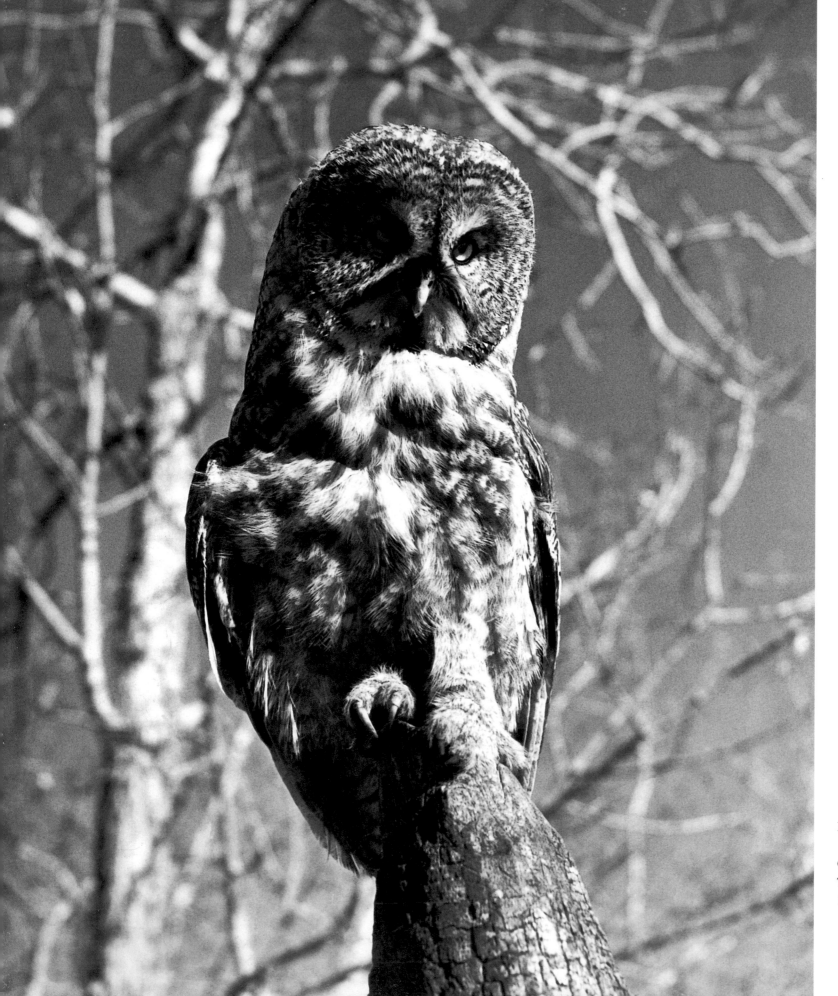

LEFT: GREAT GREY OWL

OPPOSITE: "LITTLE BIG MAN"
The movie was filmed near Morley in
1968. Director, Arthur Penn.

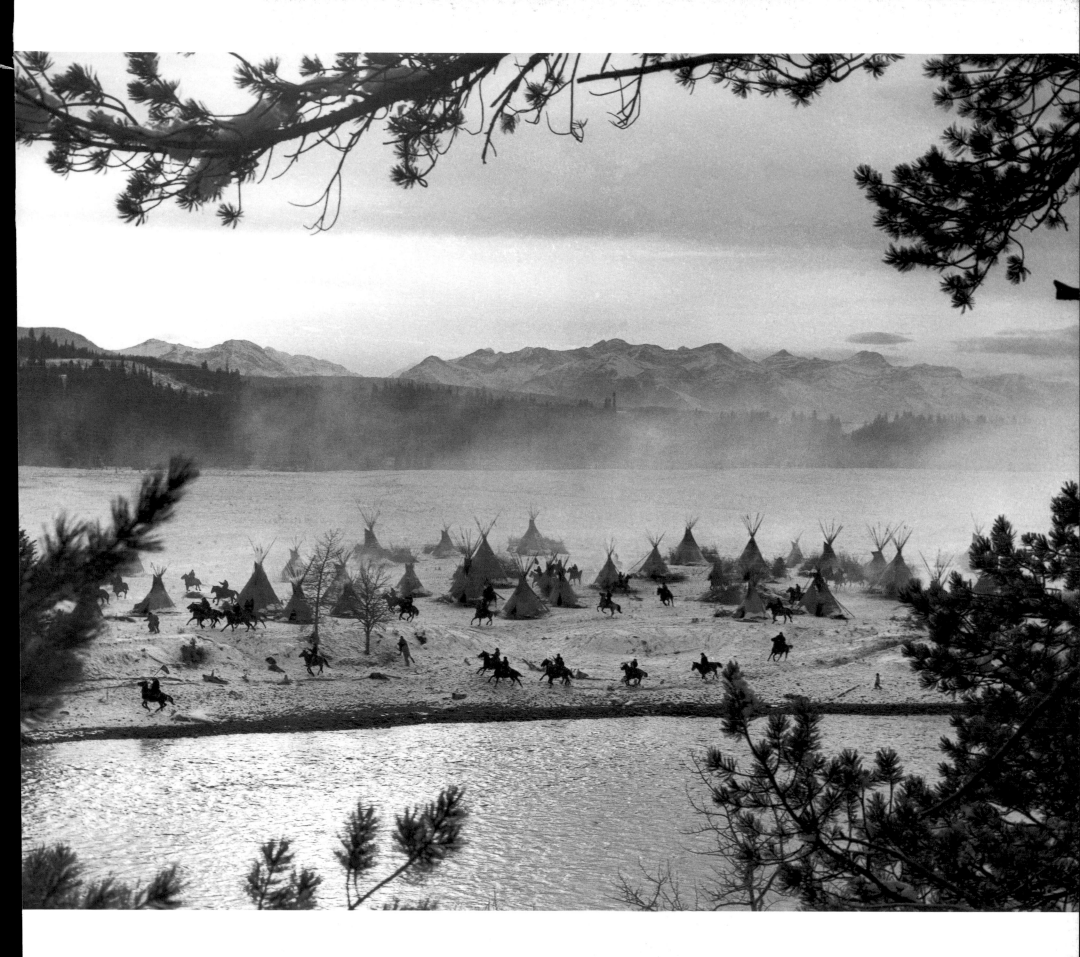

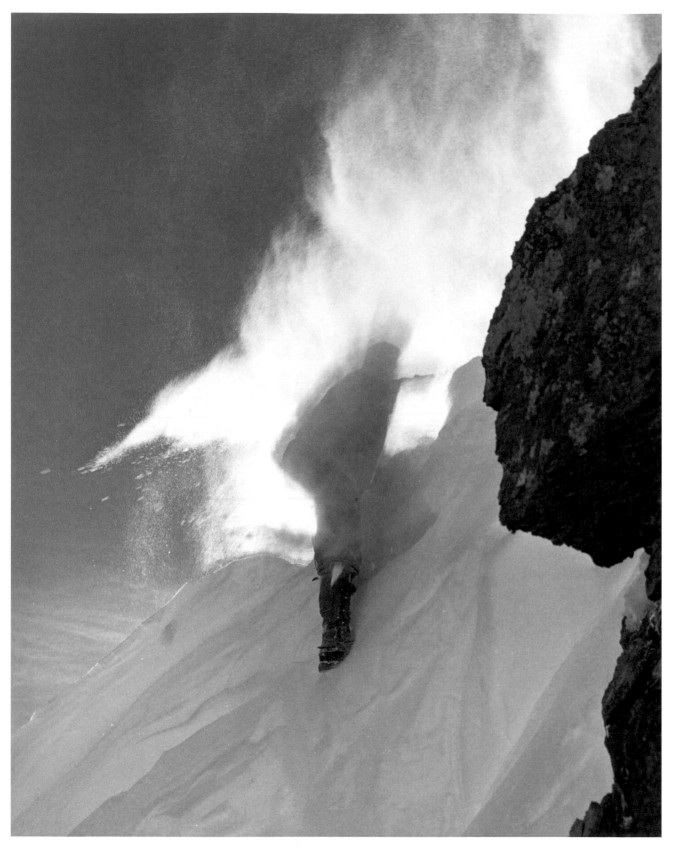

"CLIMBING THE CORNICE"

RIGHT: THE RAMPARTS NEAR JASPER

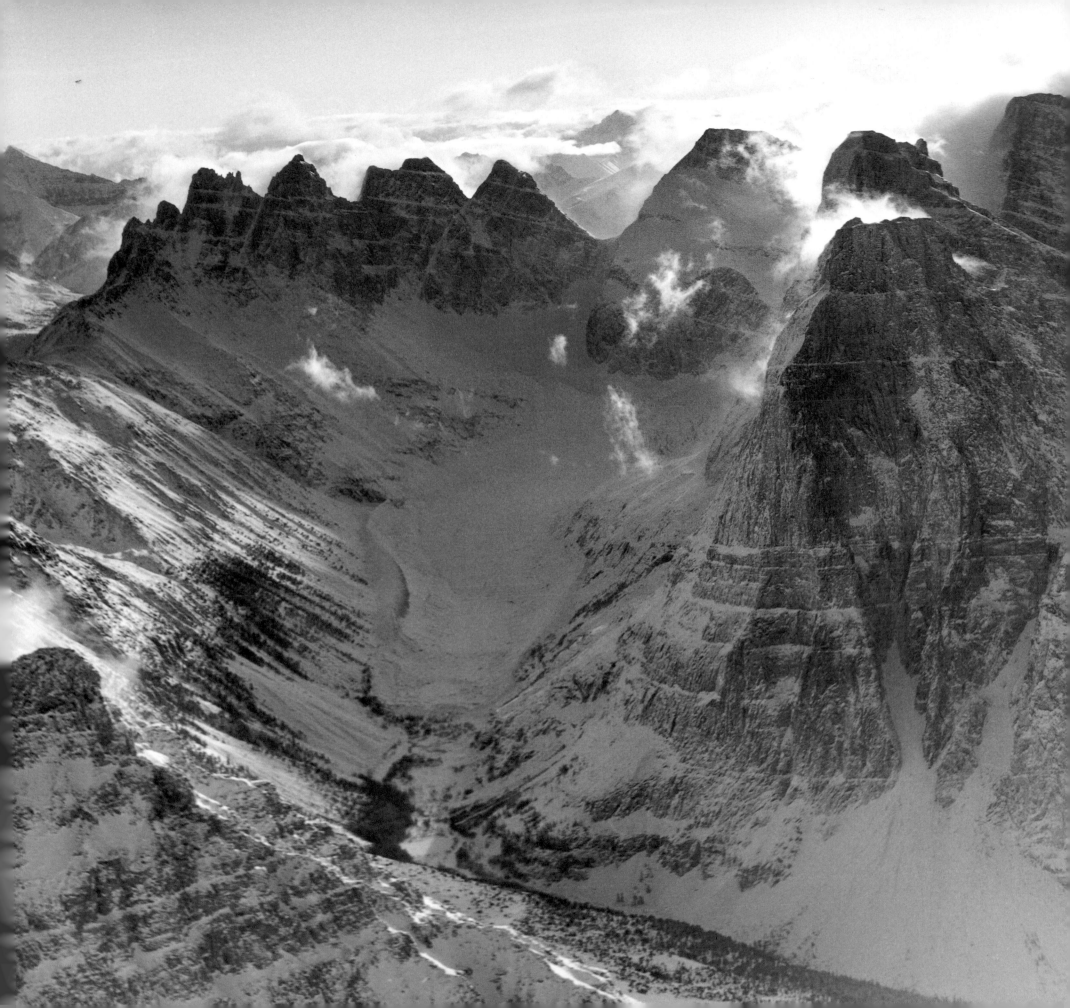

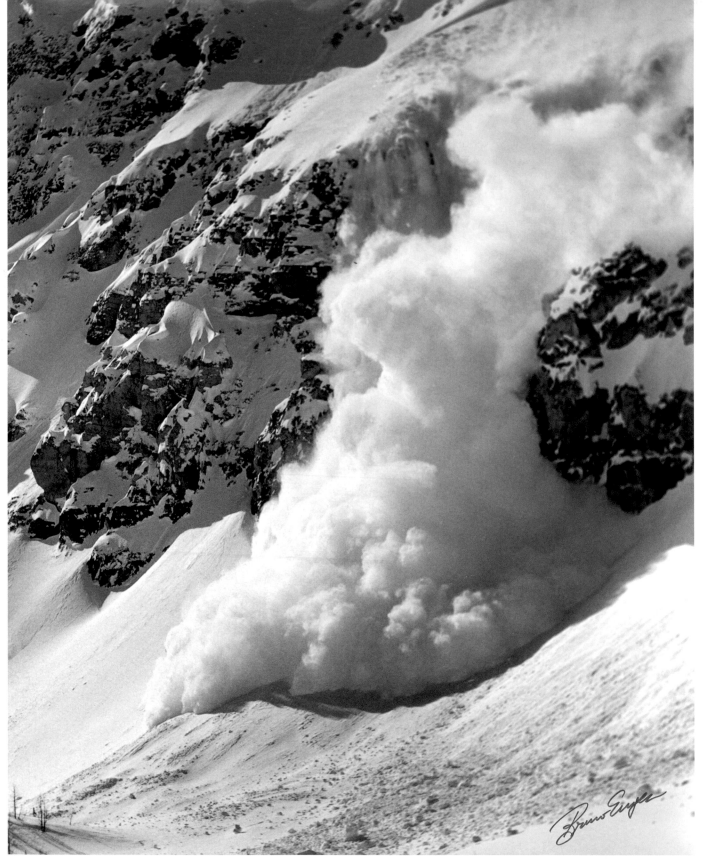

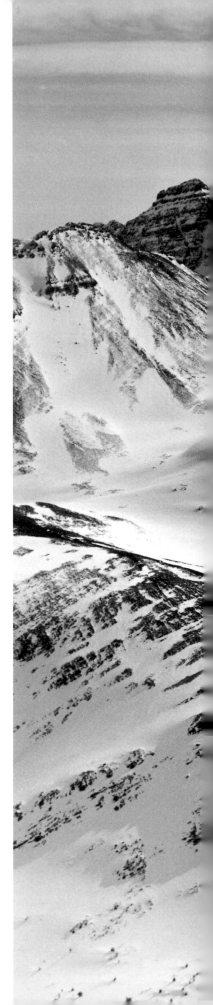

Avalanche

"Tons of snow and rock come crashing down from a cornice on Brewster Rock
above Sunshine Ski Area. The snow can roll like it's on ball bearings."

RIGHT: MOUNT ATHABASCA IN WINTER

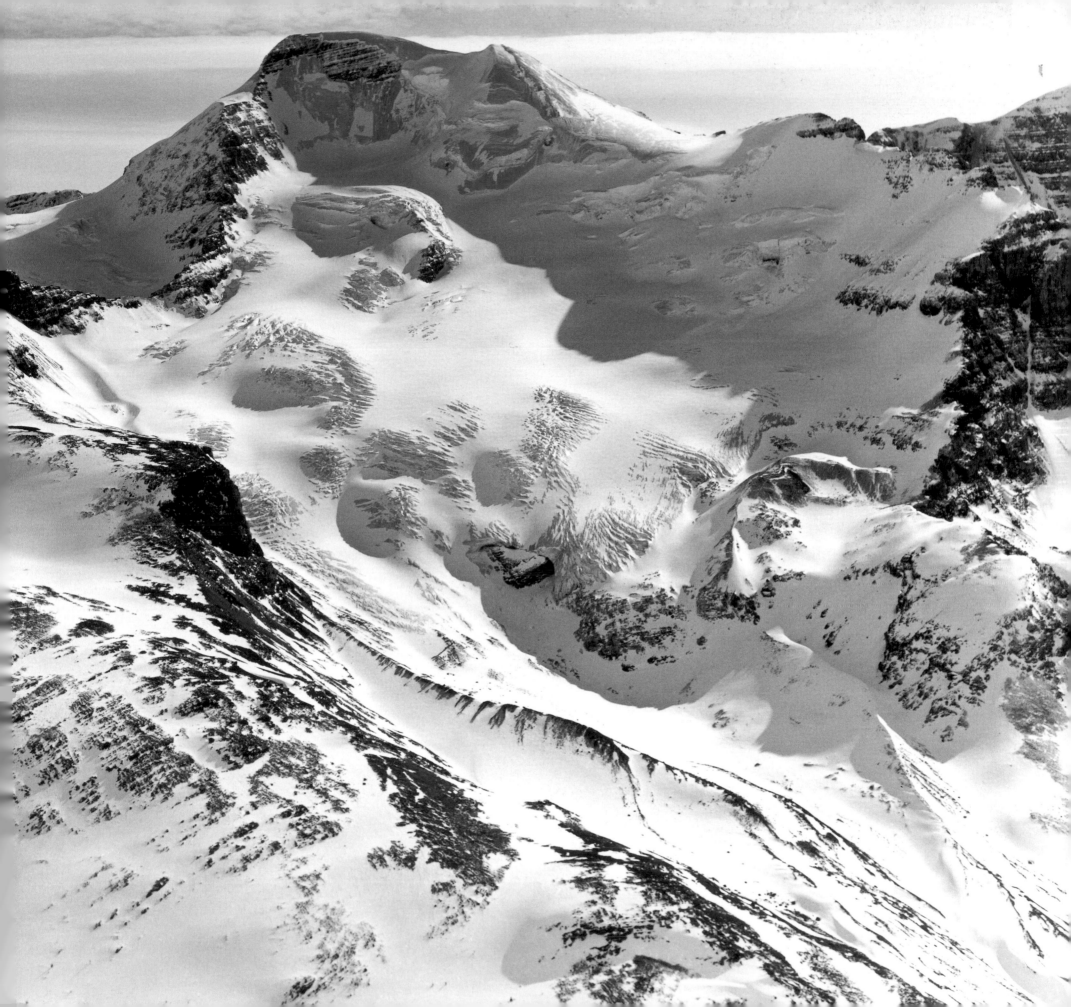

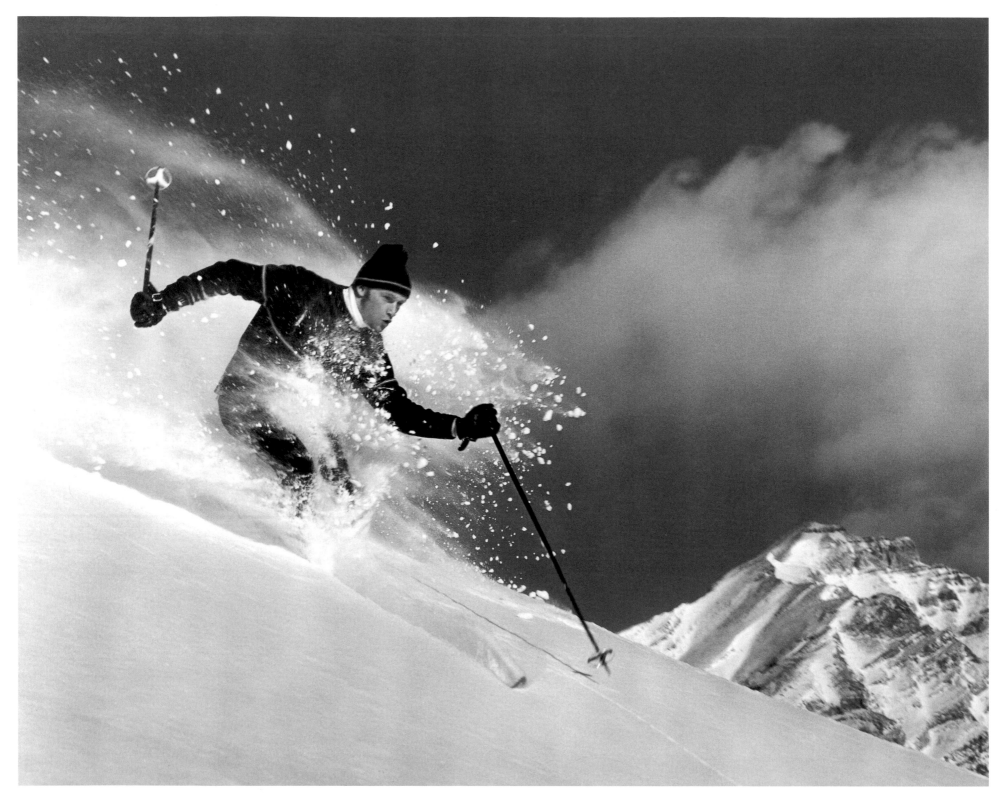

POWDER SKIING
Erwin Tontsch skiing at Mount Norquay
after a new snowfall.

OPPOSITE: FREESTYLE SKIING
The beginning of freestyle skiing at Whitehorn, Lake Louise
Ski Area, 1968. This photograph was featured in Powder
Magazine's 1996 Photo Annual issue as one of the best
photos in 100 years of ski photography.

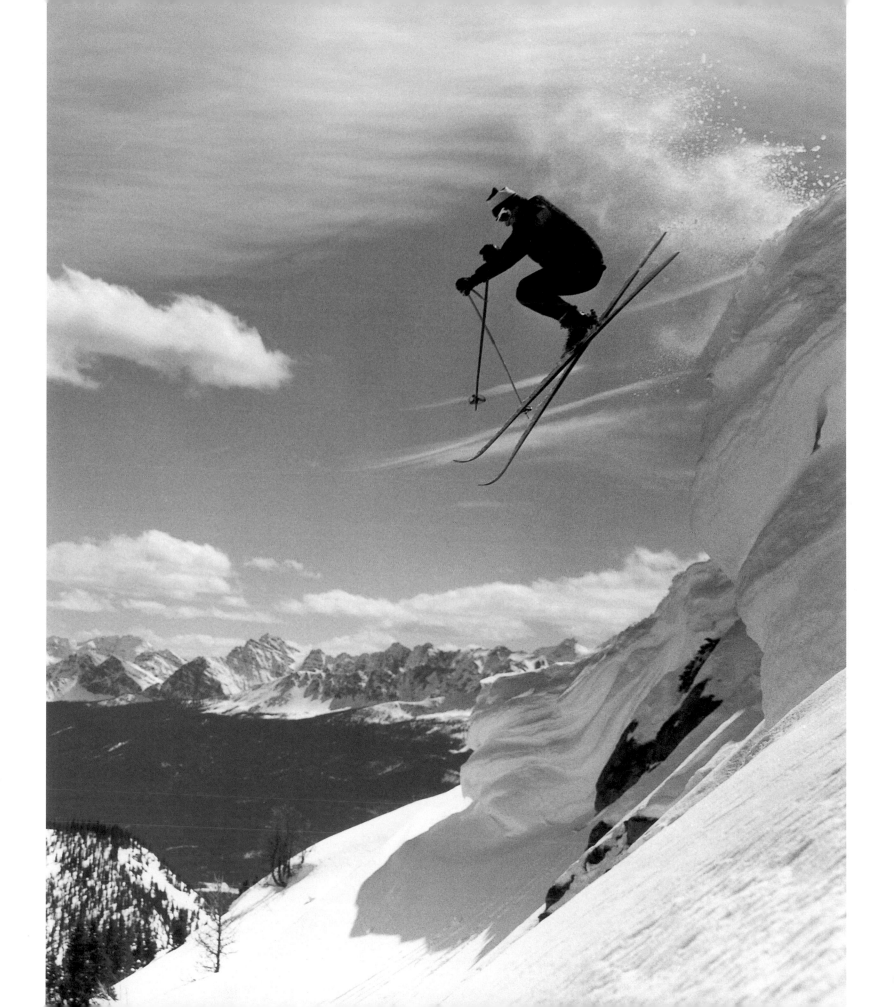

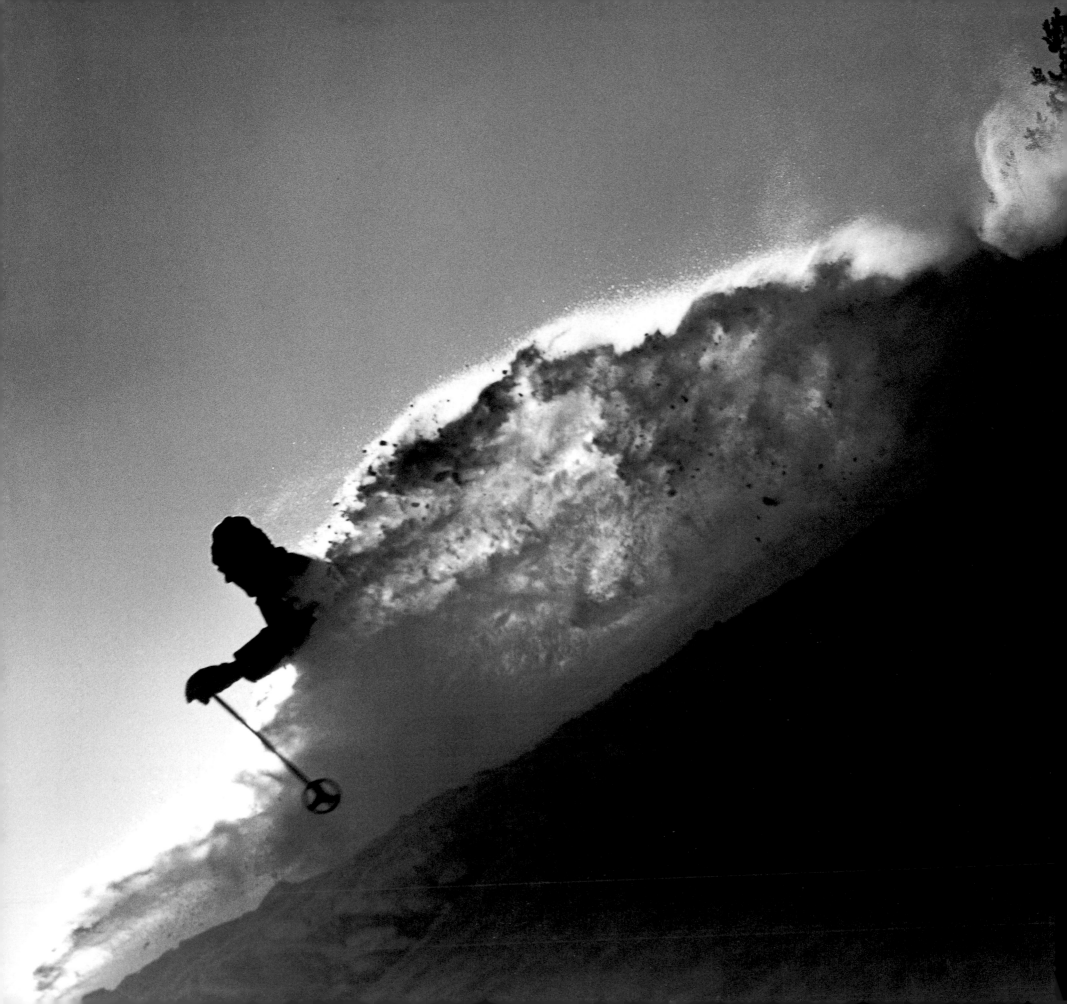

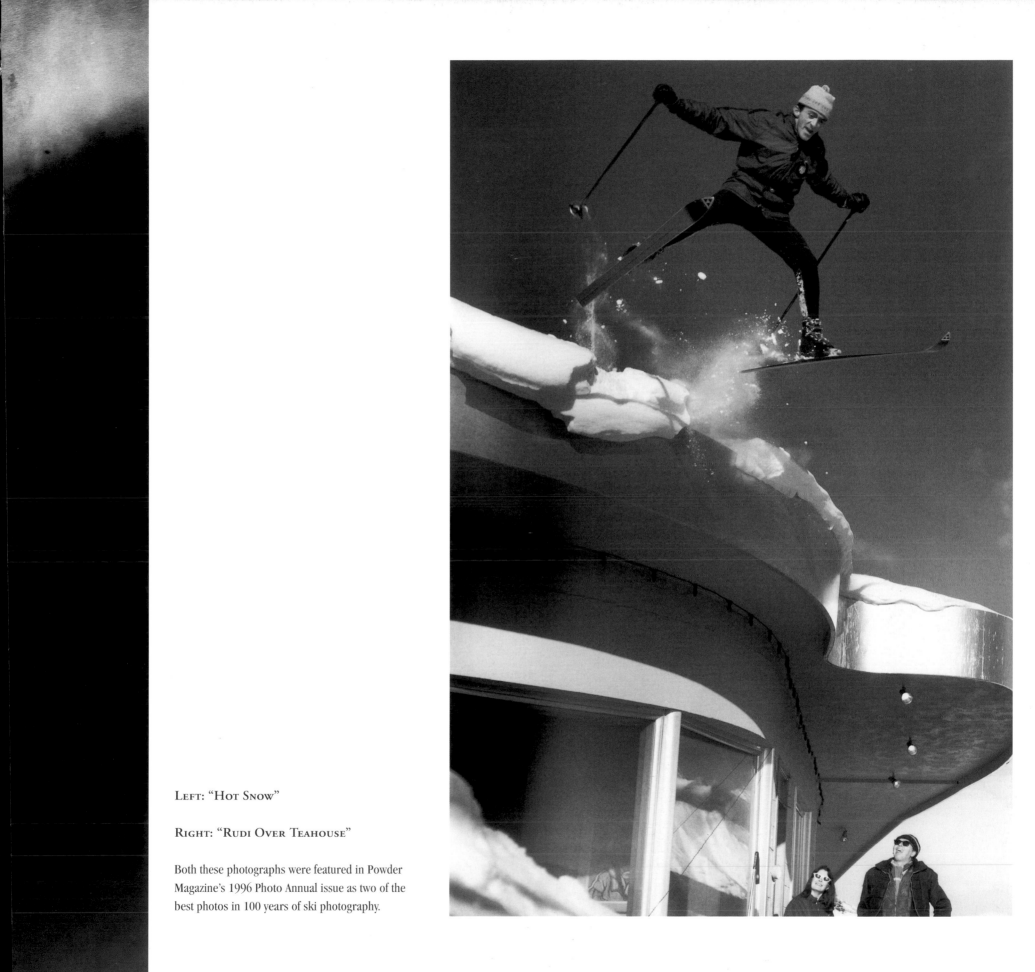

Left: "Hot Snow"

Right: "Rudi Over Teahouse"

Both these photographs were featured in Powder Magazine's 1996 Photo Annual issue as two of the best photos in 100 years of ski photography.

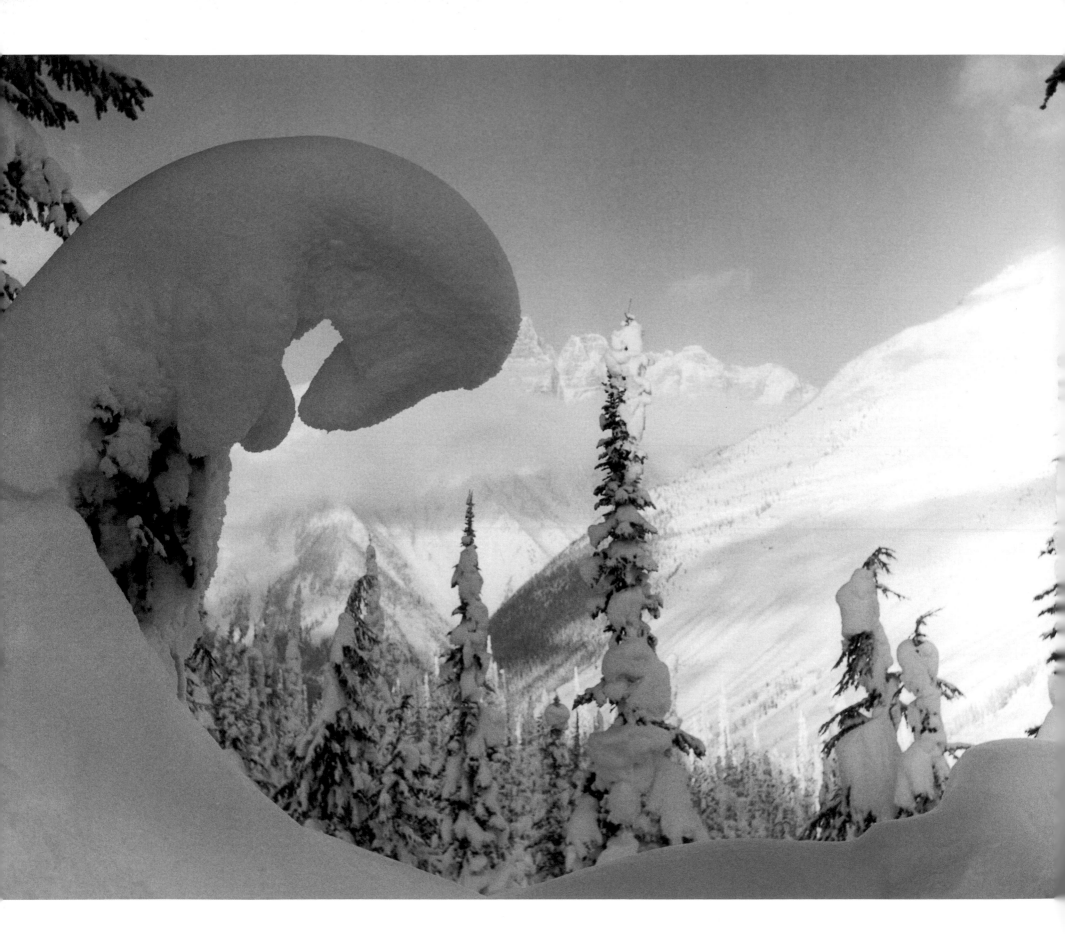

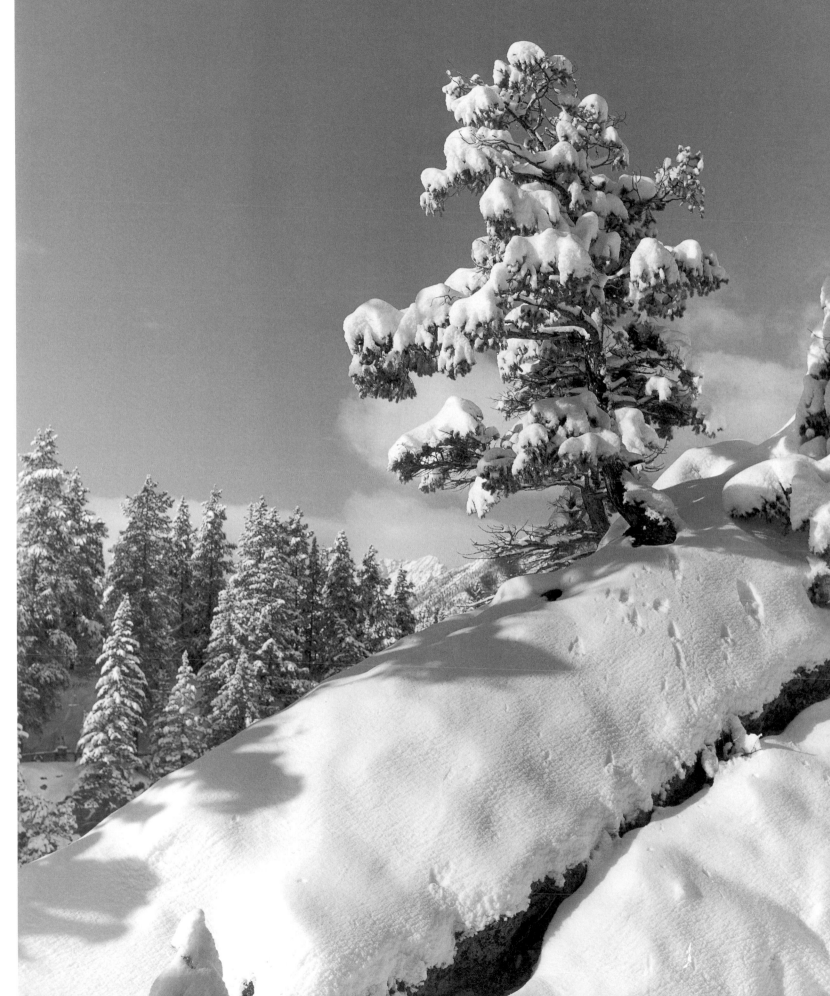

Opposite: "Snow Sculpture"
Glacier National Park.

Right: "Lone Tree in Snow"
Bow Falls, Banff.

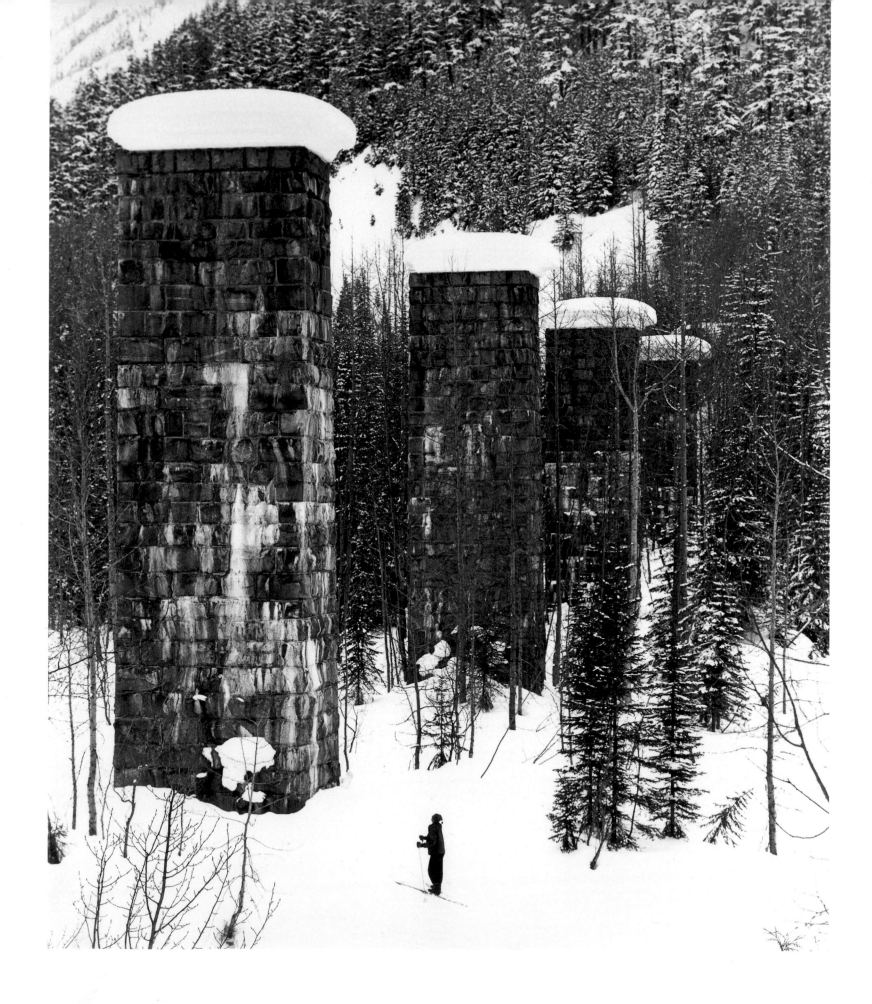

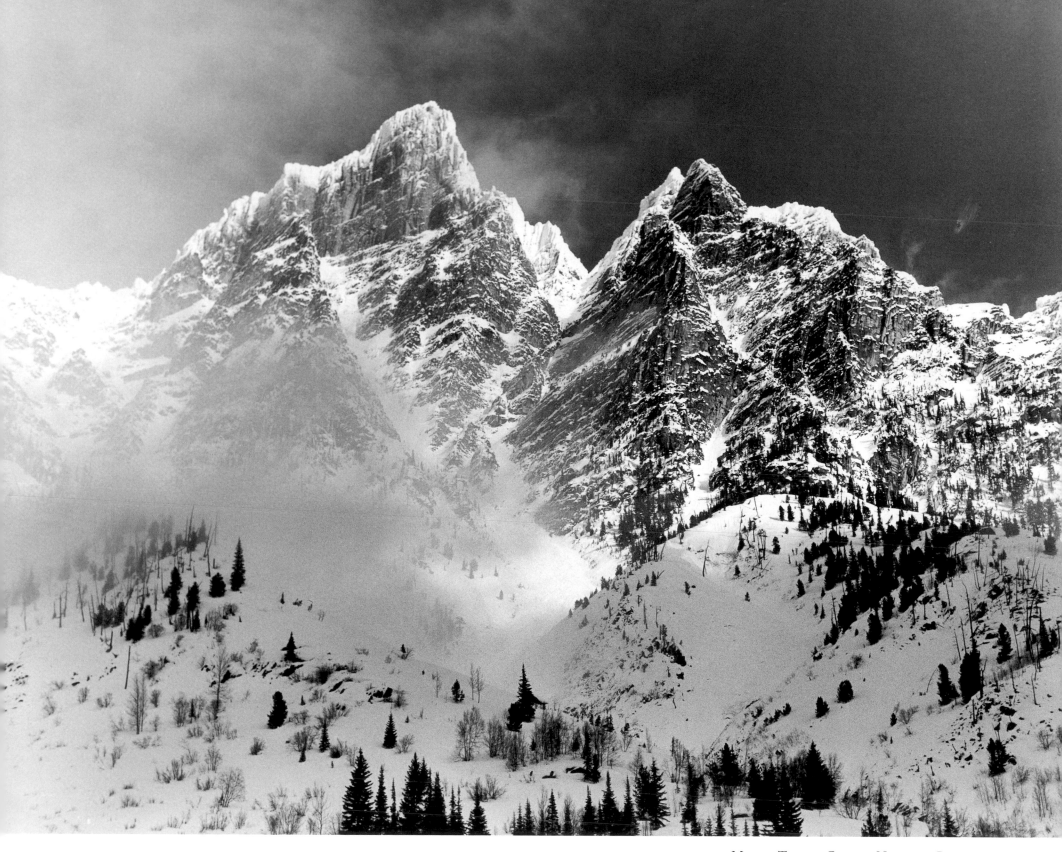

MOUNT TUPPER, GLACIER NATIONAL PARK

OPPOSITE: THE LOOP CREEK RAILWAY BRIDGE IN 1961
Rogers Pass, Glacier National Park.

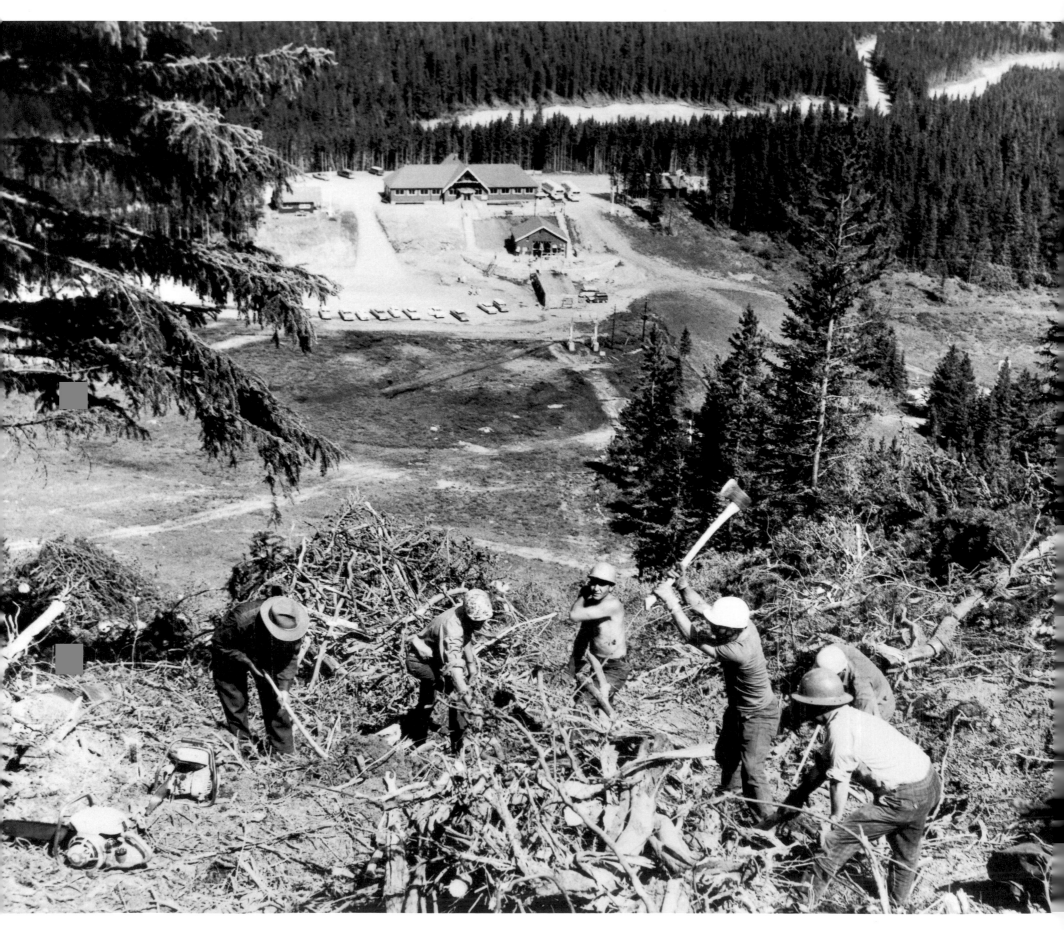

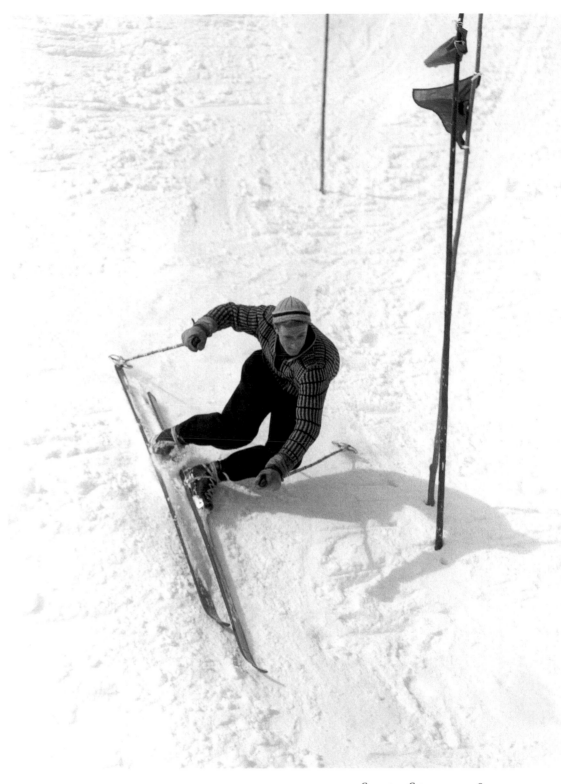

SLALOM STYLE IN 1958
Skiing the Bowl Run, Mount Norquay.

LEFT: CLEARING LONE PINE SKI RUN
Mount Norquay in 1954.

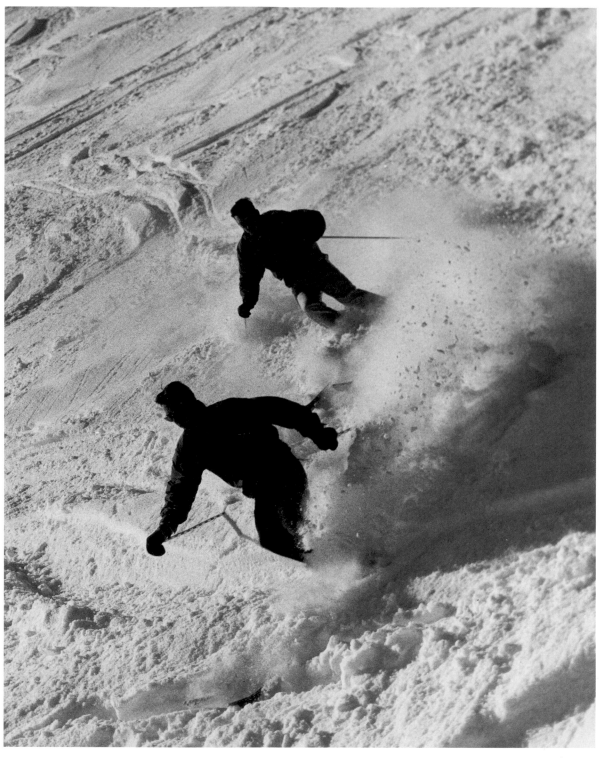

"Trrrremennndous!!!"
Skiing the Wishbone on Mount Norquay.

RIGHT: COMING OFF THE 80 METRE JUMP
Mount Norquay Ski Area in 1973.

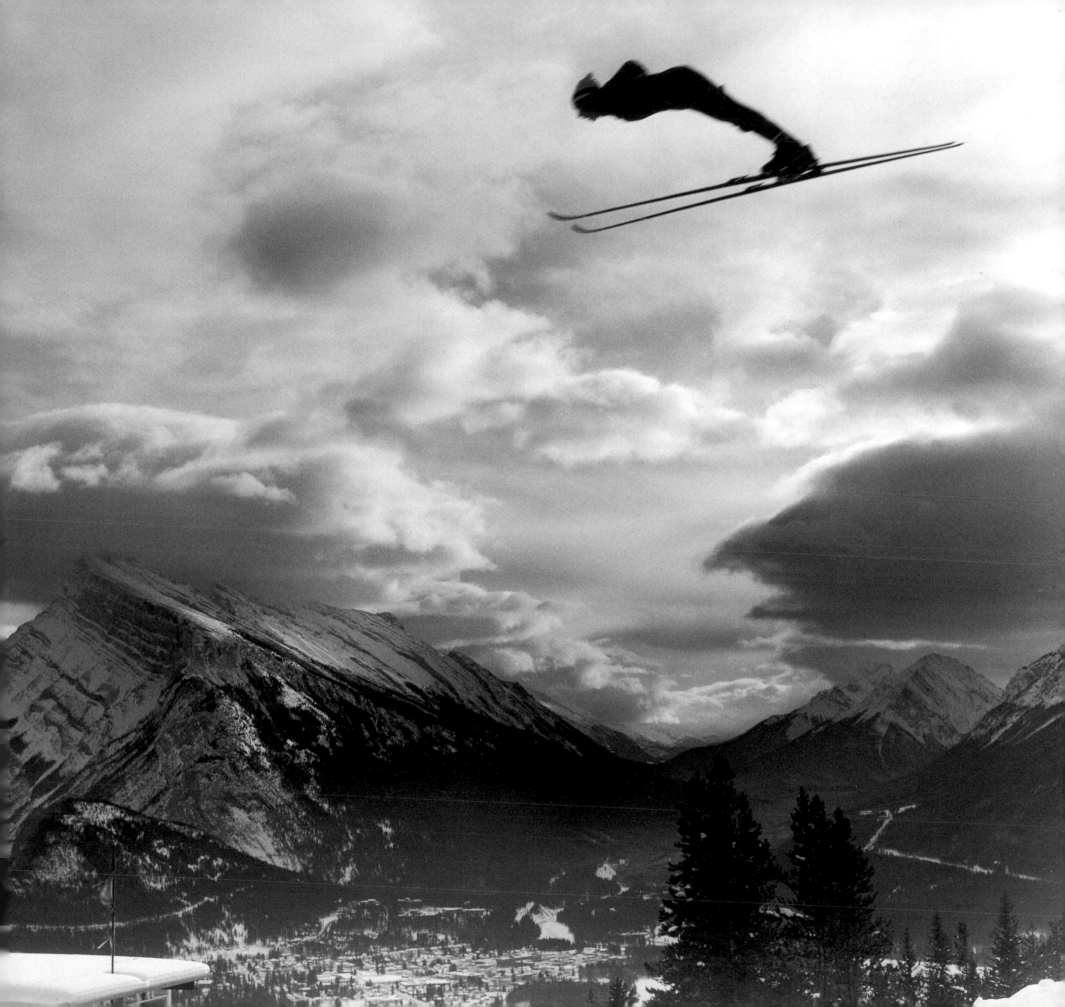

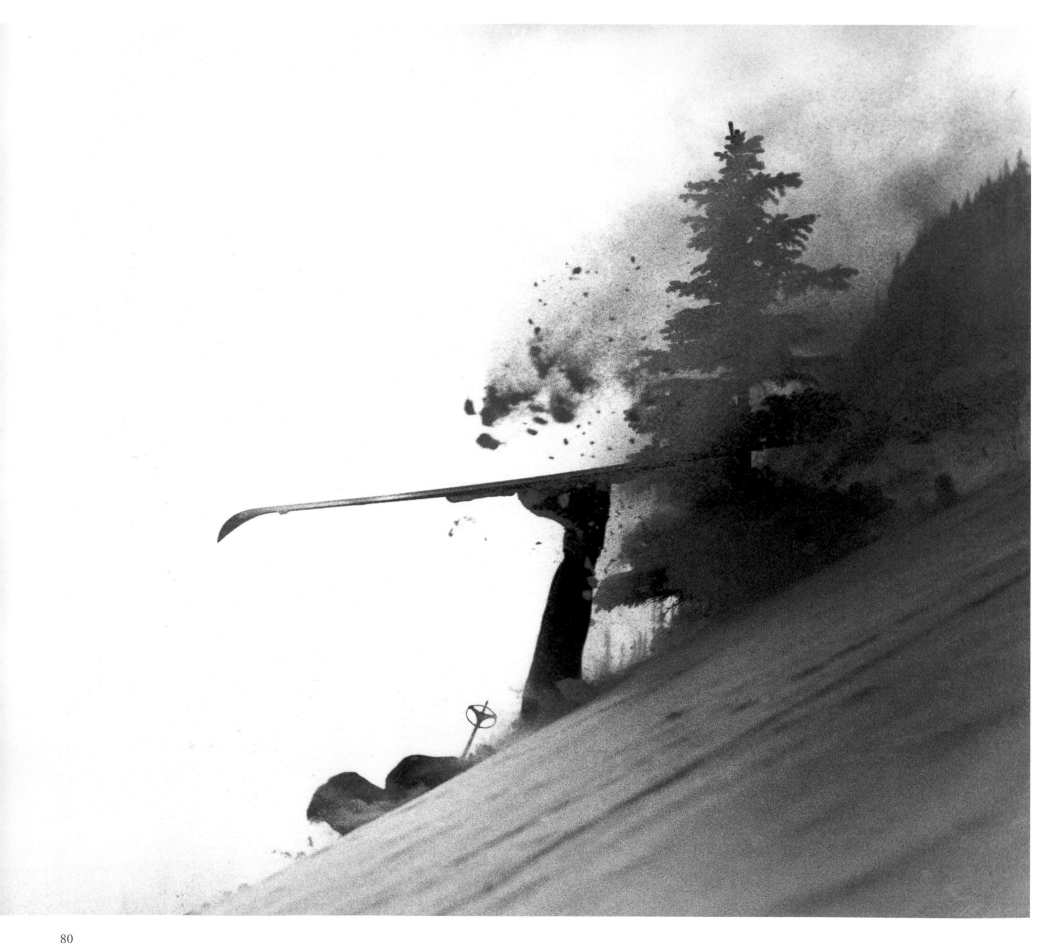

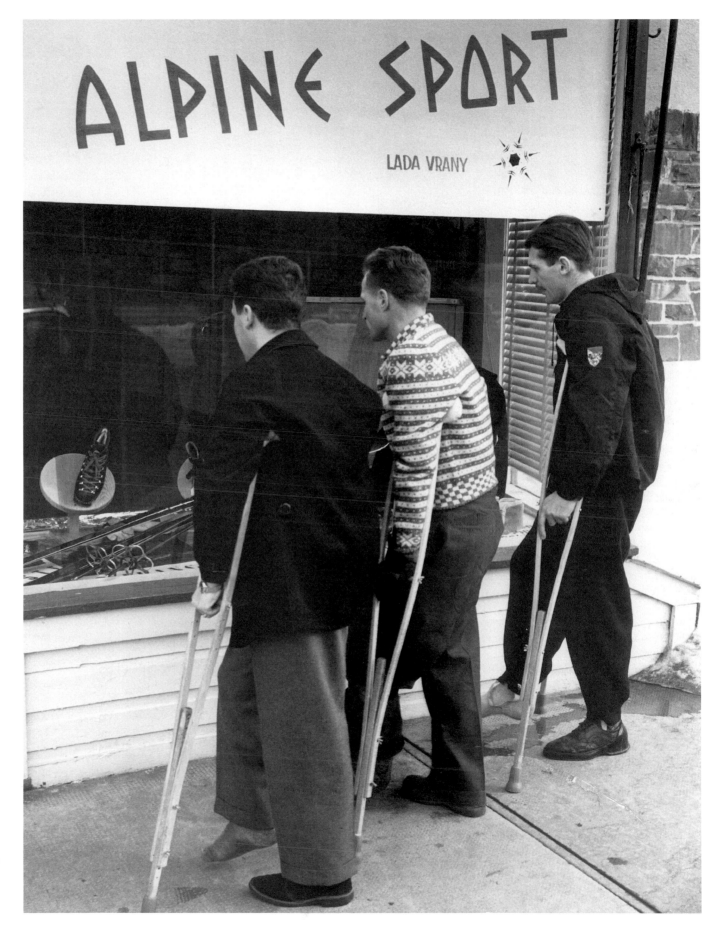

Opposite: "Hit the Powder"

Right: "Alpine Sport"

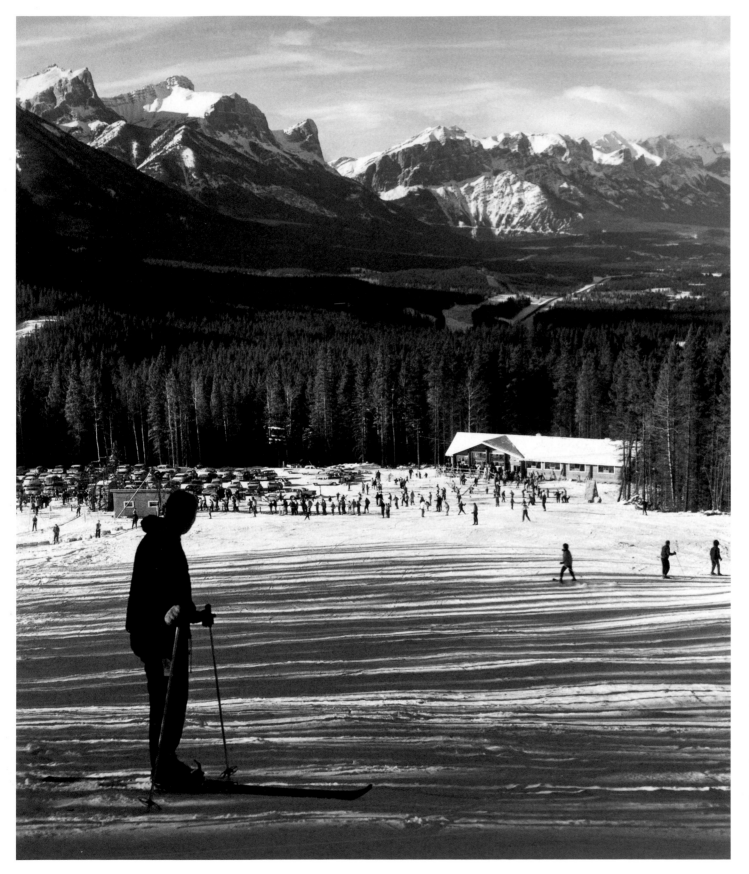

LEFT: PIGEON MOUNTAIN SKI AREA
AND LODGE IN 1963

OPPOSITE: PIGEON MOUNTAIN SKI
AREA IN 1963

Although the old lodge is still operational,
the ski hill on Pigeon Mountain has fallen
into disuse. The pine trees are slowly
reclaiming their territory.

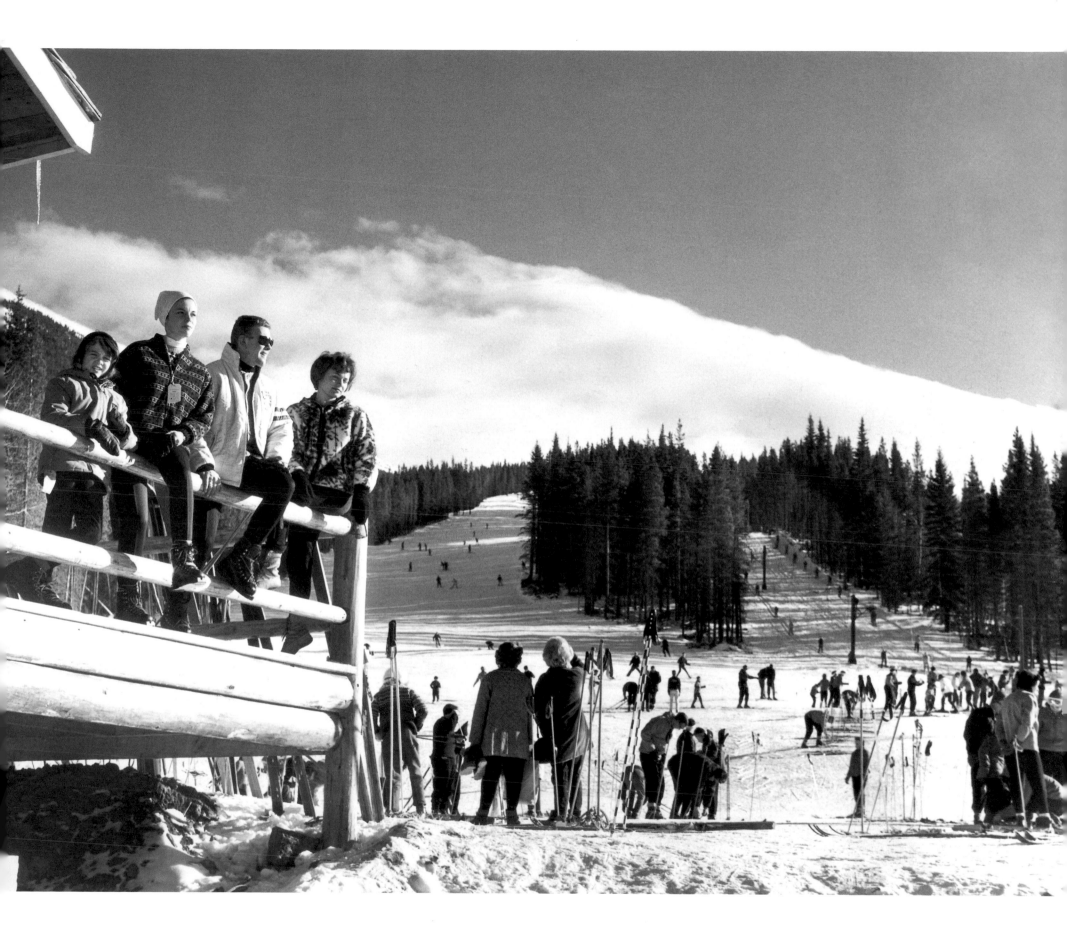

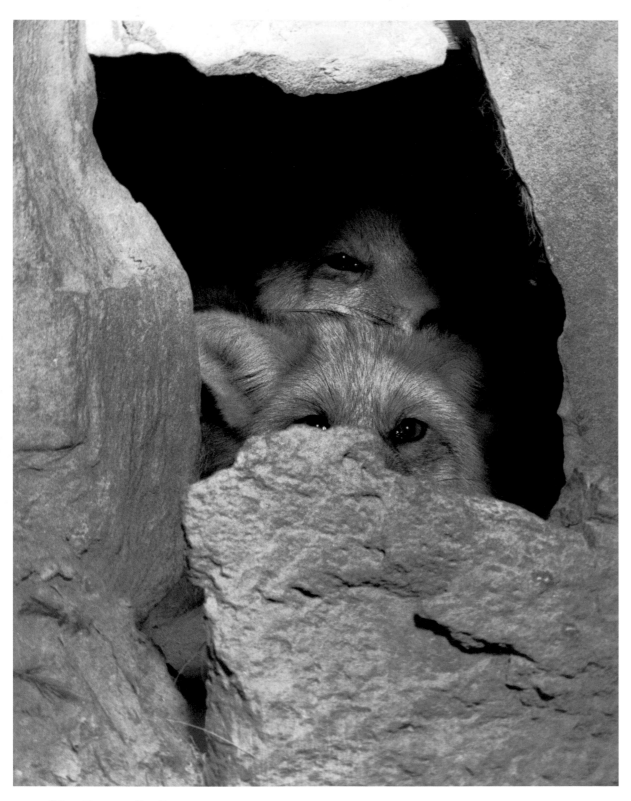

"Red Foxes in Den"

Right: "Twin Bear Cubs"
Bruno didn't use a telephoto lens for this picture. You can tell by the look in the bears' eyes that they are almost nose to nose. In relating the story later to friends, Bruno explained that he only had time for one shot because the bears' breath was fogging up his lens.

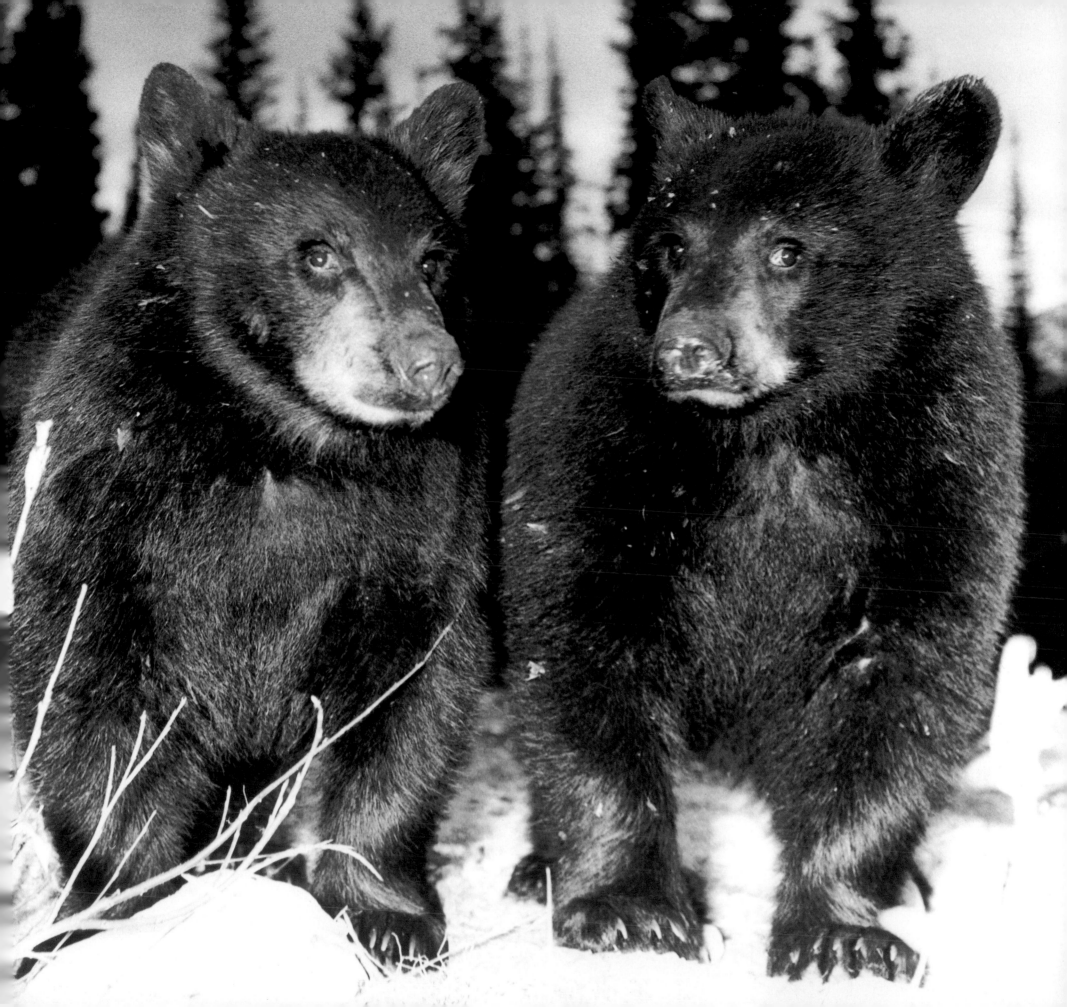

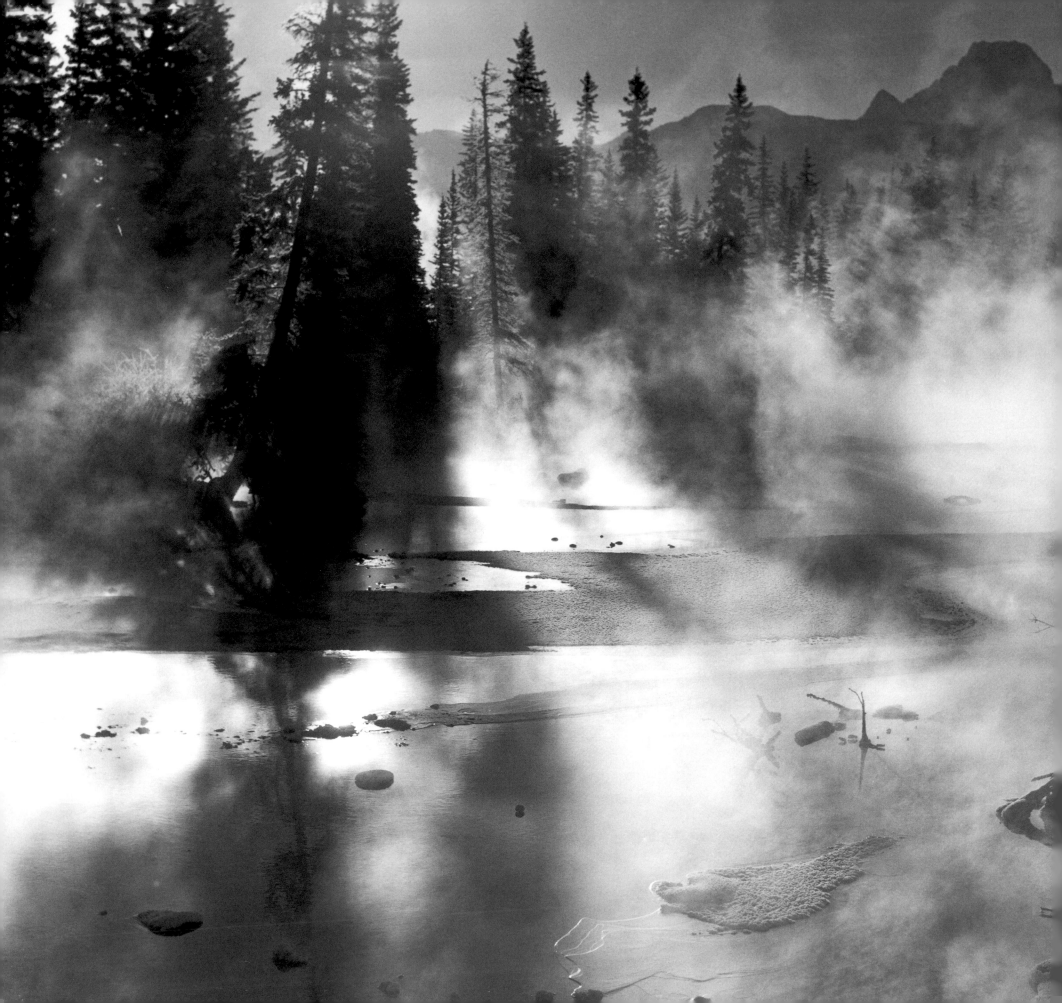

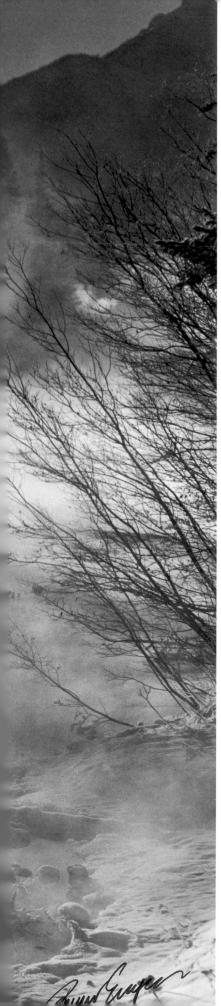

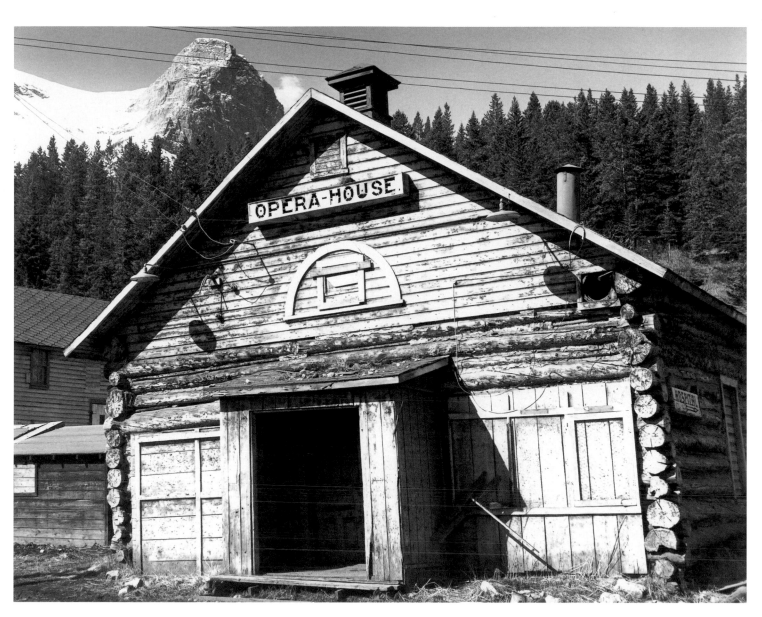

Canmore Opera House in 1965
The only log opera house in Canada and possibly in the world, the Canmore Opera House was originally built in 1898 as a band hall. It soon became a social centre for local shows, concerts, plays, dances and silent films. In 1966 it was moved to Heritage Park in Calgary.

Left: Policemans Creek, Canmore

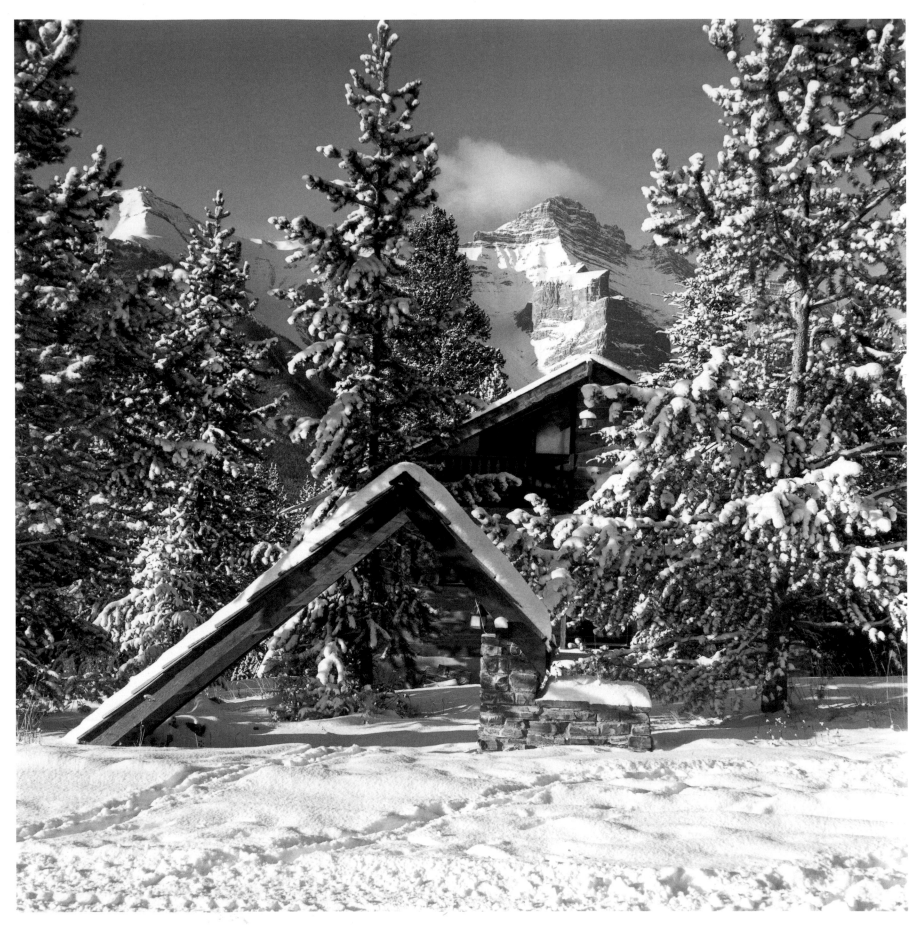

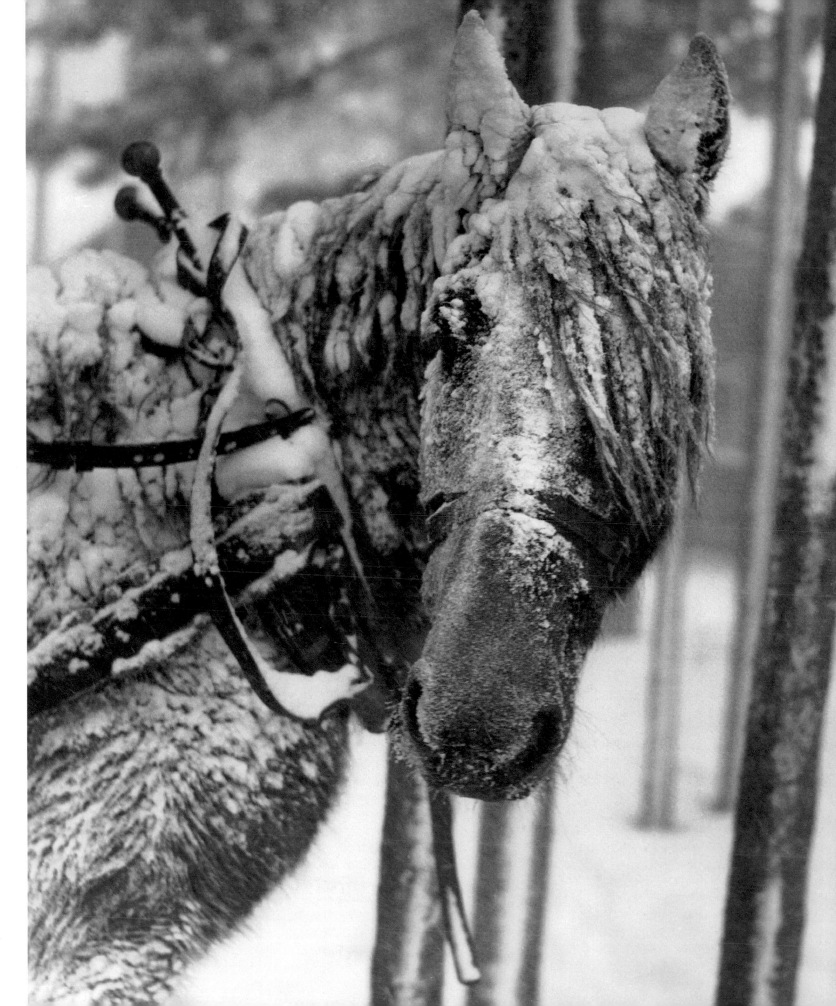

OPPOSITE: "MOUNTAIN
ARCHITECTURE"

RIGHT: "SNOWY HORSE"

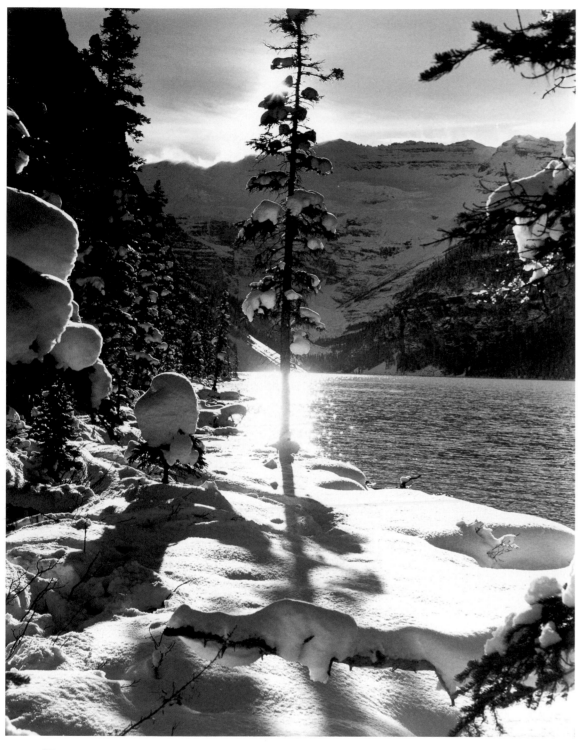

"First Snow at Lake Louise"

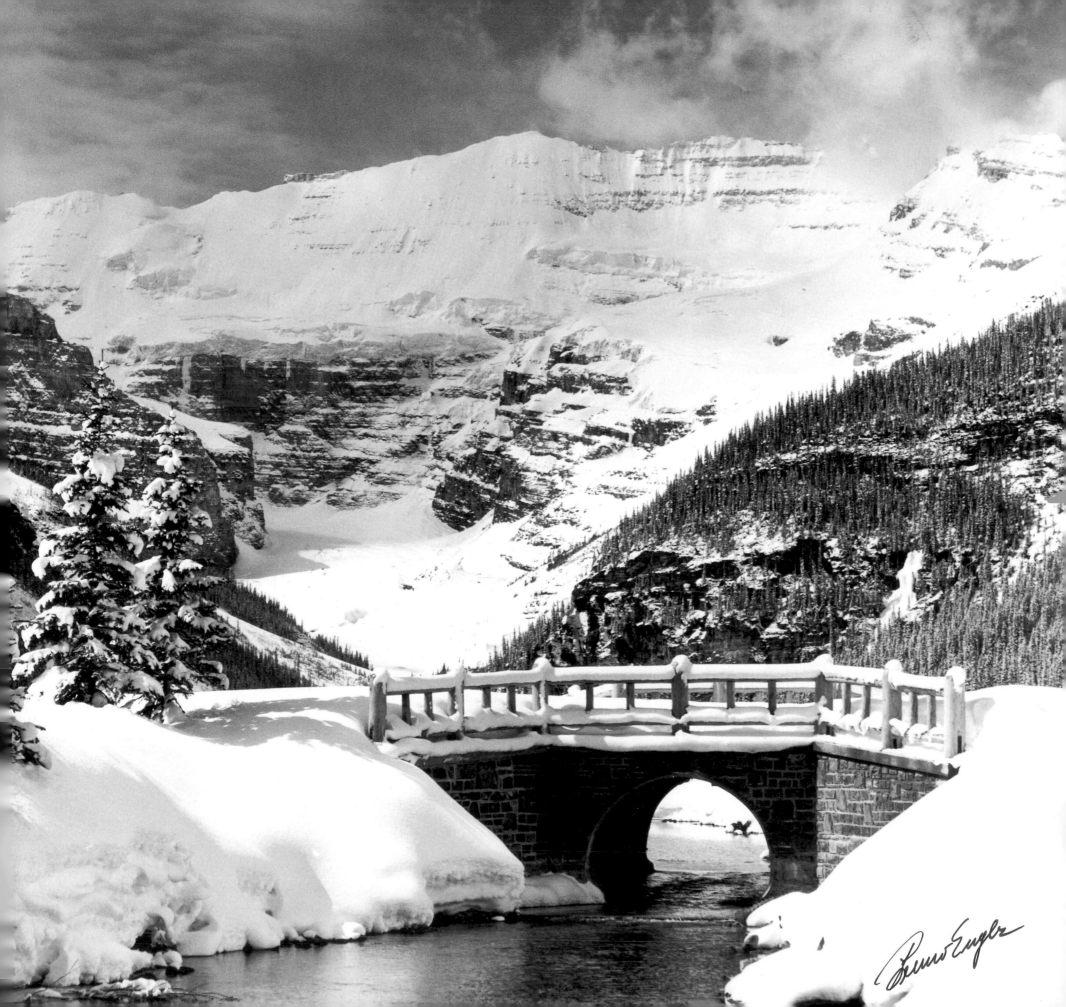

Bruno Engler

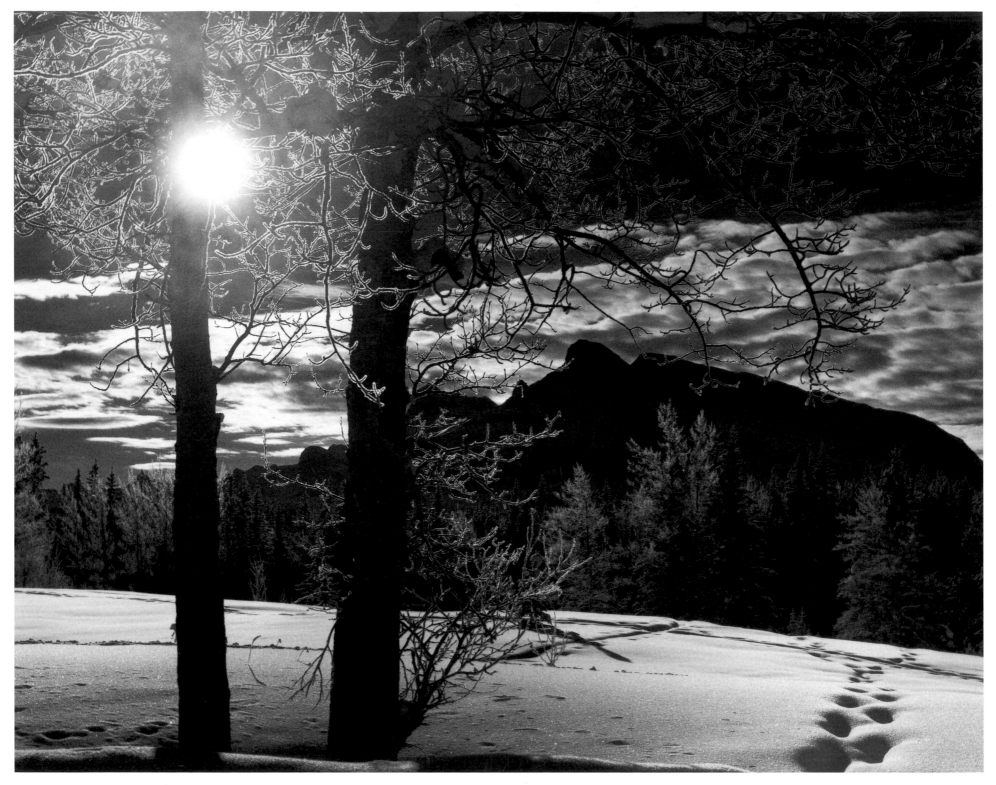

"CHRISTMAS SNOW"

OPPOSITE: "FROST AND MIST"
The temperature that day was -40°F, and Bruno
was amazed his camera was still working.

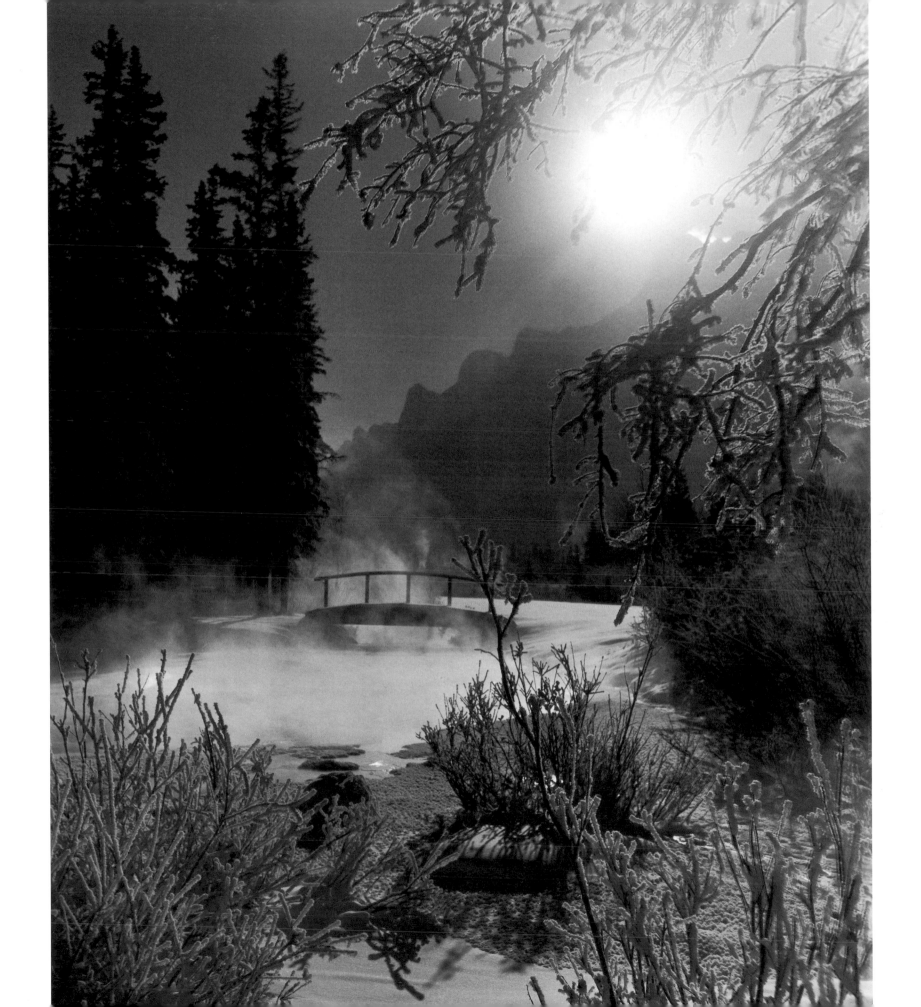

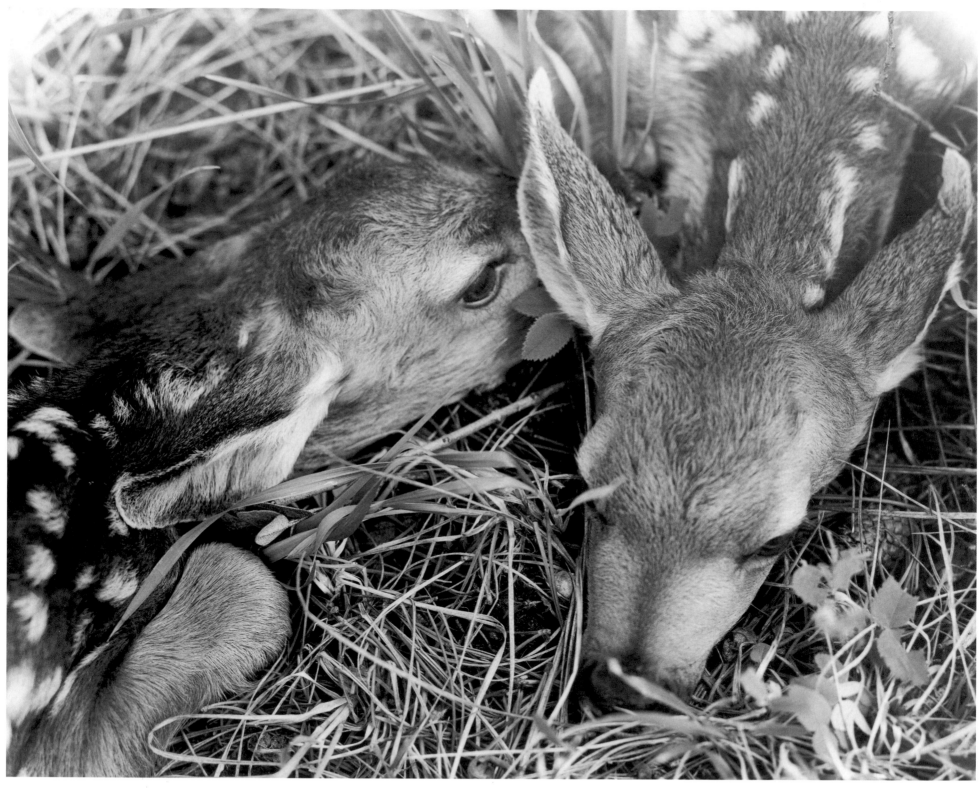

"Twin Fawns"

Opposite: "Tangle Falls"

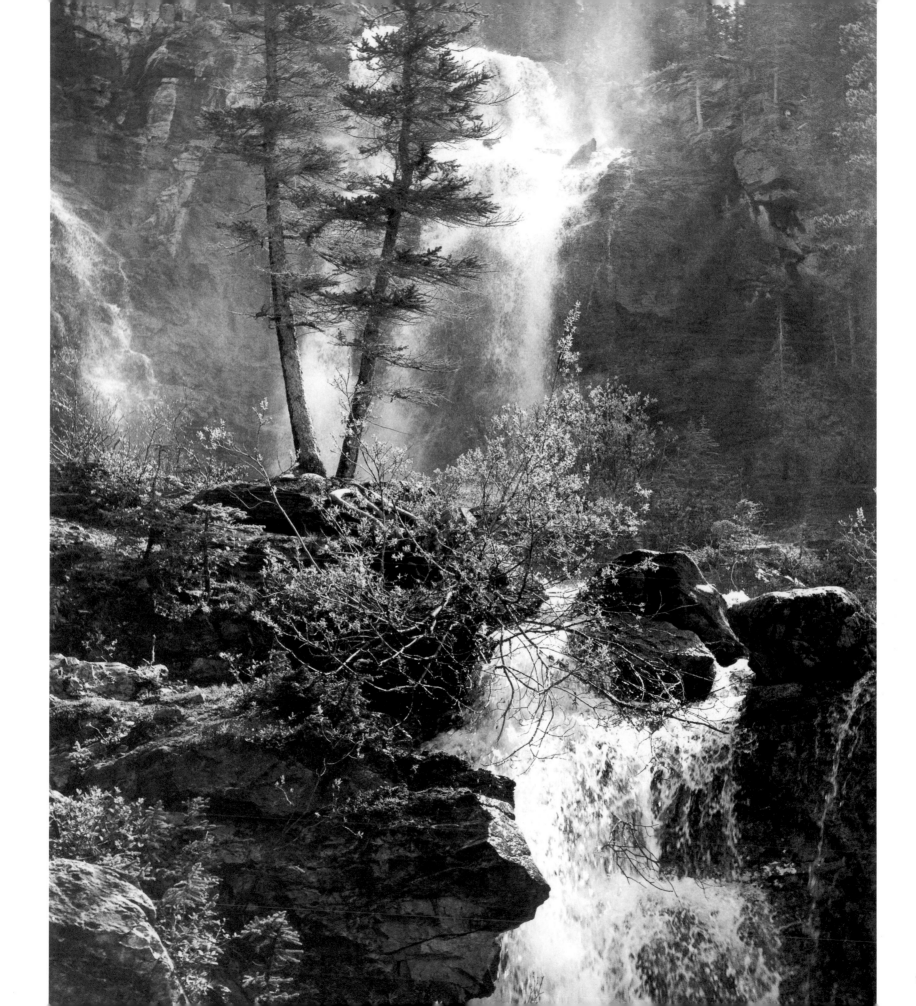

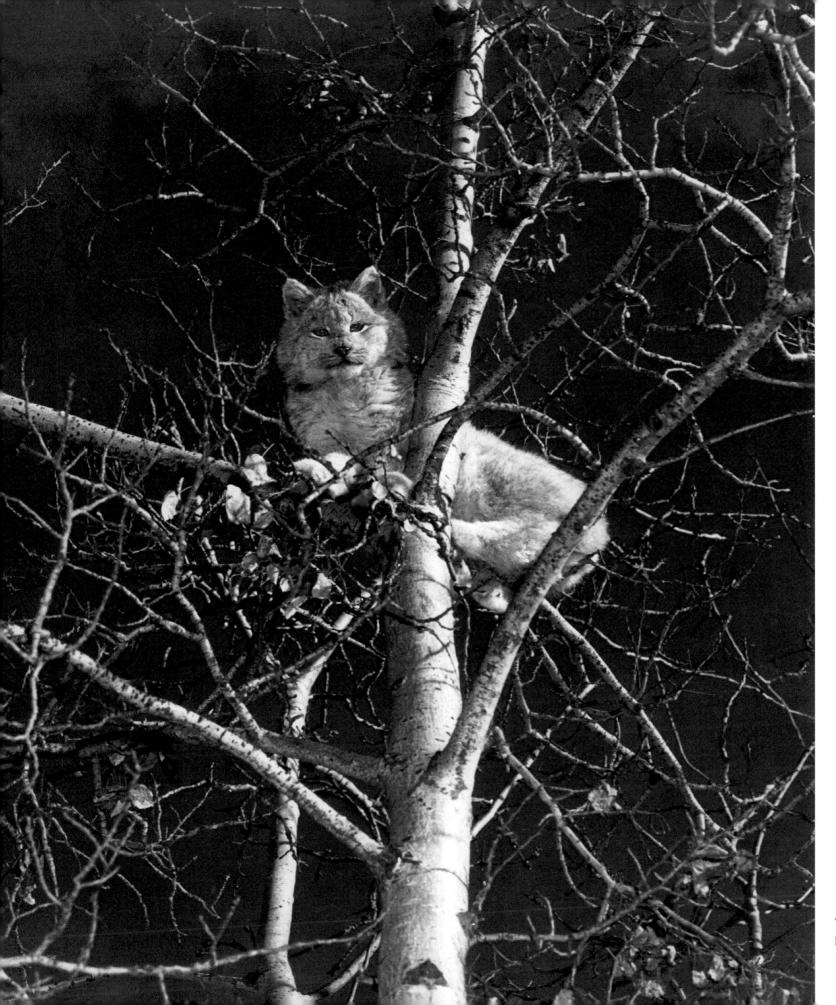

"Mountain Royalty"
Lynx in a tree.

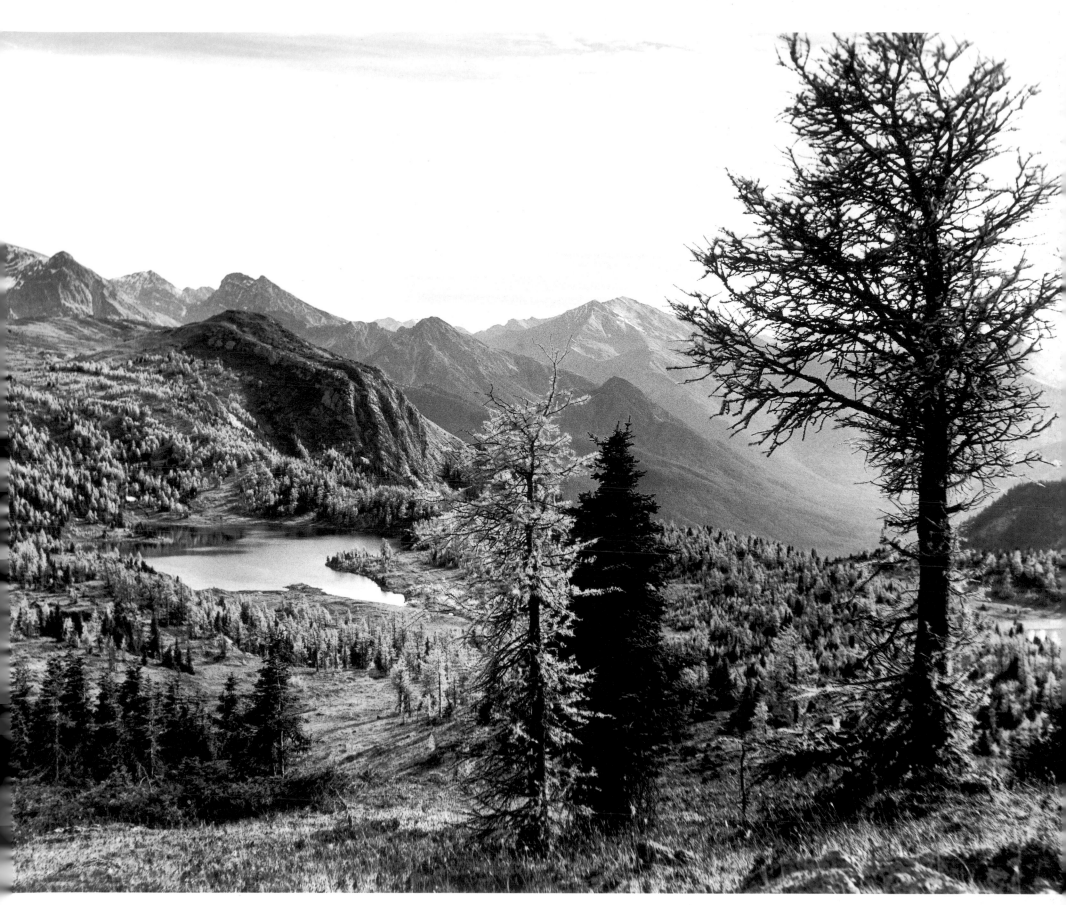

LARIX LAKE IN SUNSHINE MEADOWS

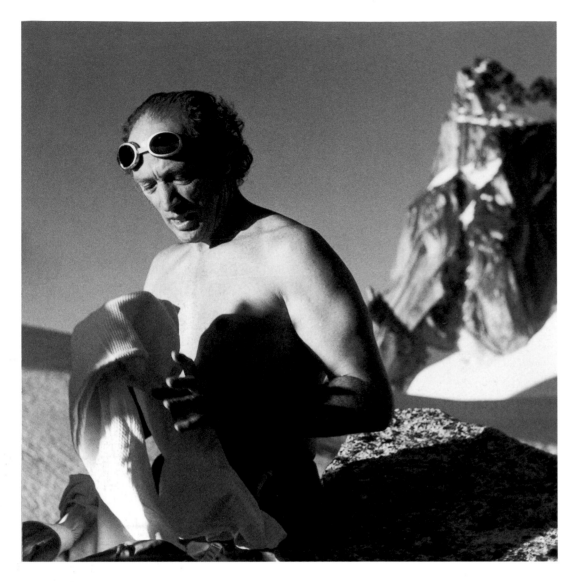

How I Remember Pierre Elliott Trudeau

"It was a hot summer day in 1972. My assignment was to take pictures and some 16 mm footage of Mr. Trudeau in the Bugaboo Mountains. I was trudging up the steep trail to the Conrad Kain Alpine Hut. I was packing two medium-size still cameras, a 16 mm Rolex movie camera and a hefty tripod. Altogether, including my lunch, my gear weighed more than seventy pounds.

Two thirds of the way up the trail, I dropped my pack near a cool bubbling waterfall that ran across the trail. I practically took a shower, fully clothed, in the cool water. After, I sat and rested, enjoying the surrounding scenery and observing the small waterfall tumbling down the glacier below. And who came bouncing up the steep trail? None other than Pierre Elliott Trudeau. He greeted me whilst he cooled his face and neck with splashes from the waterfall.

He looked at me and said, 'It's very hot today, too hot to carry such a heavy load. How far is it to Kain Hut?'

'About fifteen to twenty minutes,' I answered. 'I will make it if I rest enough.'

'Let me help you with your pack,' he said.

'Oh no. I can't let you do that. This pack is too heavy.'

Without a word, he lifted my pack and loaded it onto his back.

He turned to me and said, 'I'll see you at the hut,' and disappeared around the corner.

I was feeling a mixture of embarrassment and honour. I thought to myself, 'There goes a great sportsman, and therefore a great statesman.'

I shouldered my tripod and tried to catch up with him, but he was already too far ahead. When I reached the hut, I was still embarrassed, but thankful for his help.

The next day was clear and sunny. Hans Gmoser started early in the morning to guide the Trudeau party up the Bugaboo Spire, a very respectable climb by mountaineering standards. There was no better guide than Hans to take them to the summit.

Our trip was successful for everyone. I returned tired and happy, with many good pictures and a day that would last in my memory."

Dear Bruno:

 You have captured with great talent our immense interest in the Bugaboos and our love for that magnificient area.

 Many warm thanks, from my wife and me, for your photographs which Hans has so kindly sent to us and which, indeed, have brought back many happy memories.

 With kind regards and wishes,

 Sincerely,

Mr. Bruno Engler,
 c/o Mr. Hans Gmoser,
 P.O. Box 1660,
 Banff, Alberta.

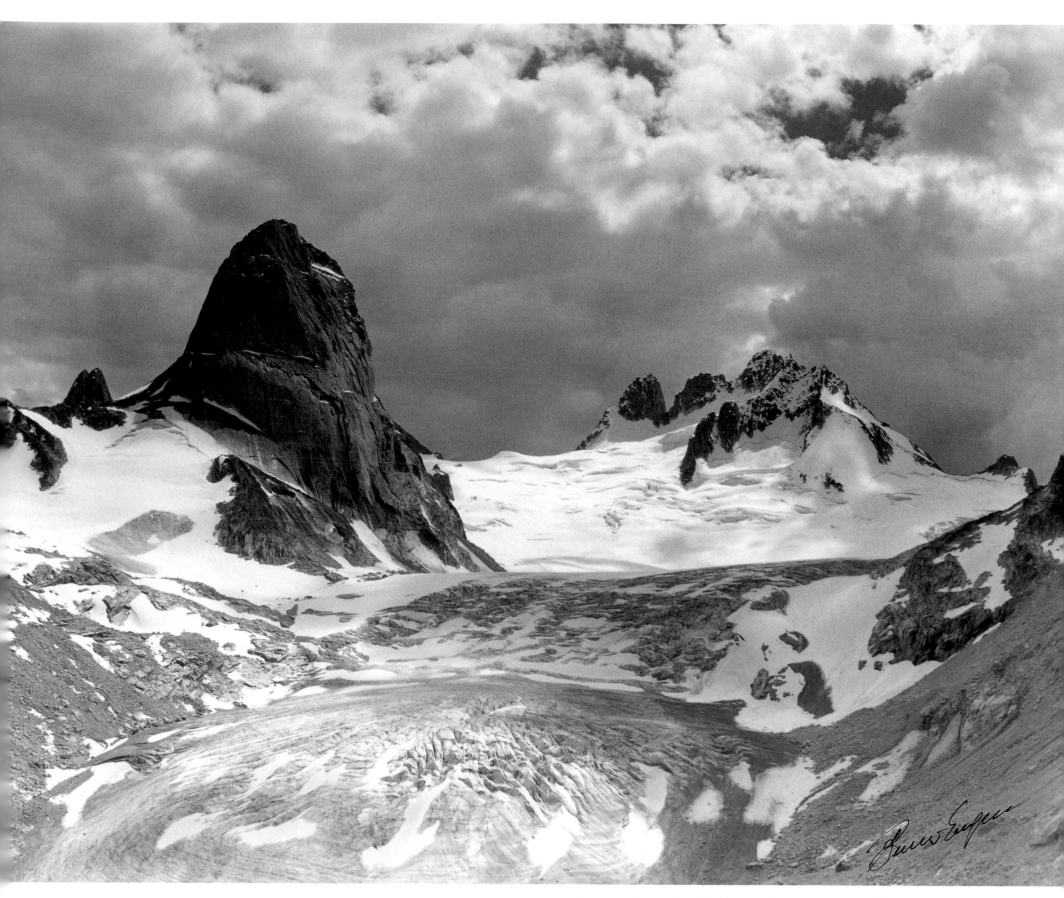

Bugaboo Spire (3176 m), Vowell Glacier and the Howser Towers

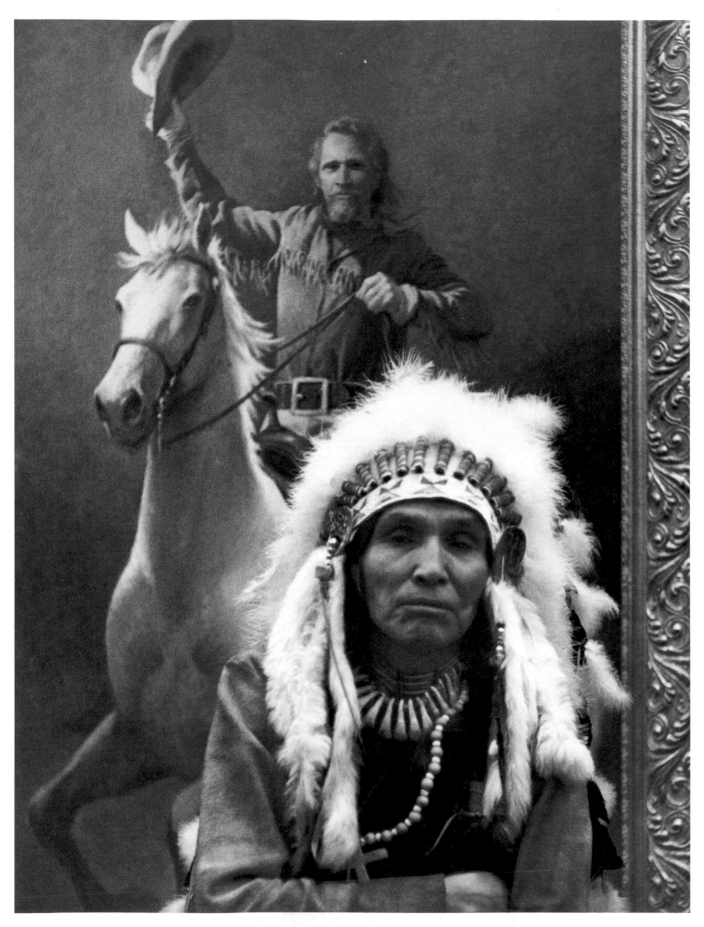

LEFT: FRANK KAQUITTS AS SIOUX CHIEF SITTING BULL

OPPOSITE: PAUL NEWMAN AS BUFFALO BILL

The movie "Buffalo Bill and the Indians" was filmed in Morley in 1975. Director, Robert Altman.

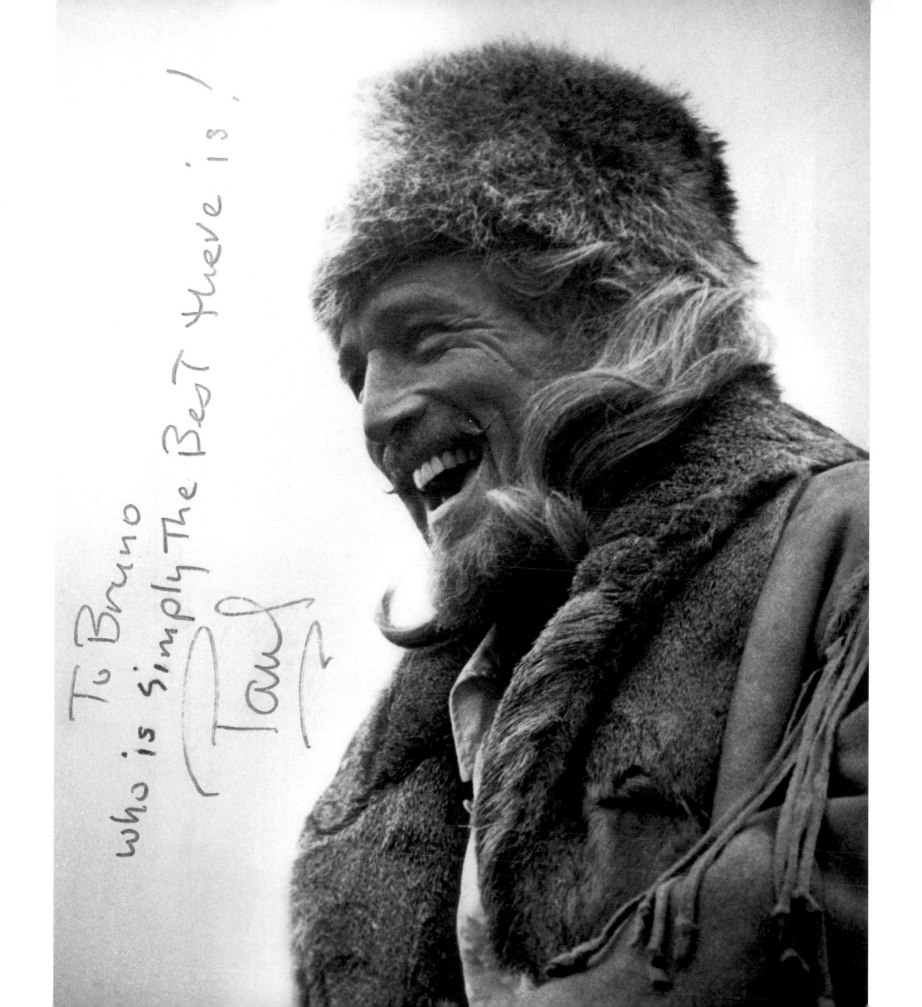

To Bruno
who is simply the Best There is!

Paul

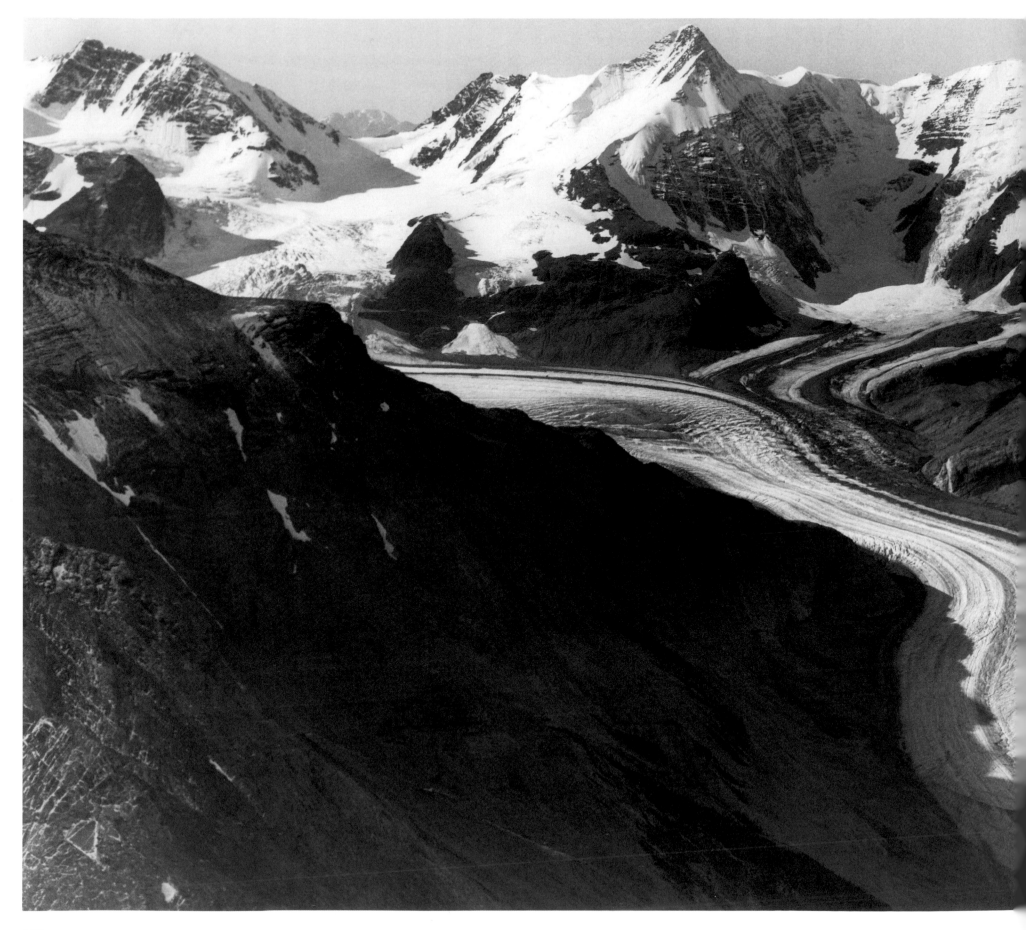

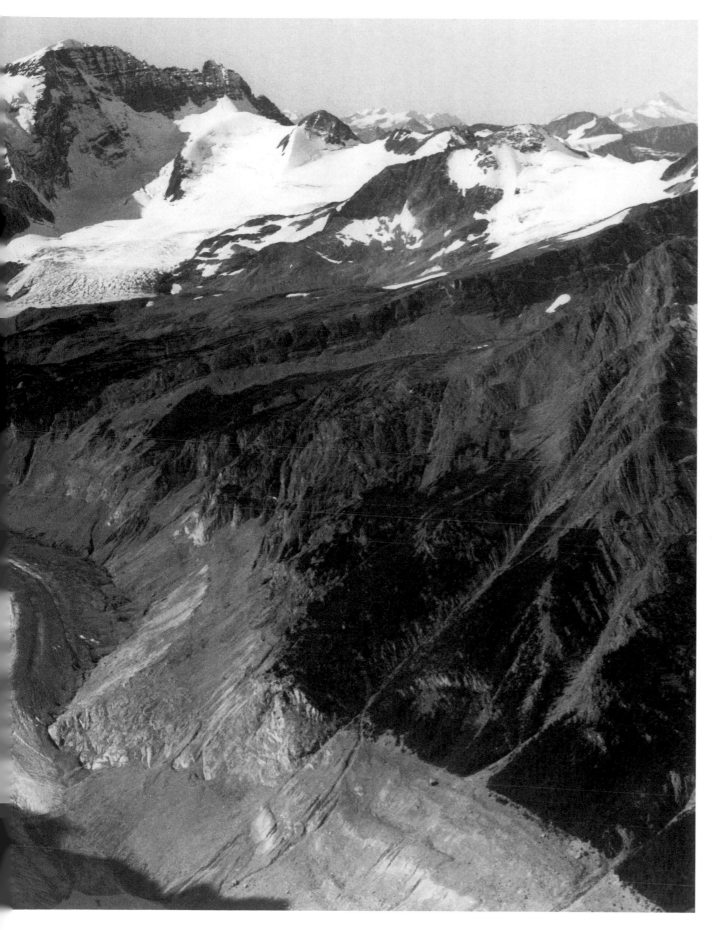

"Freshfield Glacier Tongue," 1975

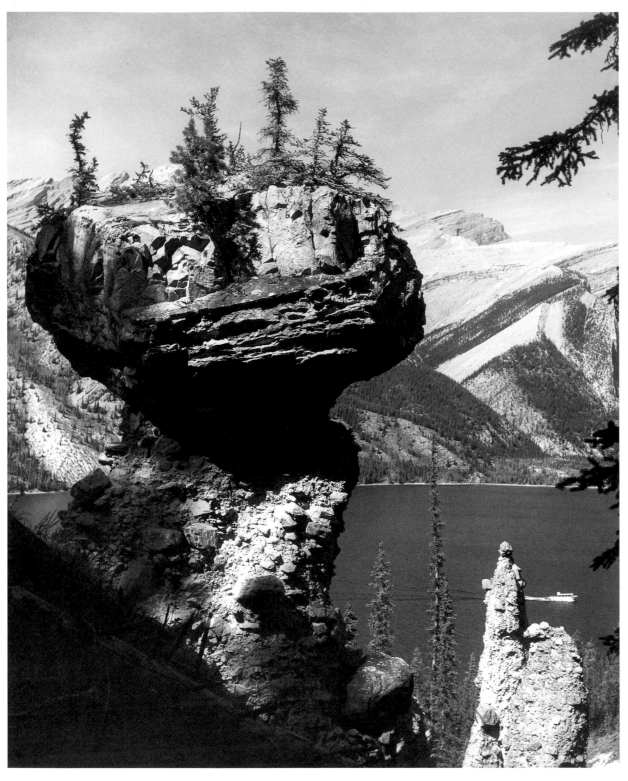

Lake Minnewanka

RIGHT: BILL VROOM ON WARDEN PATROL

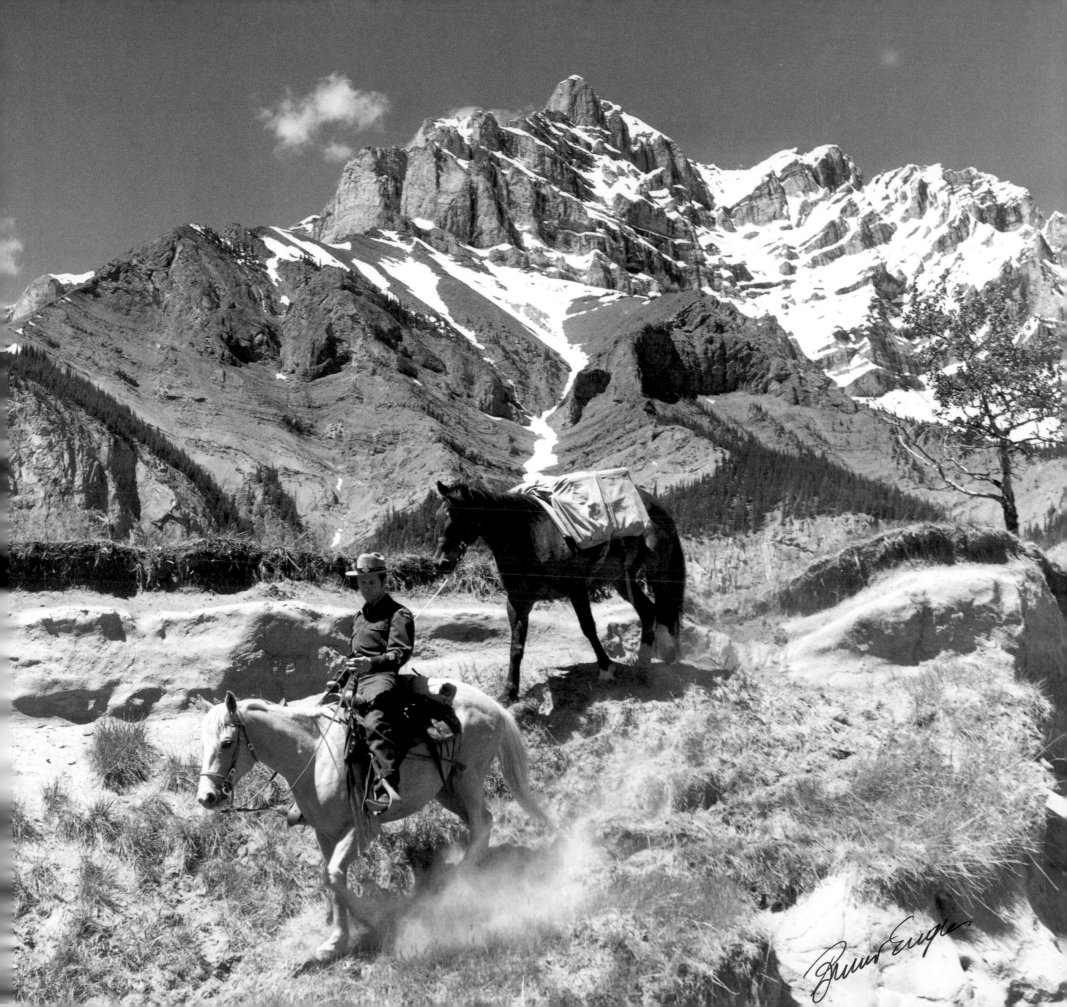

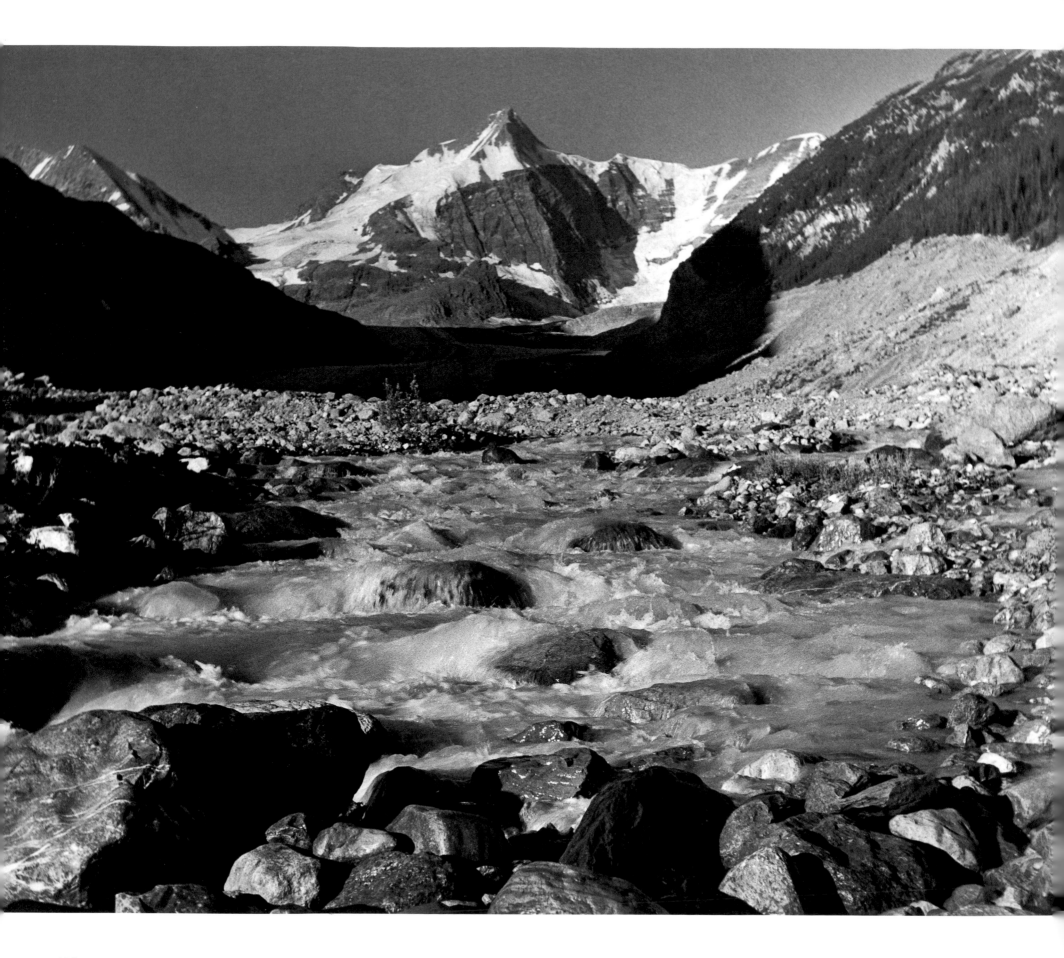

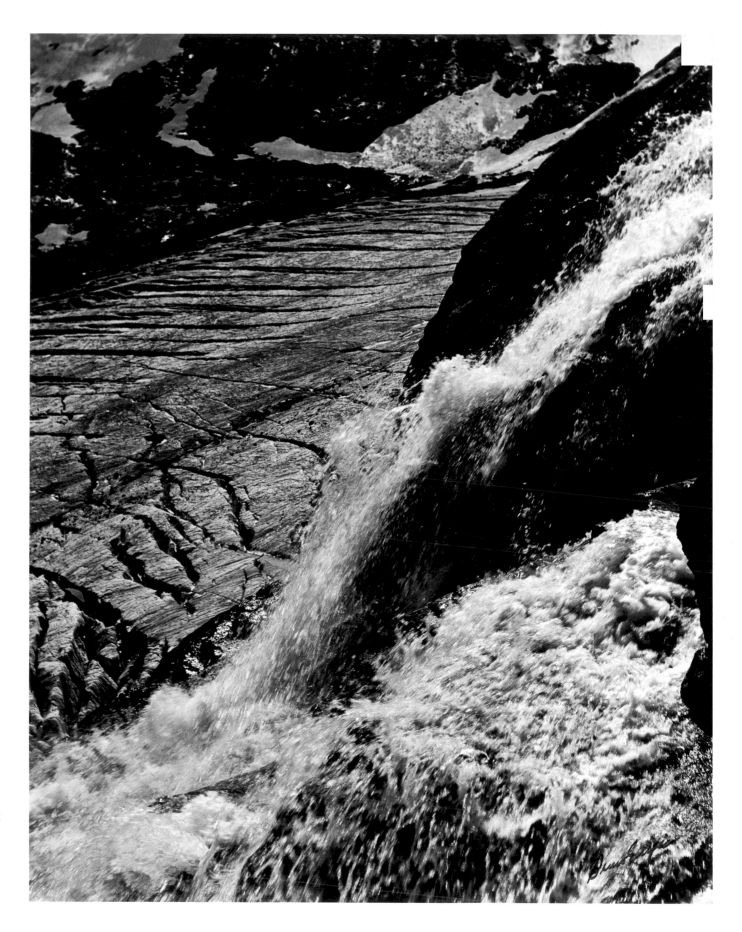

OPPOSITE: MOUNT FRESHFIELD
The mountain is the source of Freshfield Creek
that flows to the North Saskatchewan River.

RIGHT: "WATER AND ICE"
Bugaboo Glacier.

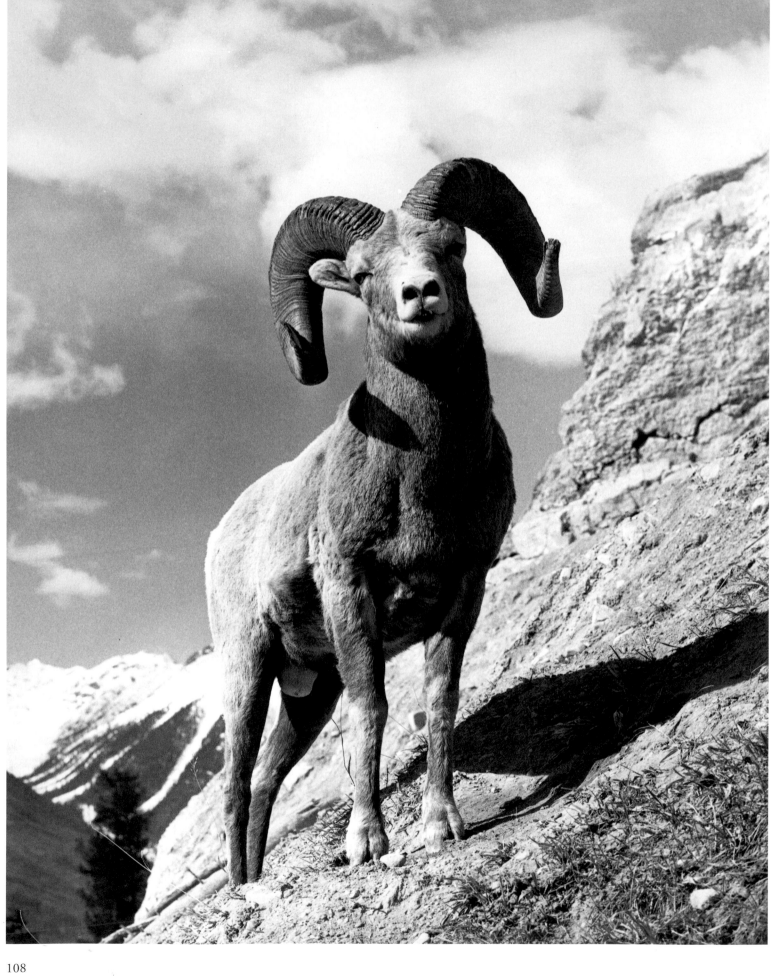

"Mountain Ram"

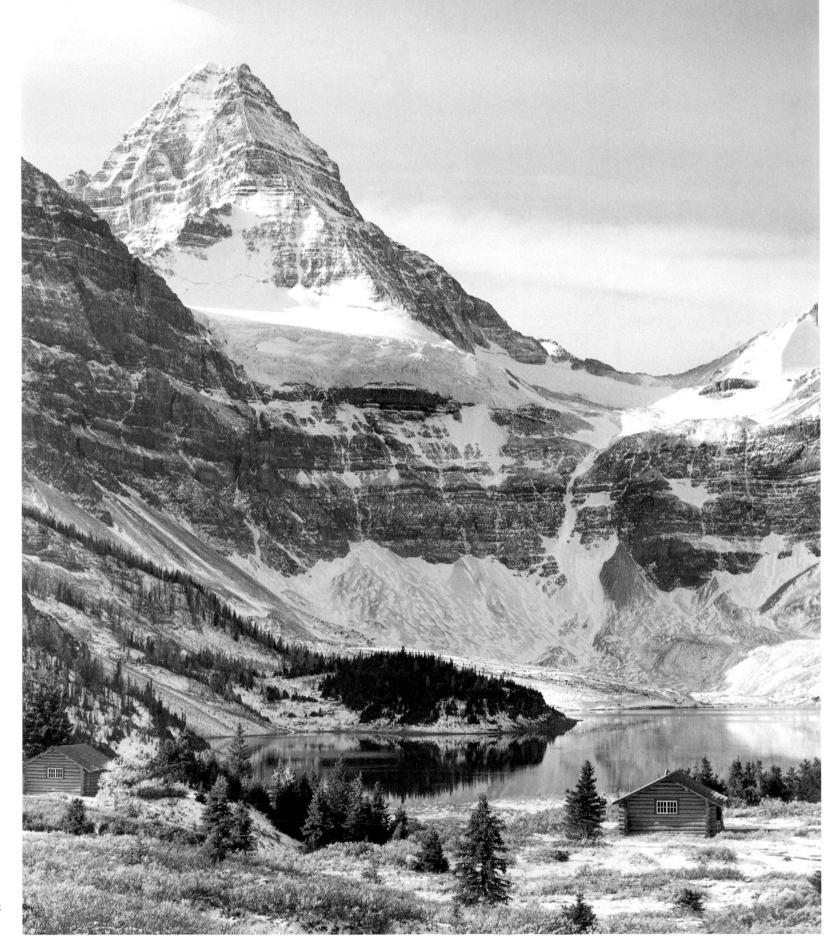

Mount Assiniboine
and Lake Magog

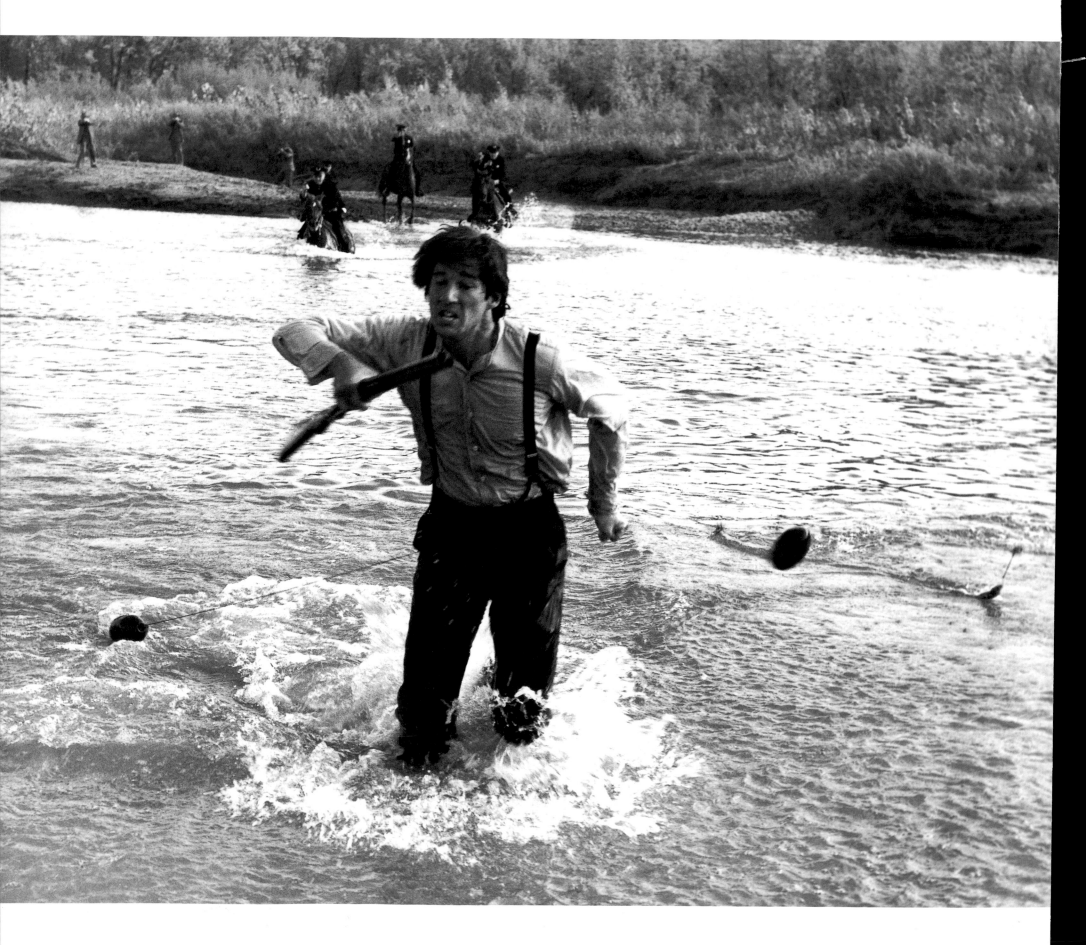

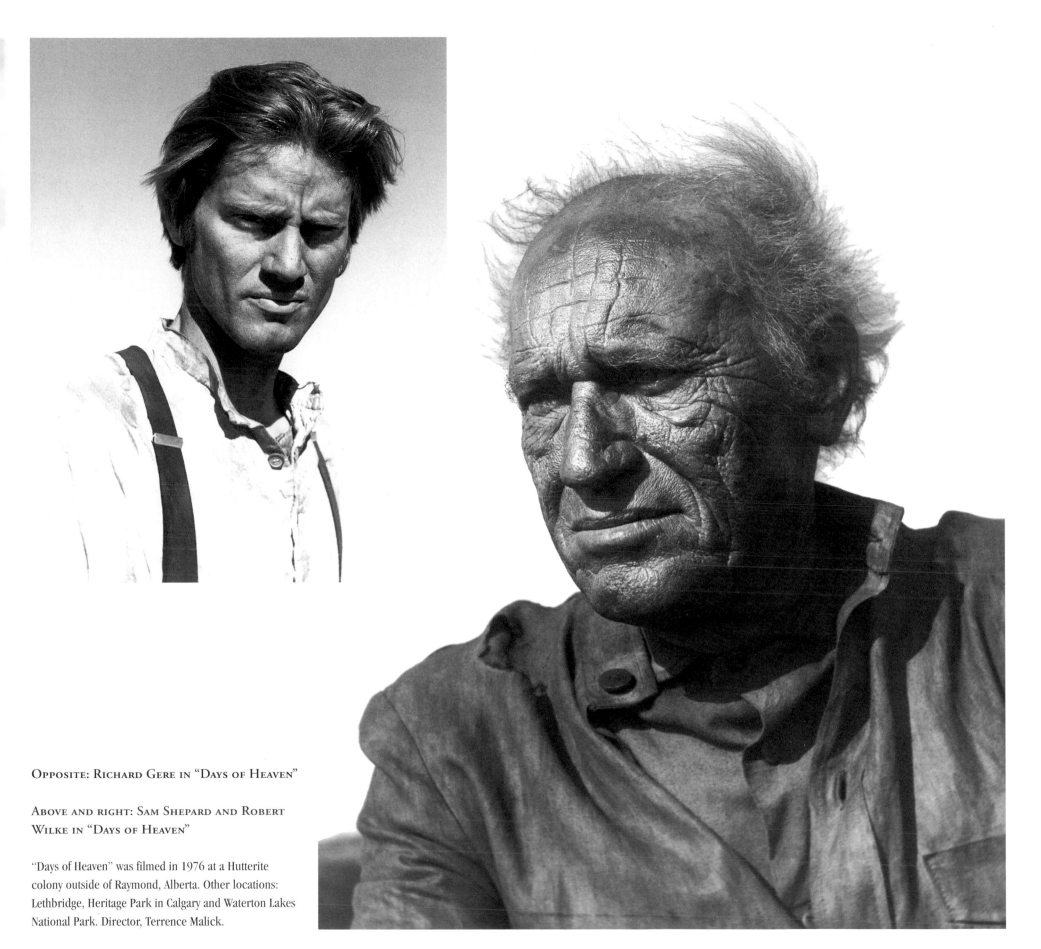

OPPOSITE: RICHARD GERE IN "DAYS OF HEAVEN"

ABOVE AND RIGHT: SAM SHEPARD AND ROBERT
WILKE IN "DAYS OF HEAVEN"

"Days of Heaven" was filmed in 1976 at a Hutterite
colony outside of Raymond, Alberta. Other locations:
Lethbridge, Heritage Park in Calgary and Waterton Lakes
National Park. Director, Terrence Malick.

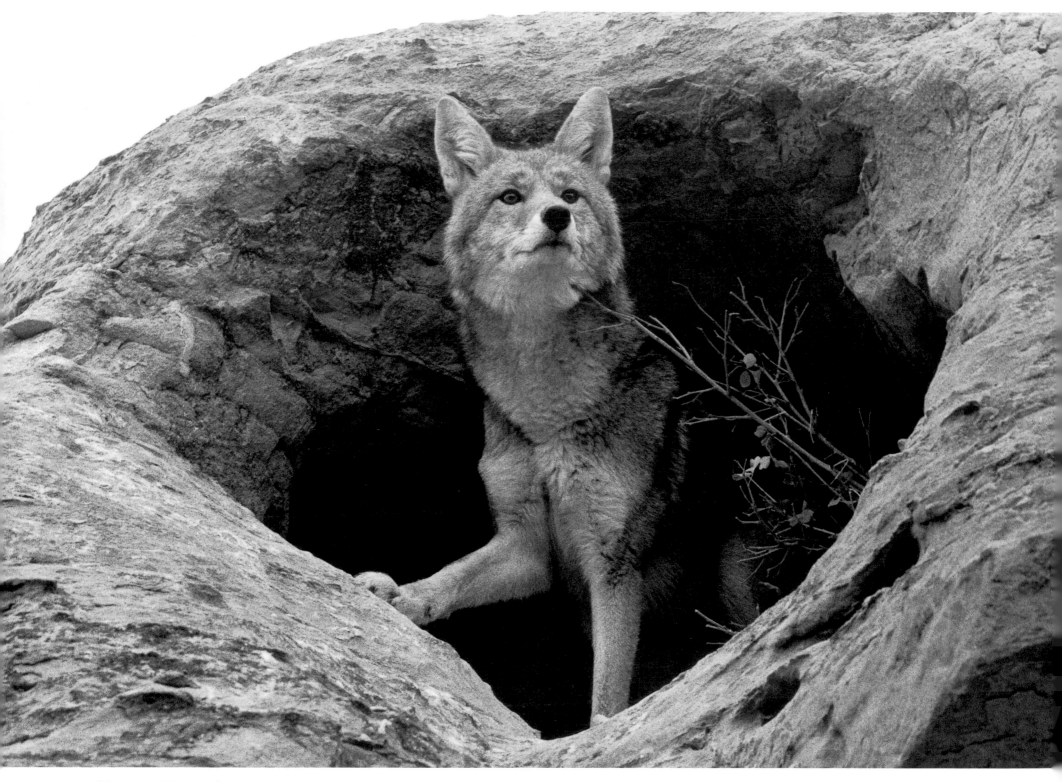

"Coyote in Hollow," Milk River
"My name is Wylie. Where I am is a secret.
Anywhere but a zoo!"

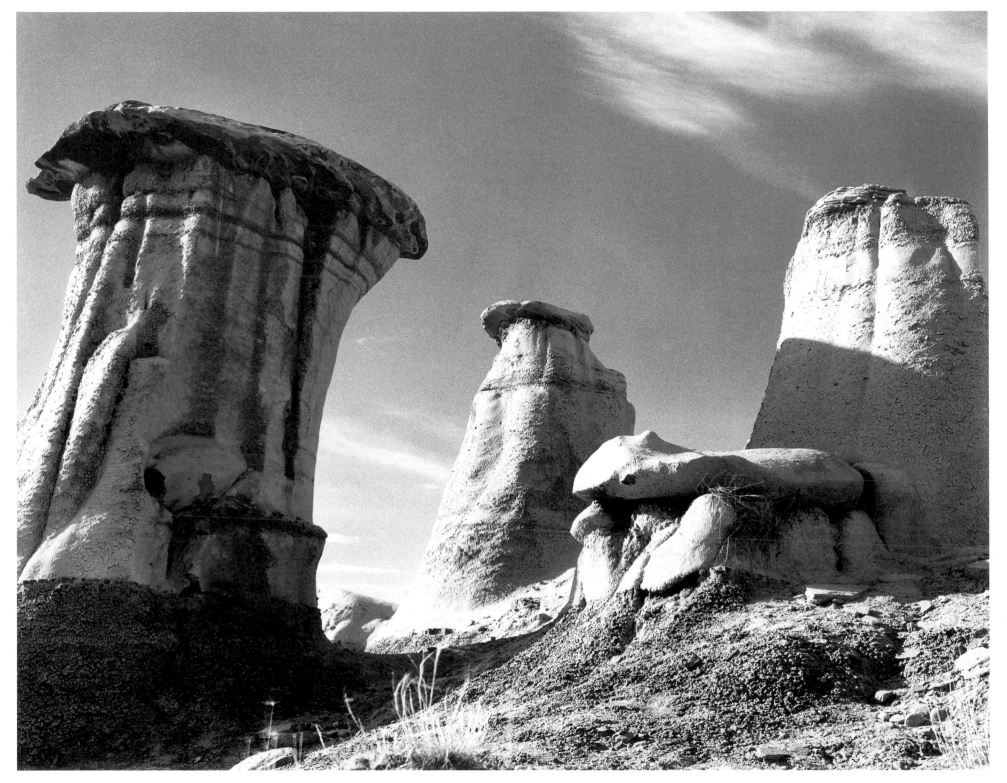

"MILK RIVER BADLANDS"

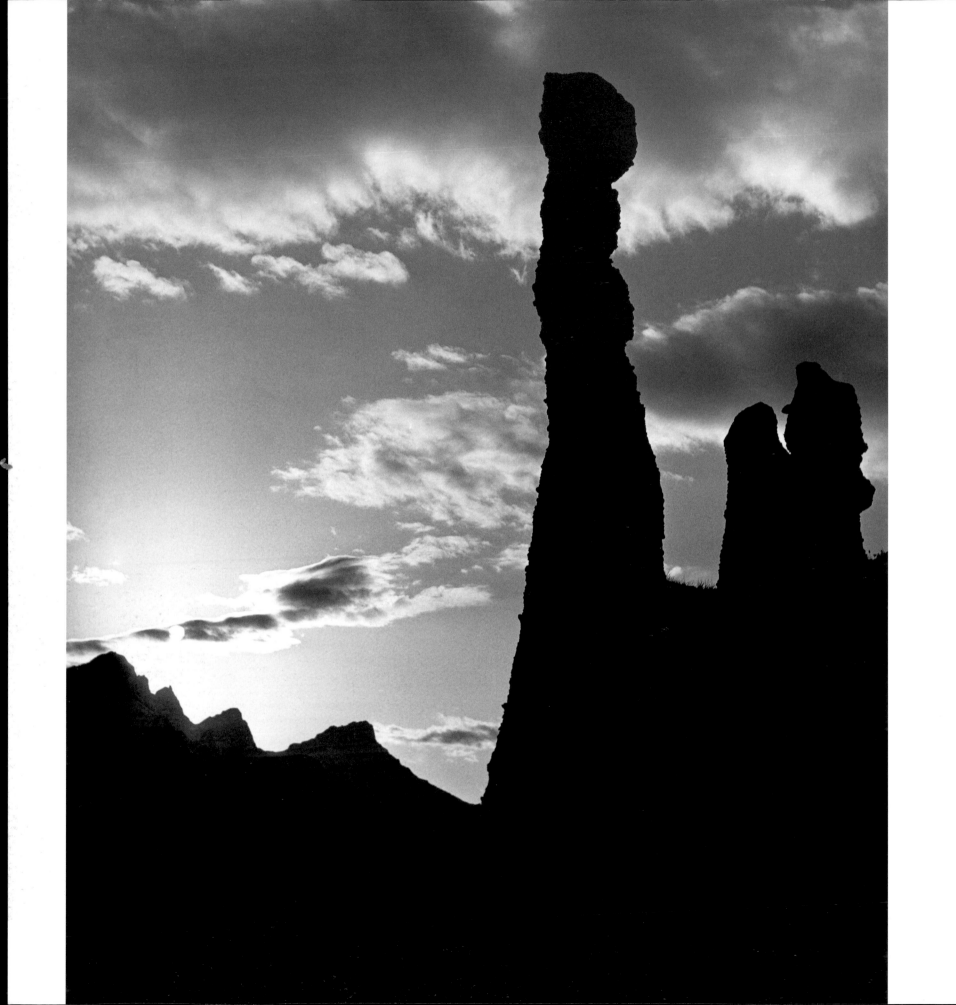

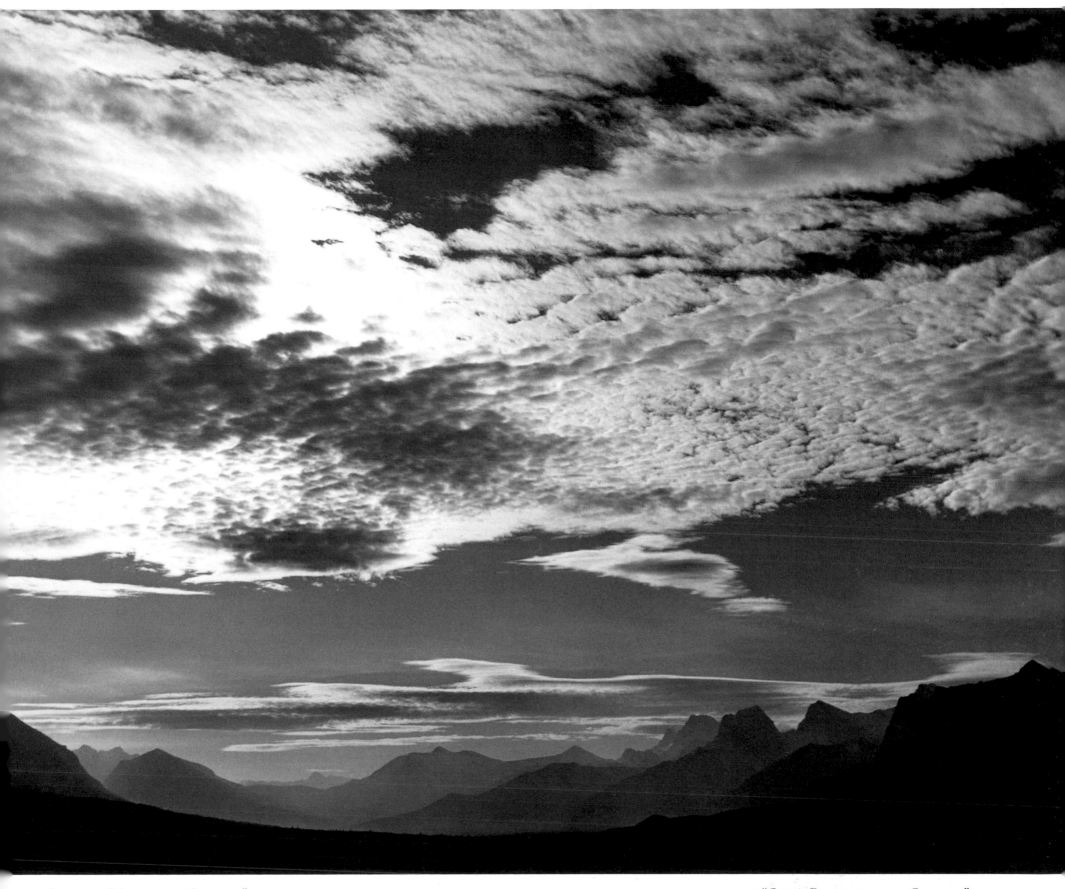

OPPOSITE: "HOODOOS AT CANMORE"

"CLOUD FORMATION NEAR CANMORE"

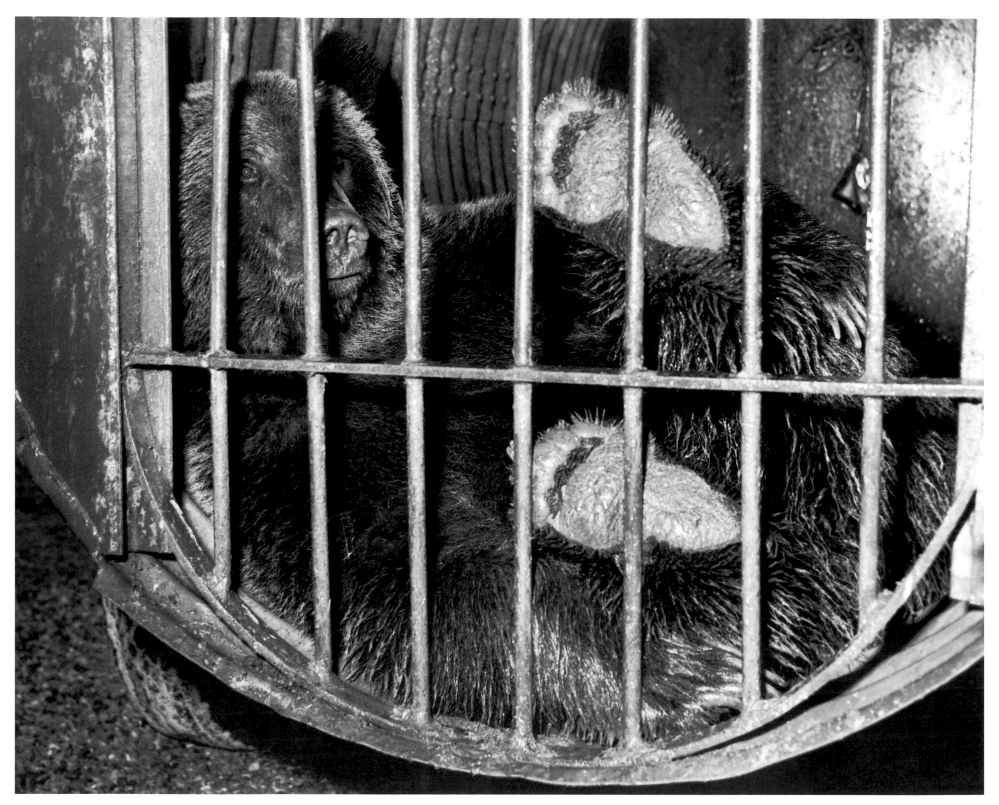

"GRIZZLY BEAR IN TRAP"
"Help Mommy!"

OPPOSITE: "HELP MOMMY!"
"Two year-old Janet Engler wandered outside the yard in Harvie
Heights and could not find her way back through the gate."

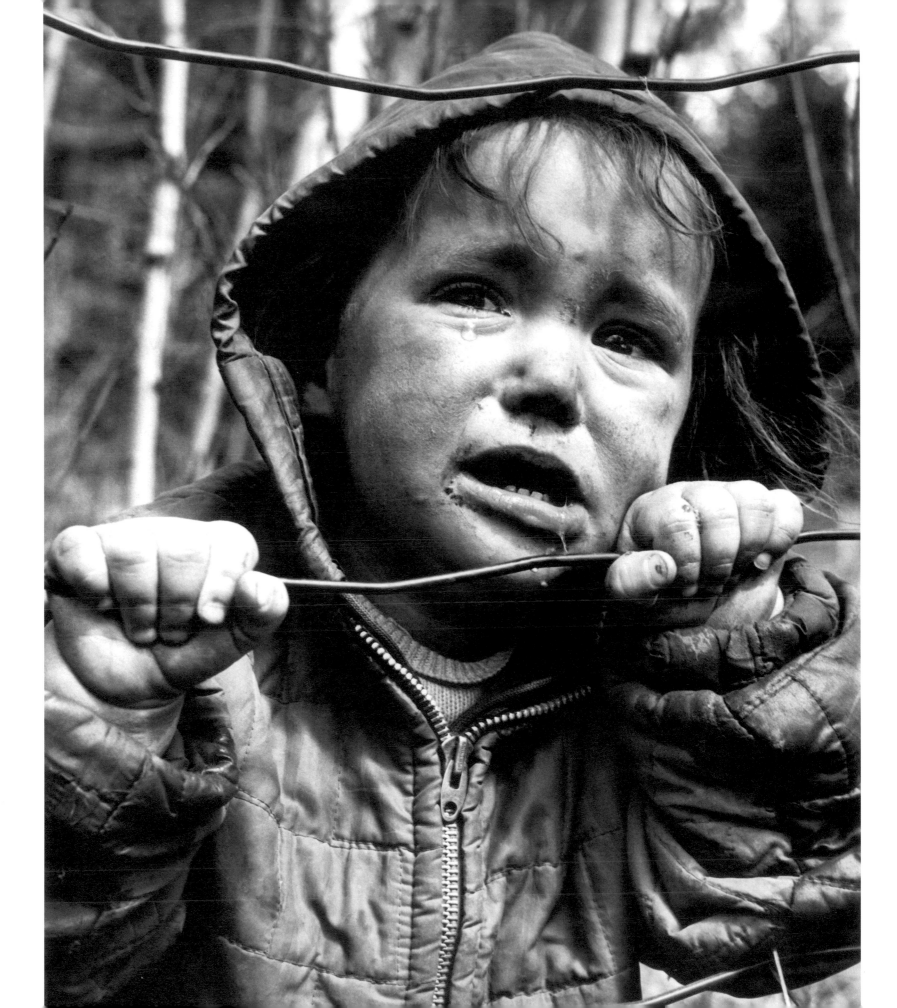

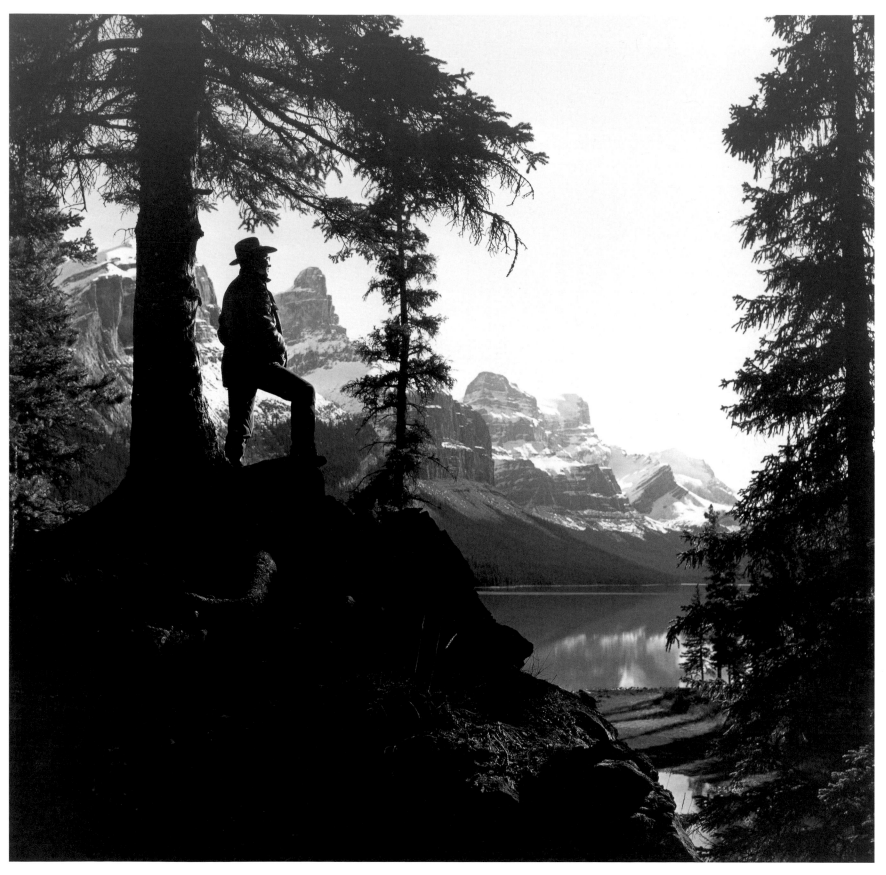

WARDEN AT THE JASPER NARROWS, MALIGNE LAKE

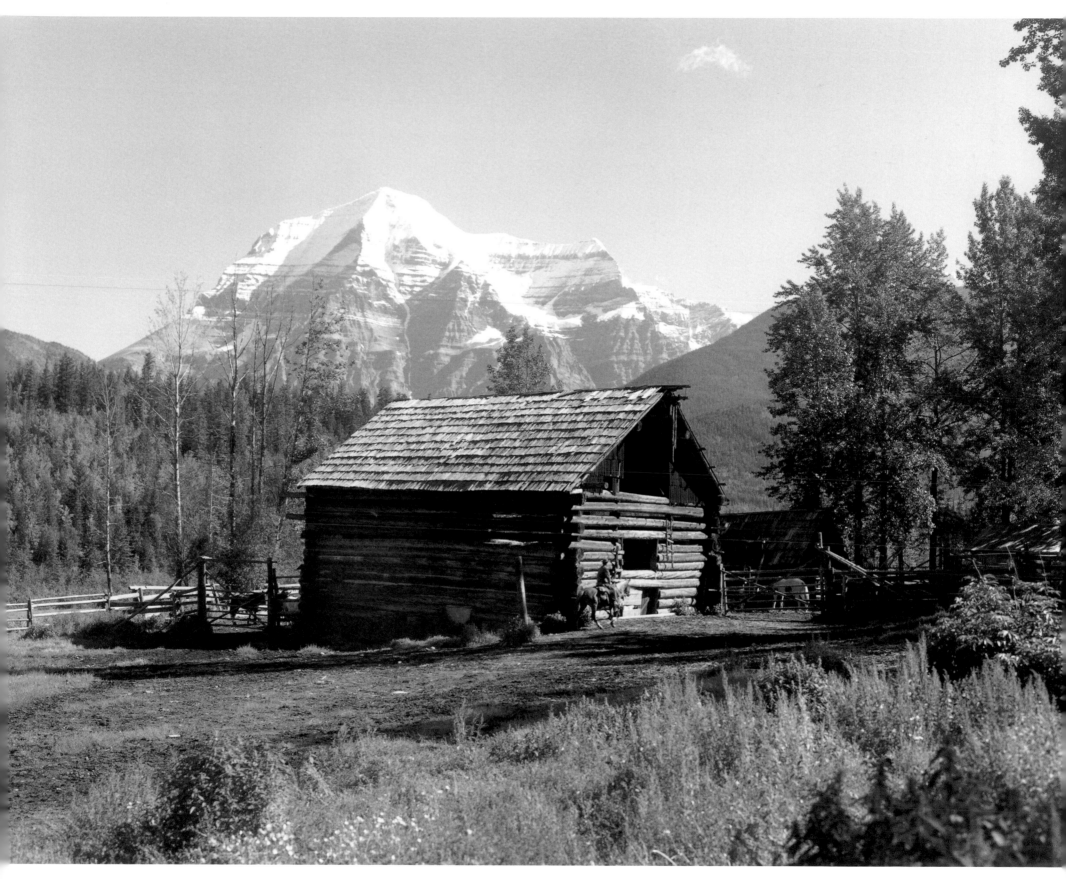

OLD BARN AND MOUNT ROBSON, 1968

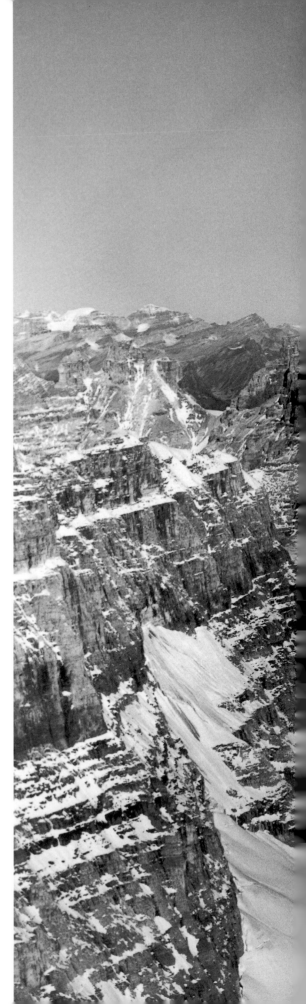

Right: "The Chief"
Mount Assiniboine from Mount Eon.

"Spring Melt"
Small creek near Mount Assiniboine.

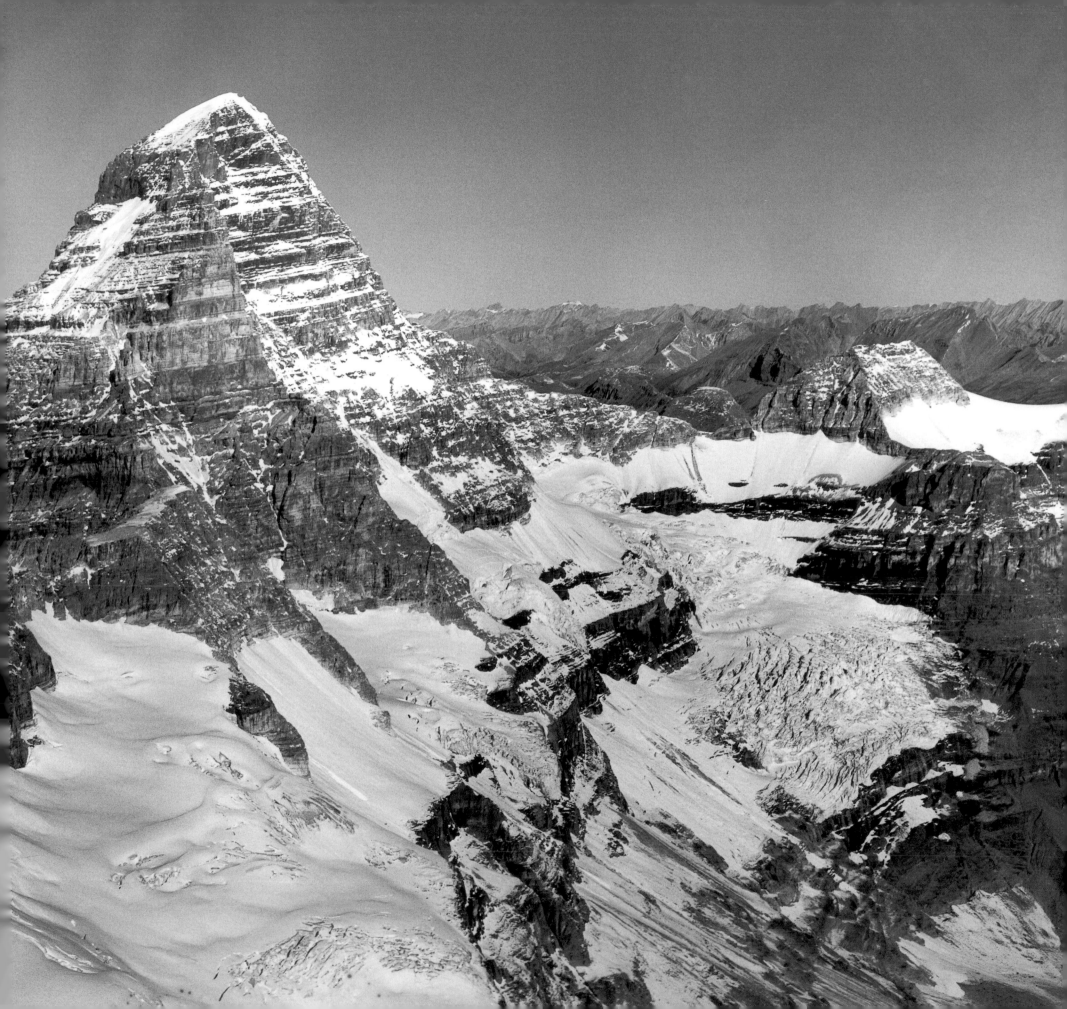

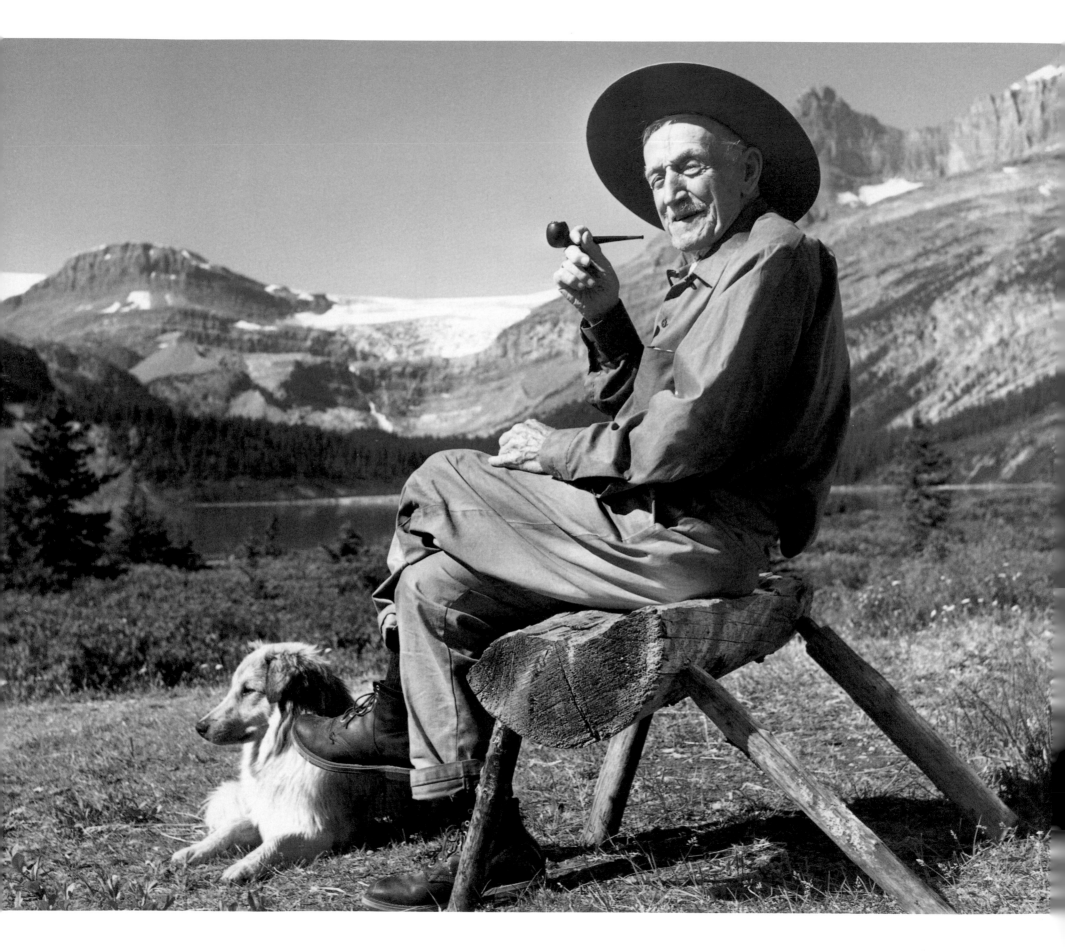

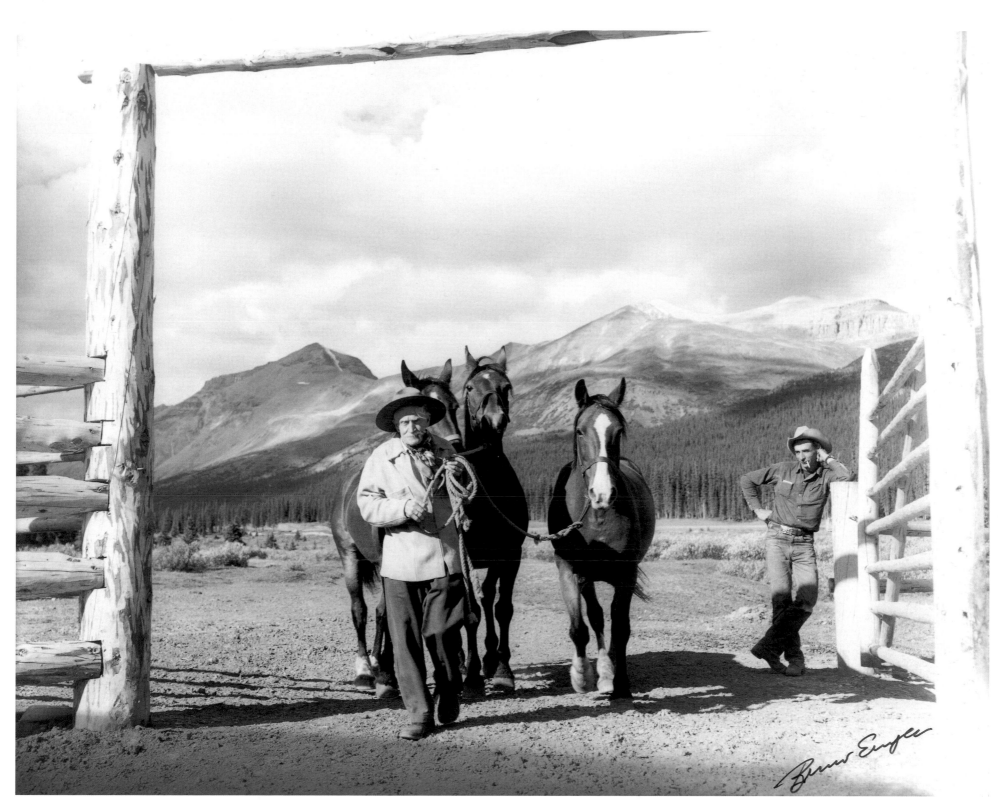

Opposite: "Jimmy Simpson and Dog"
Jimmy Simpson sitting on a "Rocky Mountain Chippendale Bench"
outside of Num-Ti-Jah Lodge in 1970. Jimmy passed away on
October 30, 1972, at the age of 95.

"Jimmy Simpson and Horses"
Justin James McCarthy "Jimmy" Simpson settled in Banff in 1898 at
the age of 21. For many years he was a guide and outfitter. In 1924
he built a base camp on the shores of Bow Lake. Several years later,
in 1939, he built Num-Ti-Jah Lodge out of log and stone.

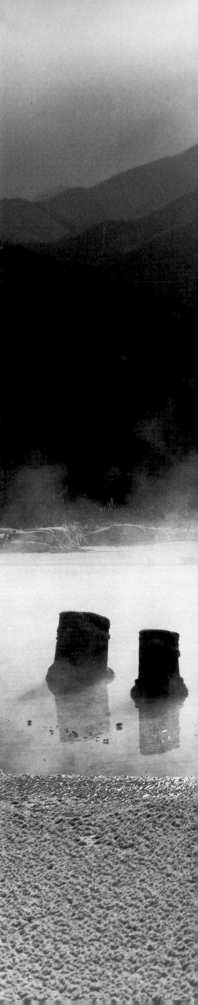

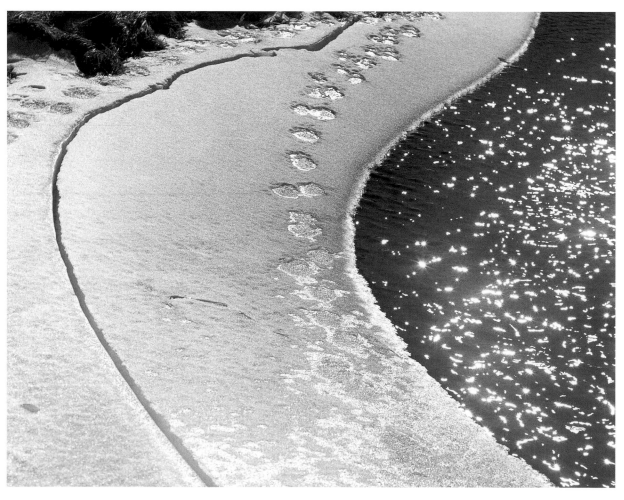

Spring Glitter

124

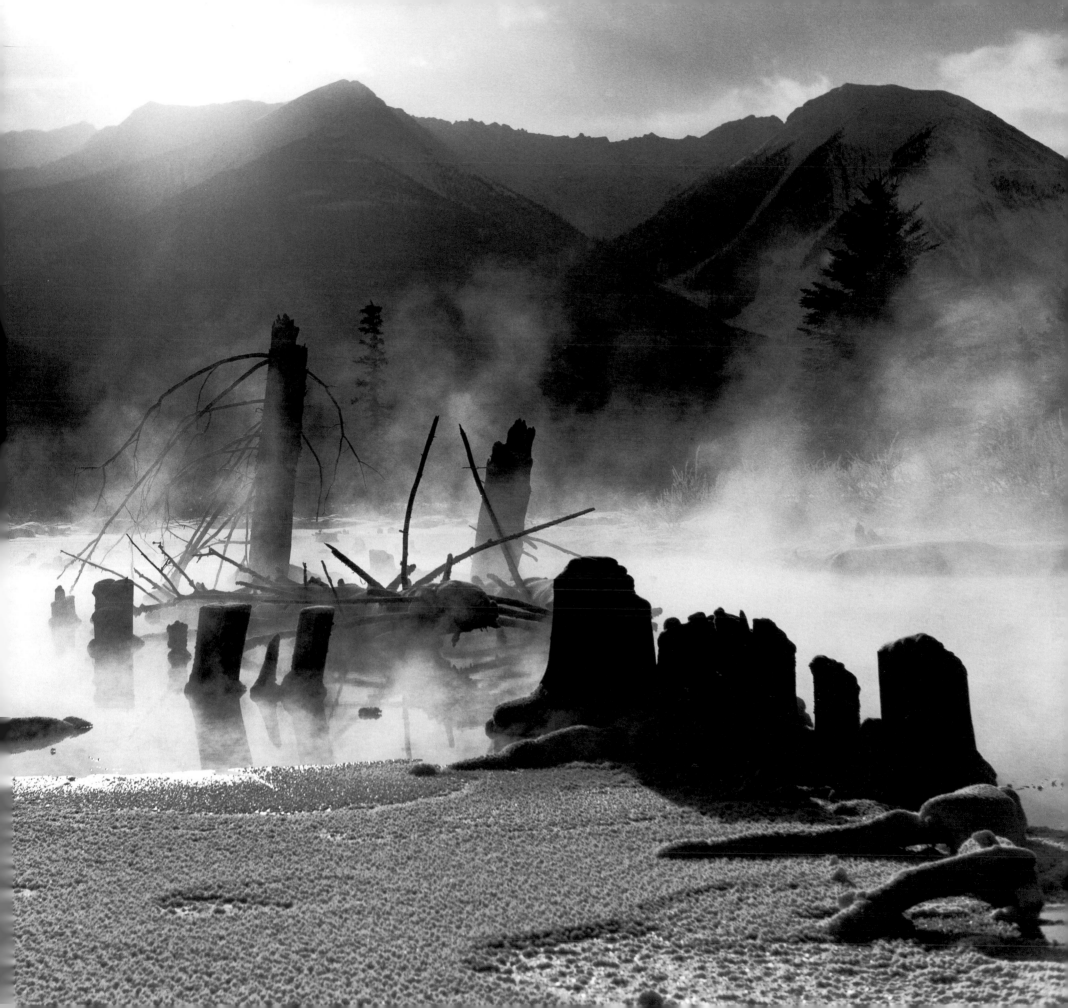

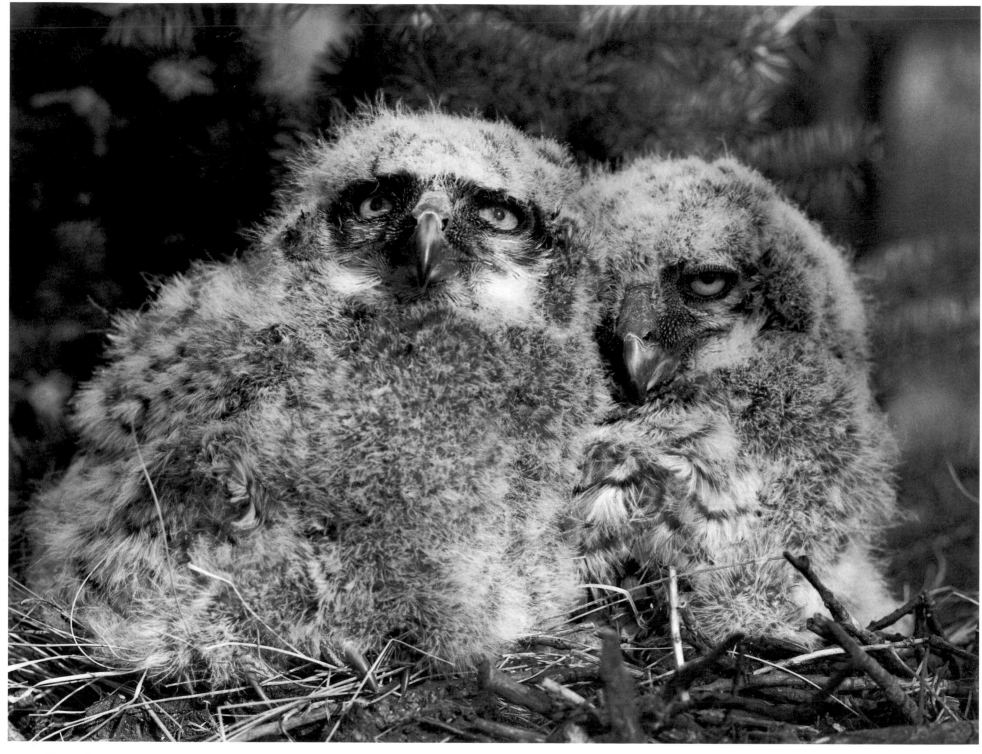

Young Predators

Opposite: Hidden in the Mist
Mountain goat and kid at Athabasca Lookout.

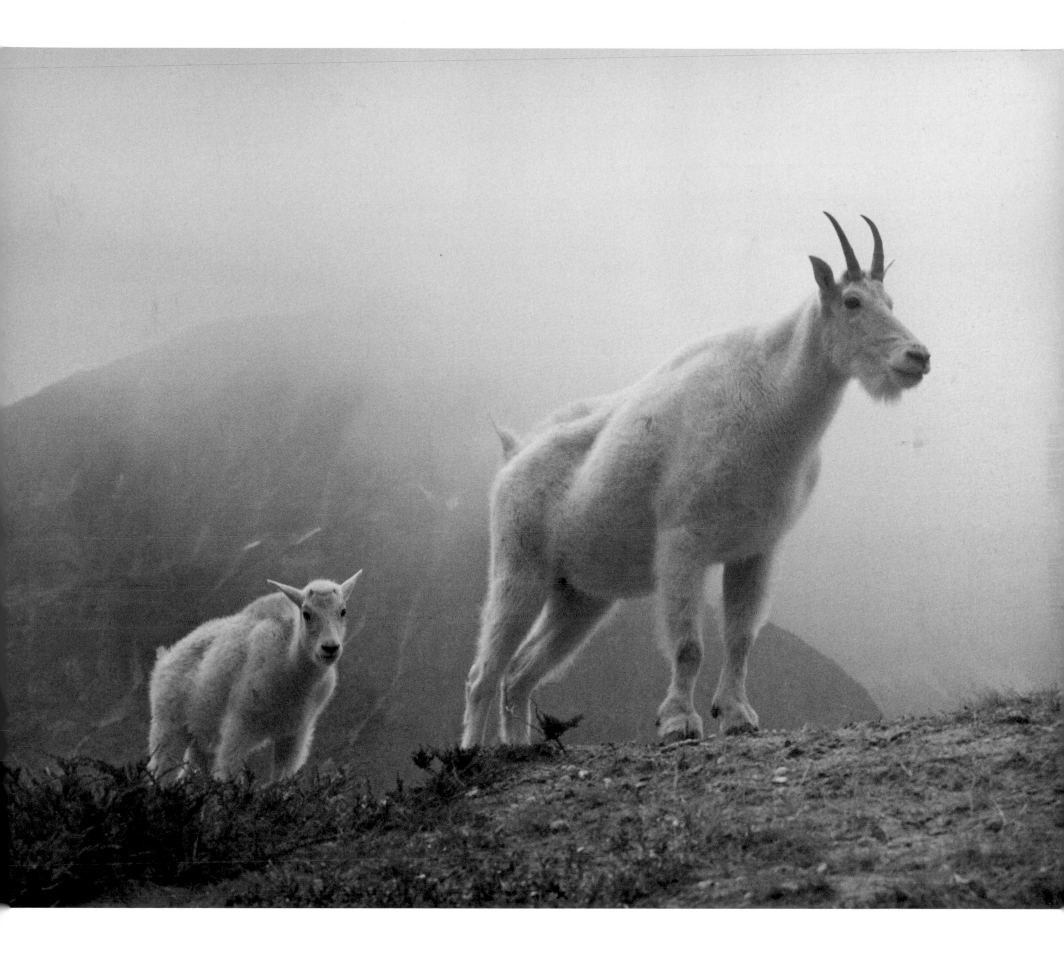

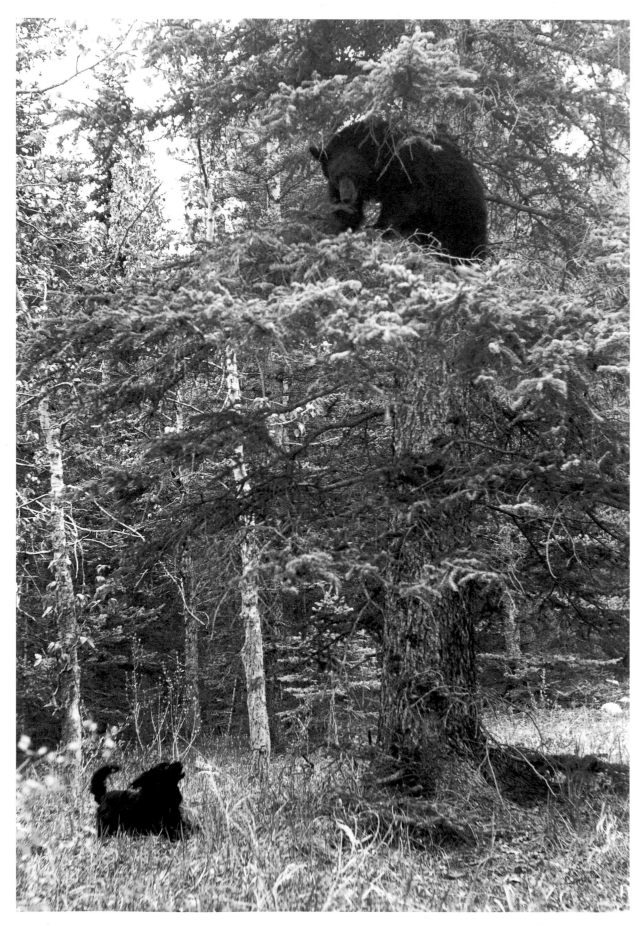

LEFT: THE UNDER DOG

OPPOSITE: BLACK BEAR IN TREE

One day, Dad was setting up his camera to take a shot of a spider web still glistening with dew. His dog Fang was patiently waiting nearby. Dad was so engrossed in the task at hand he didn't notice a small black bear lumbering out of the trees towards him. He was crouched down examining the beauty of the web. Fang, however, sprang into immediate action. He knew there was danger here. With a loud bark that startled my father, Fang took off after the bear. The bear must have been quite surprised to see this little black ball of fur coming after him. In some amusement, he waited until the dog was close enough, and with the movement of one large paw, knocked his noisy adversary about fifteen feet across the ground. But Fang was protecting his master. He was immediately back on his feet, and with a ferocity that belied his size, he was back in the fray. My dad watched in astonishment as his little spaniel mutt charged in again. Surely the bear would do major damage this time. But no, the bear must have been confused to see the match resuming. Maybe there was something here he didn't know about. For whatever reason, the bear turned tail with Fang in hot pursuit, yipping and growling all the way. The bear found sanctuary in a tree, with Fang fifteen feet below him, still challenging. My dad had never seen anything like it. He reset his camera and got a classic picture of our little dog triumphant over the bear, who was cowering in the tree. Dad never did get his picture of the spider web. (Susan Engler Potts)

128

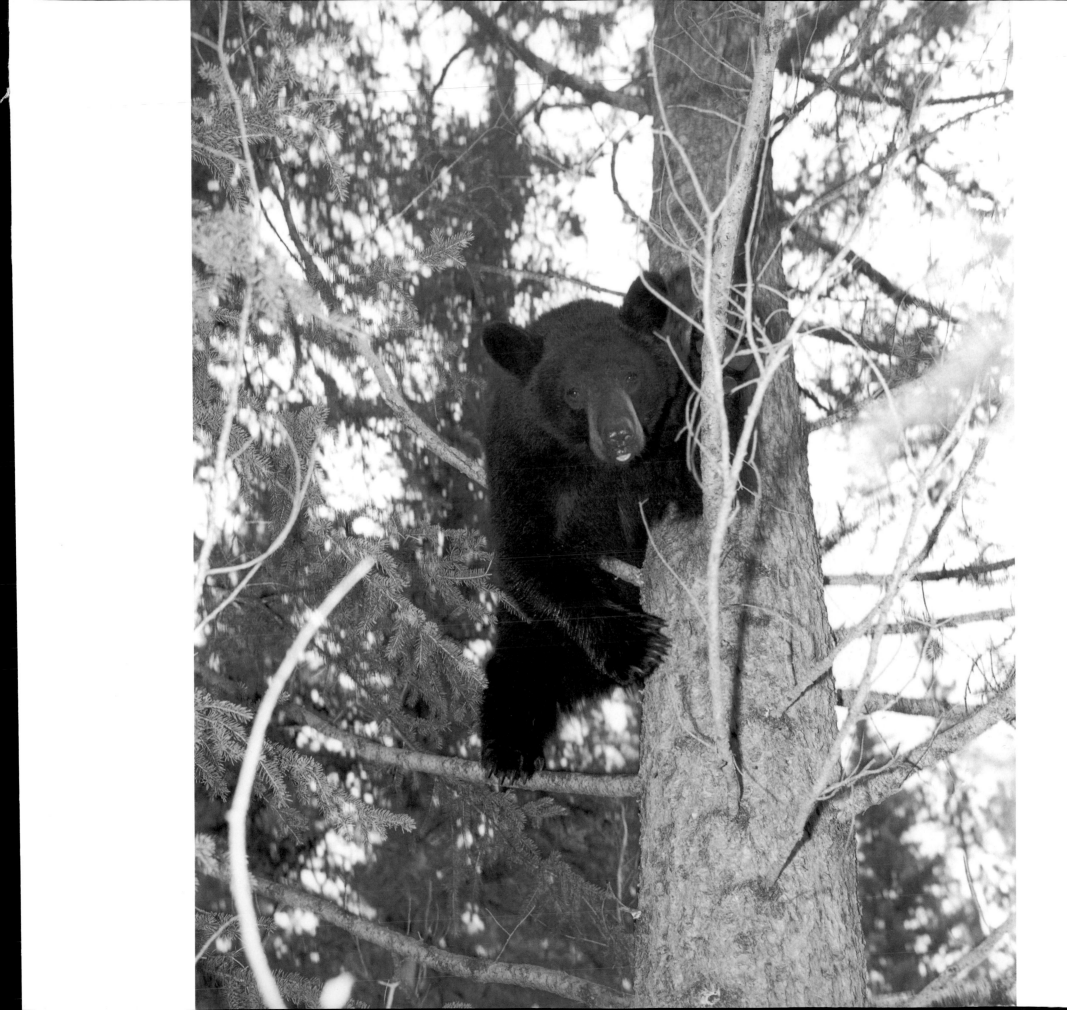

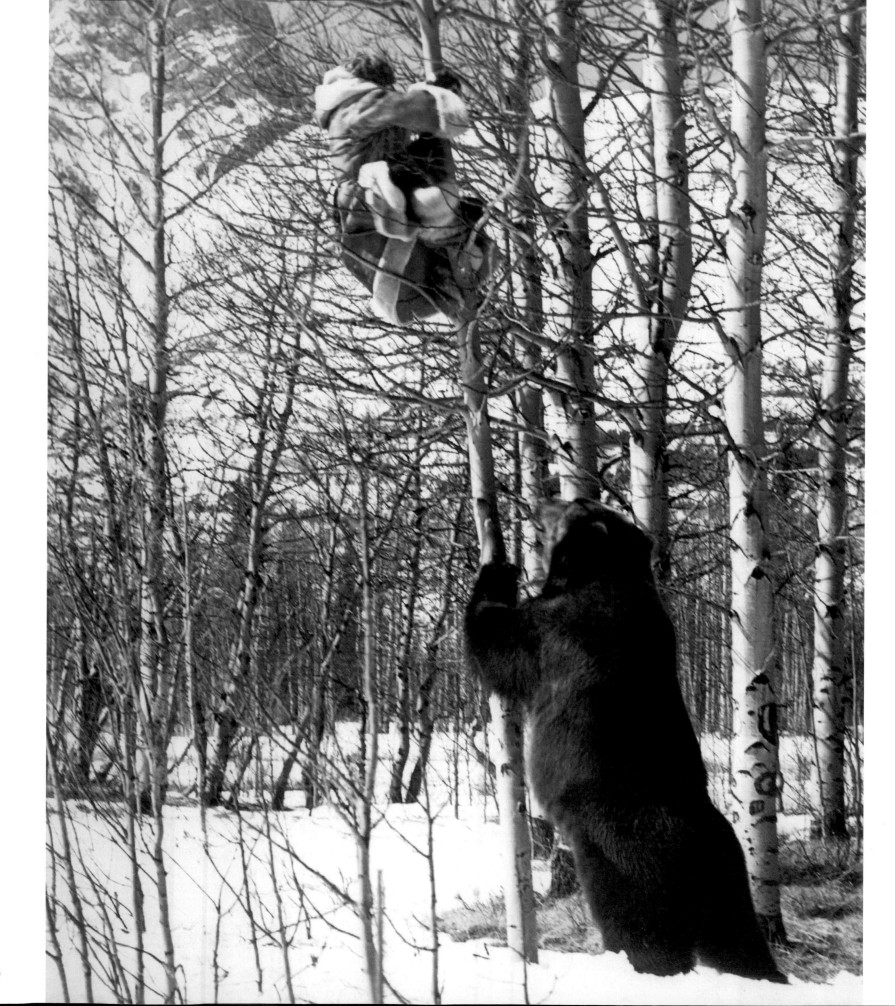

**OPPOSITE: ACTOR HENRY BRANDON
AND GRIZZLY**

RIGHT: HENRY BRANDON TREED
Great acting, or real fear?

"When the North Wind Blows" was filmed
on location near Canmore in 1974.
Director, Stewart Raffill.

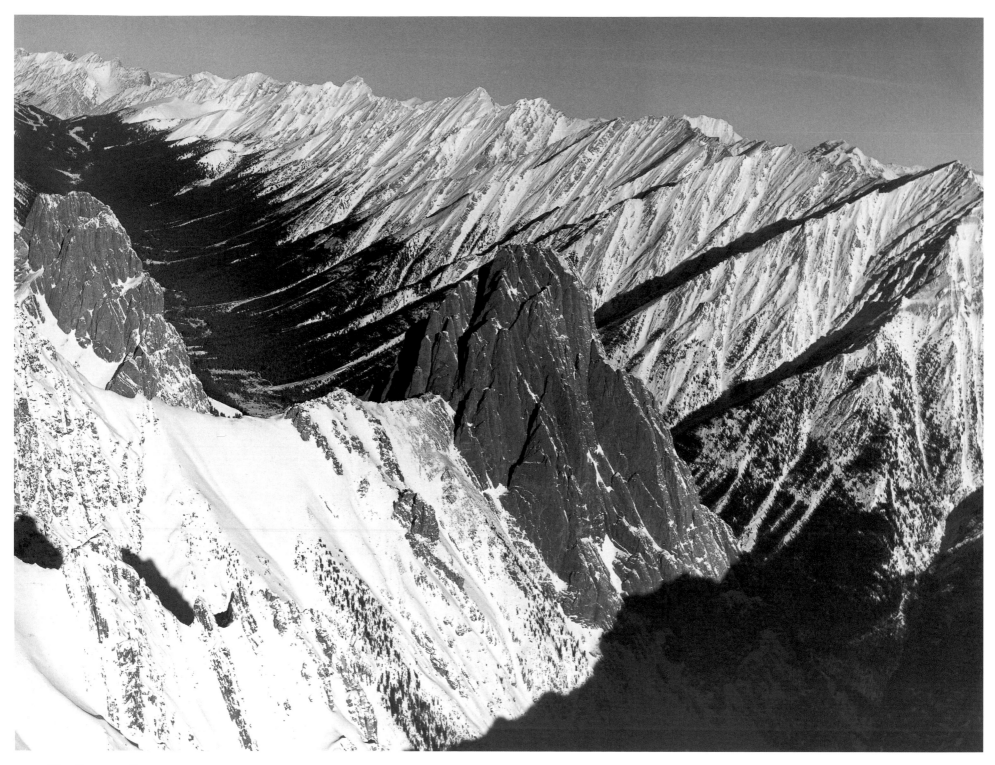

The Sawback Range

Mount Louis overlooks Forty Mile Creek.

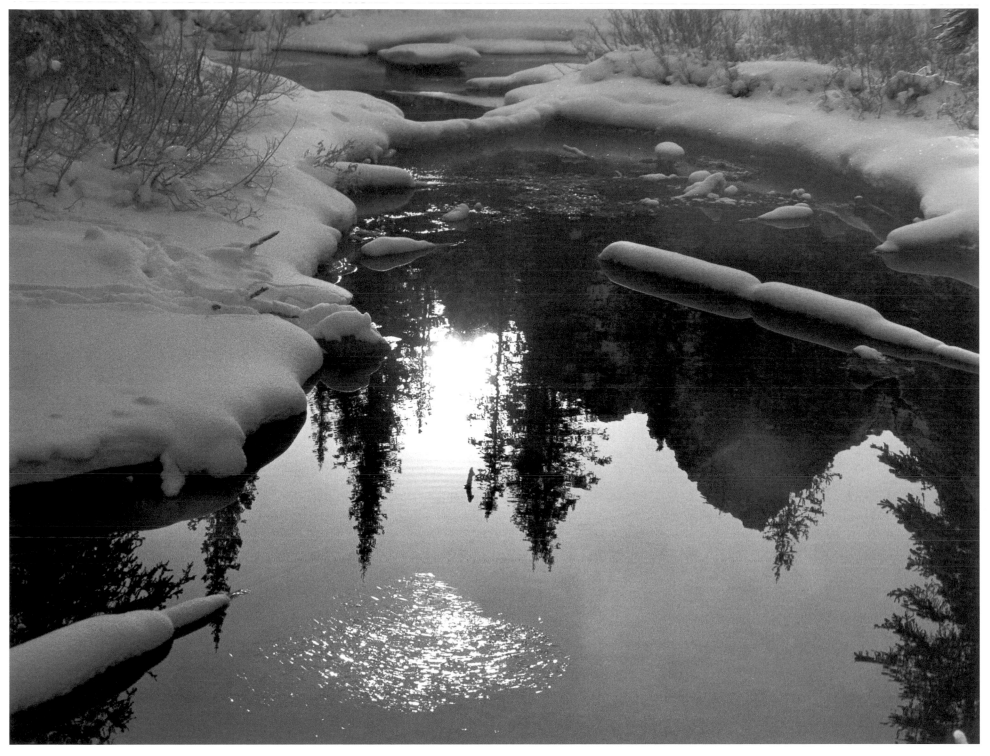

FORTY MILE CREEK
Mount Edith reflected in the pond.

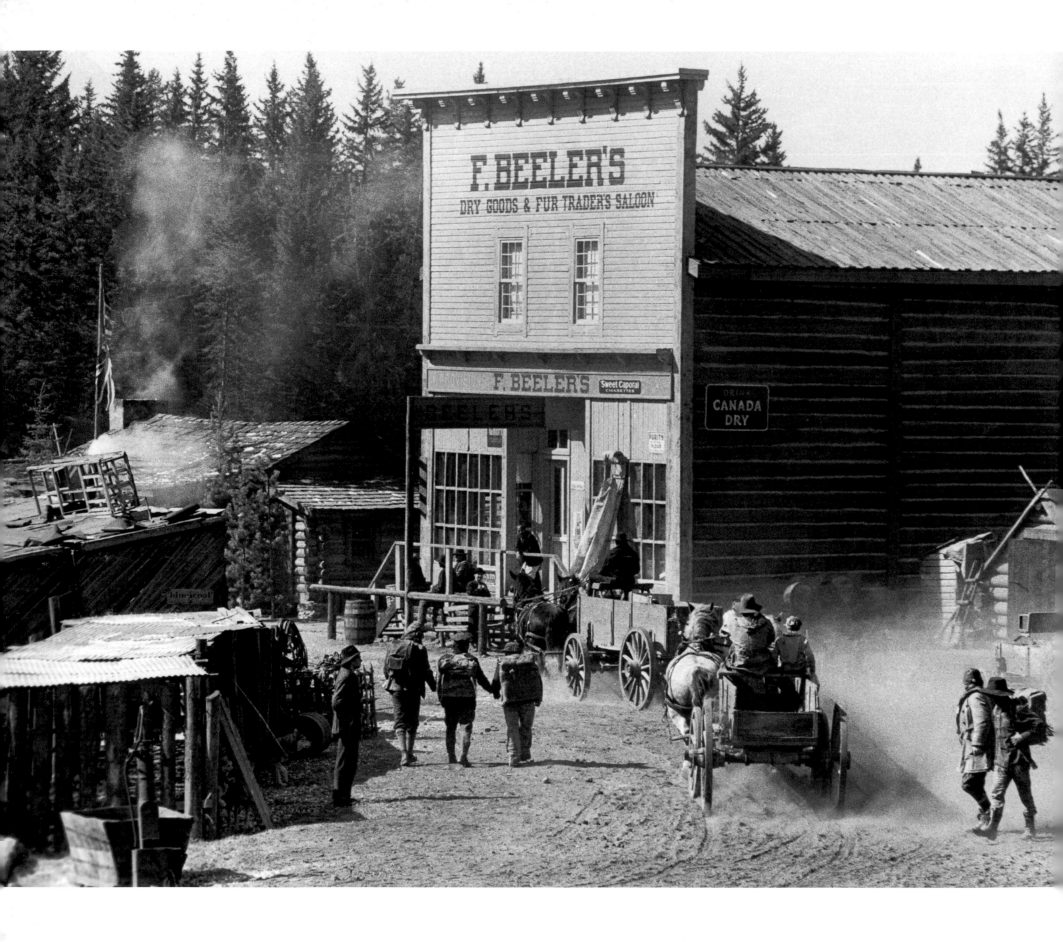

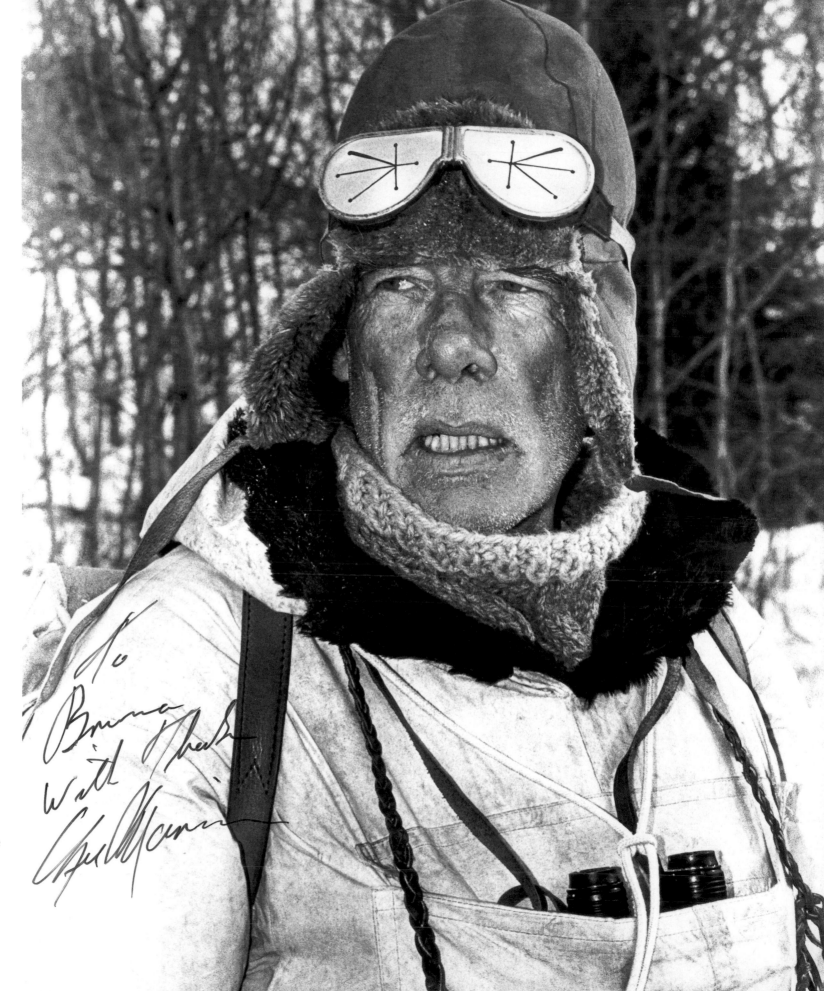

OPPOSITE: THE CANMORE SET OF
THE MOVIE "DEATH HUNT"

RIGHT: ACTOR LEE MARVIN

"Death Hunt" was filmed in 1980 in the
Spray Lakes, Athabasca Glacier and
Jasper areas. Director, Peter Hunt.

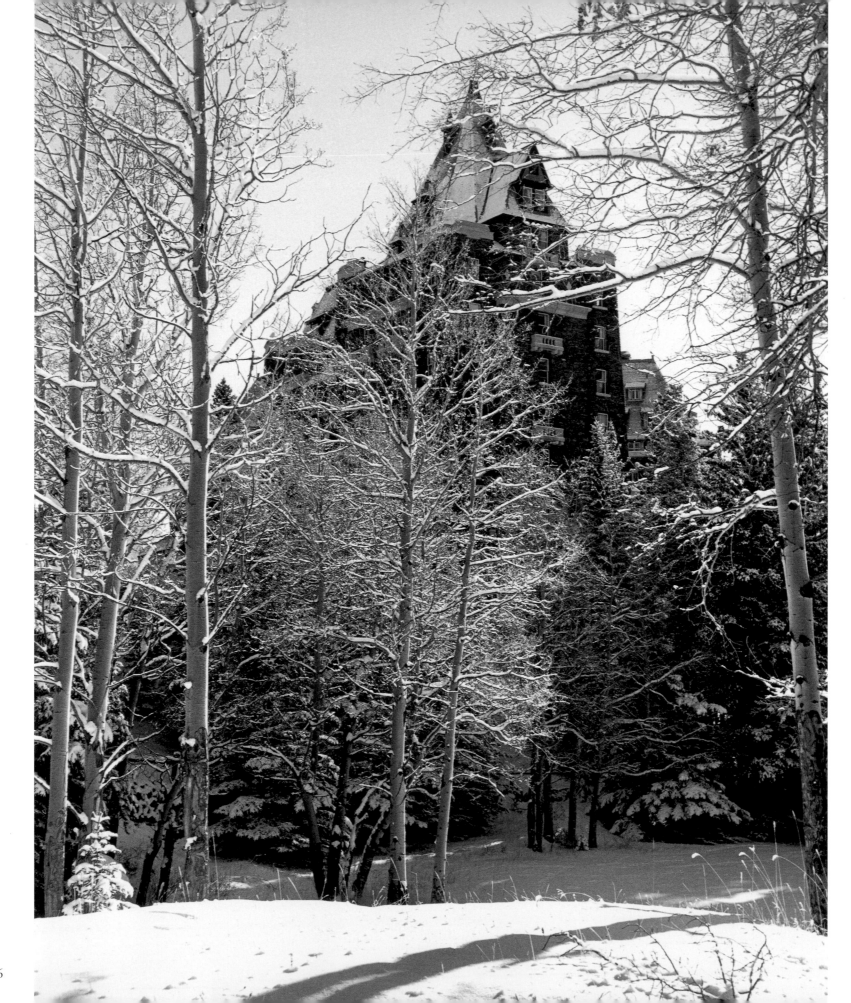

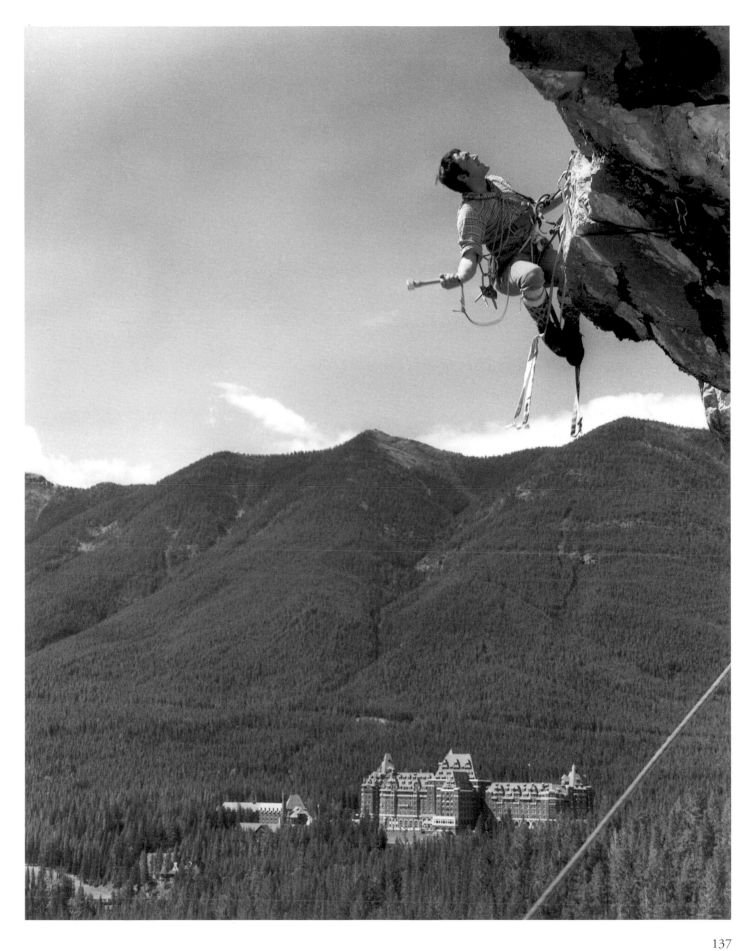

OPPOSITE: BANFF SPRINGS HOTEL
Frosted trees screen the castle-like hotel.

RIGHT: GONDA TRAVERSE
Rudi Gertsch climbing on Tunnel Mountain, Banff, 1971. In the background is the Banff Springs Hotel.

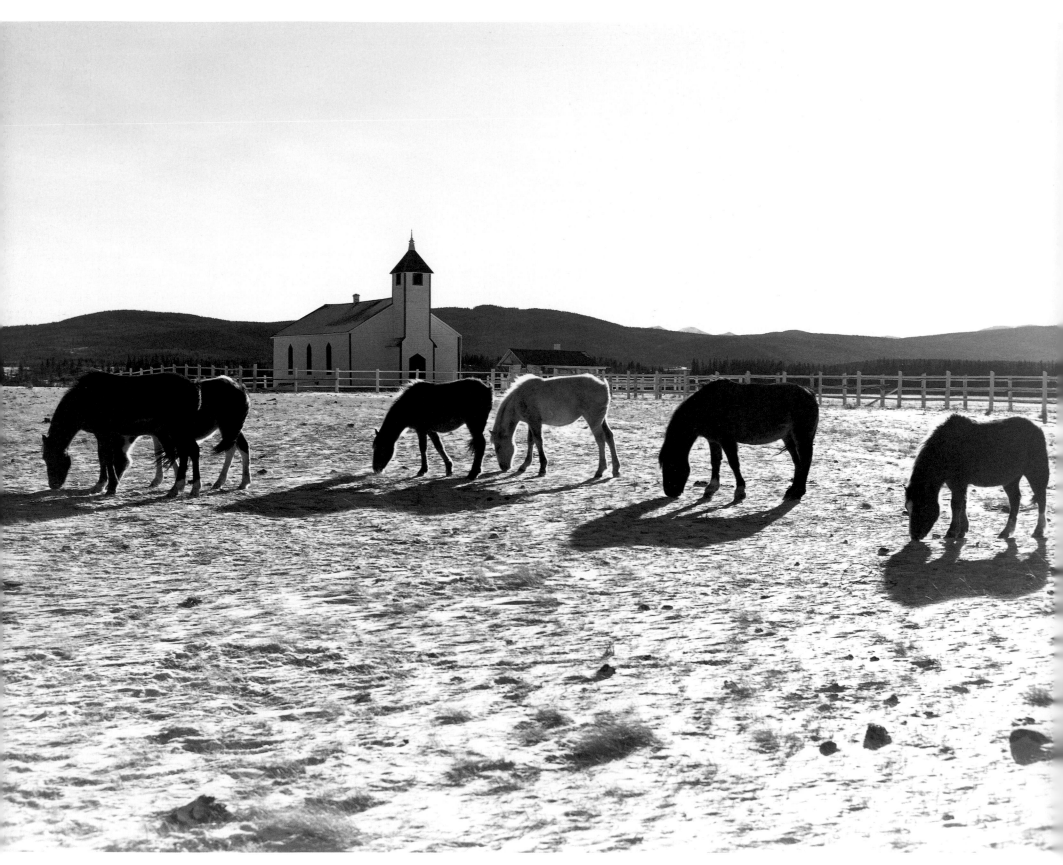

CHURCH AND HORSES
McDougall Memorial Church at Morley.

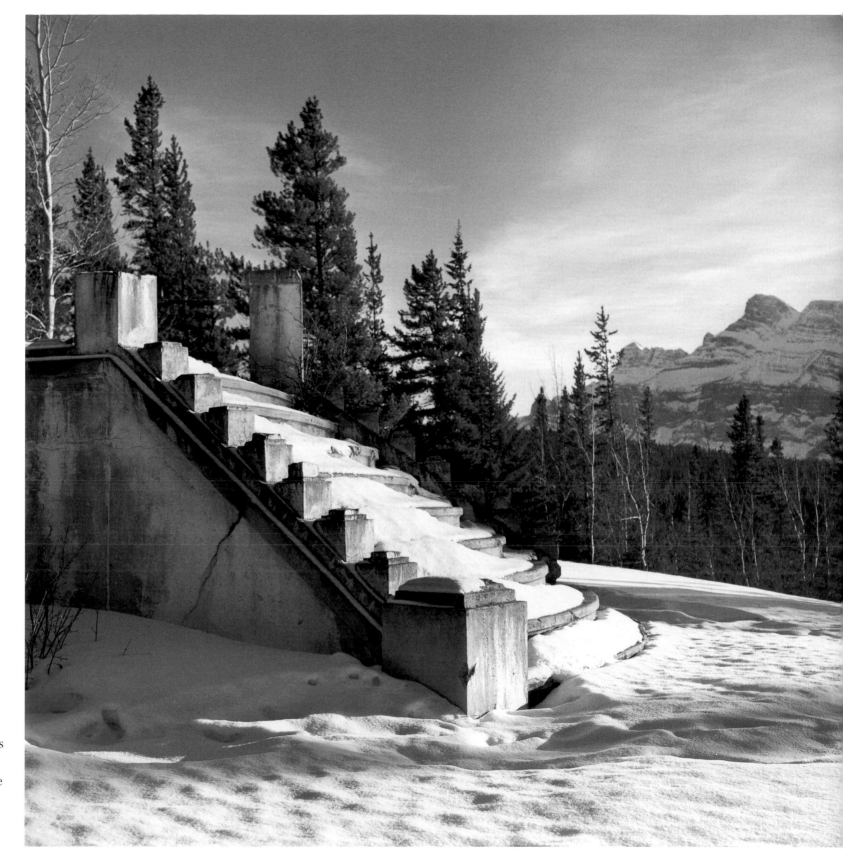

"Stairway in the Snow," 1965
"Banff miners walked up these stairs for Sunday worship. Nature has slowly taken over. The old coal mine at Bankhead is now abandoned and silent in the shadows of towering Cascade Mountain."

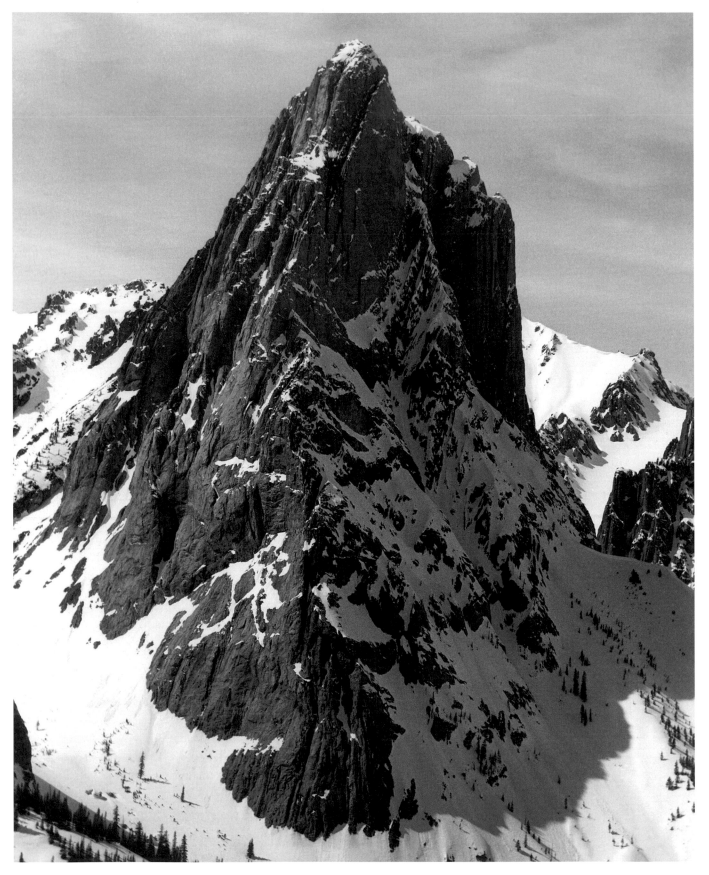

Mount Louis

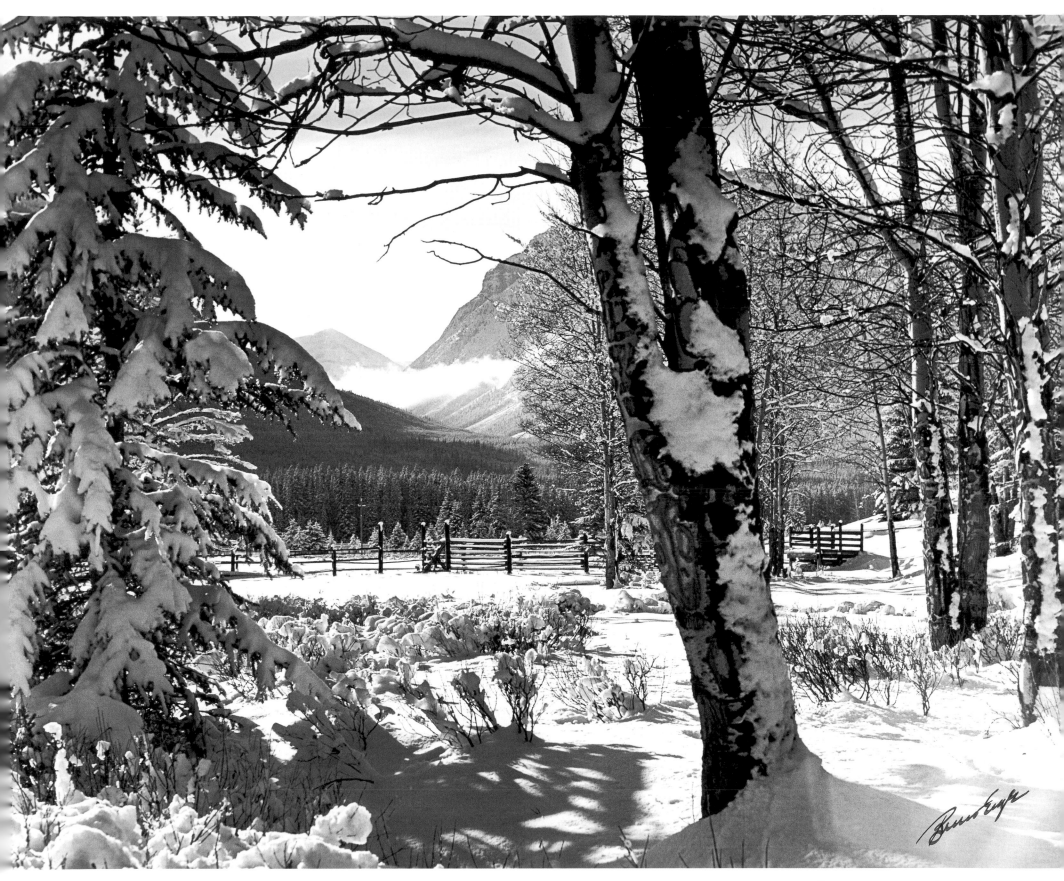

"Hillsdale Corral," 1968

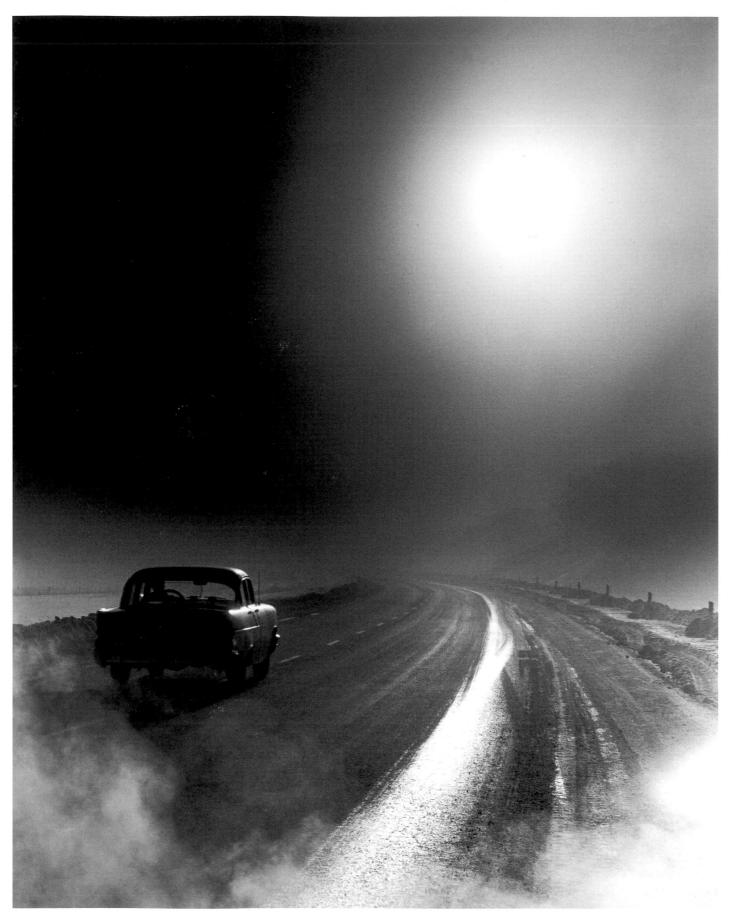

LEFT: "WINTER HIGHWAY"
The early morning drive to the ski area.

OPPOSITE: WHITE ENCHANTMENT
Skiing the Wishbone at Mount Norquay
Ski Area in 1968.

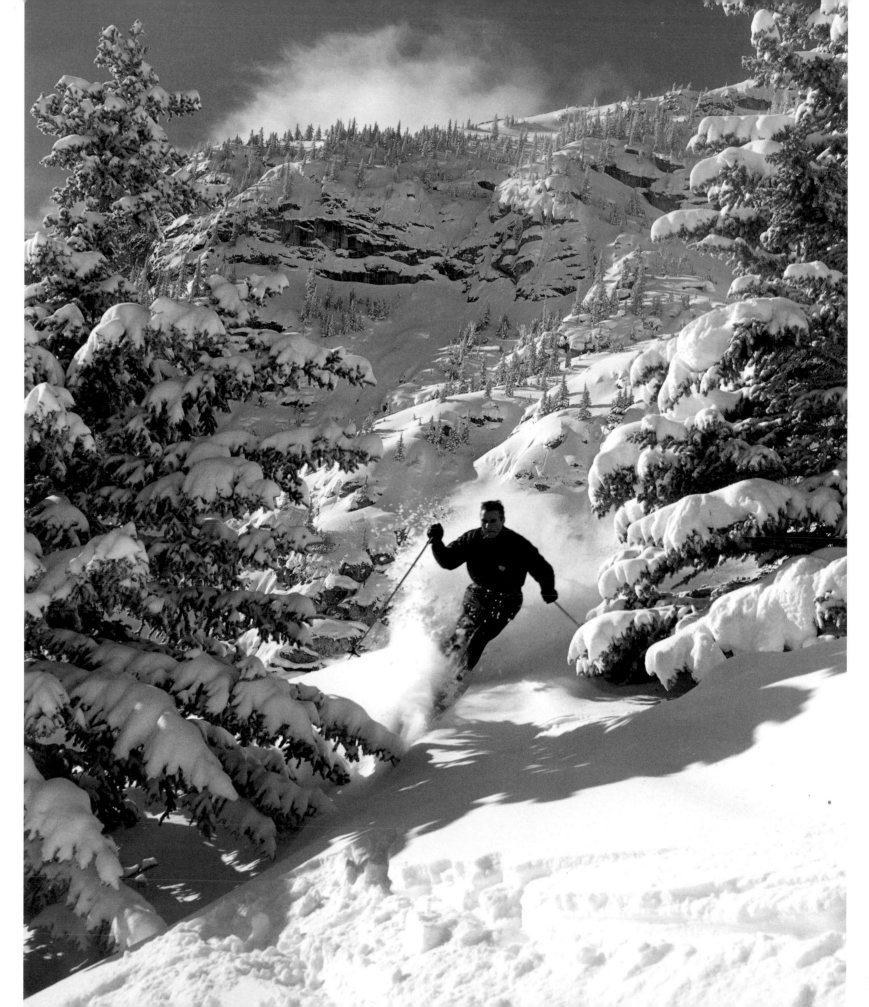

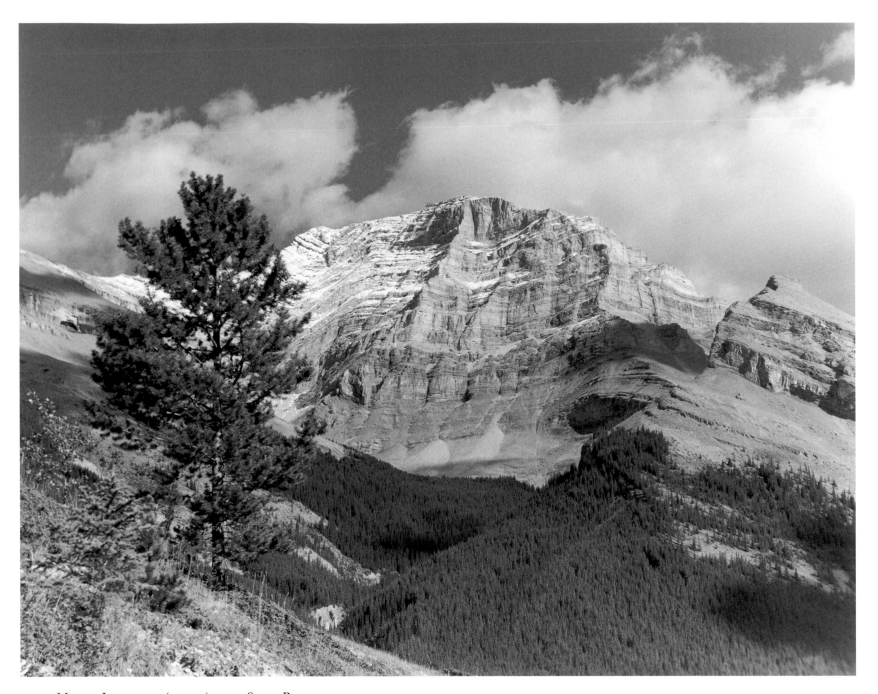

Mount Lougheed (3105 m) from Spray Reservoir

"I suggested the climb to Peter Lougheed when we used to ski together, long before he was premier of Alberta. The idea resurfaced one winter when we met at Sunshine. I thought the 75th anniversary of Alberta would be the perfect time. I told Peter, 'This is the perfect excuse to do it now, and stop procrastinating. Let's do it now, before we both get too old.'"

Celebrating the Province of Alberta's 75th birthday, Premier Peter Lougheed and his family climbed the main peak of Mount Lougheed on August 29, 1980, and commissioned Bruno to photograph the historical event. Bruno's reputation as a mountain photographer is legendary. However, few people were aware of his penchant for leaving a trail of light-meters, film, sunglasses, etc., en route to capturing that singular moment of magic. On this particular climb we hired Dave Smith as an extra guide and Bruno's artistic shadow, to follow him and pick up the pieces the master left behind. (Lloyd "Kiwi" Gallagher, who with Bernie Schiesser, Joe Dutton, Dave and Bruno guided the Lougheed family to the summit.)

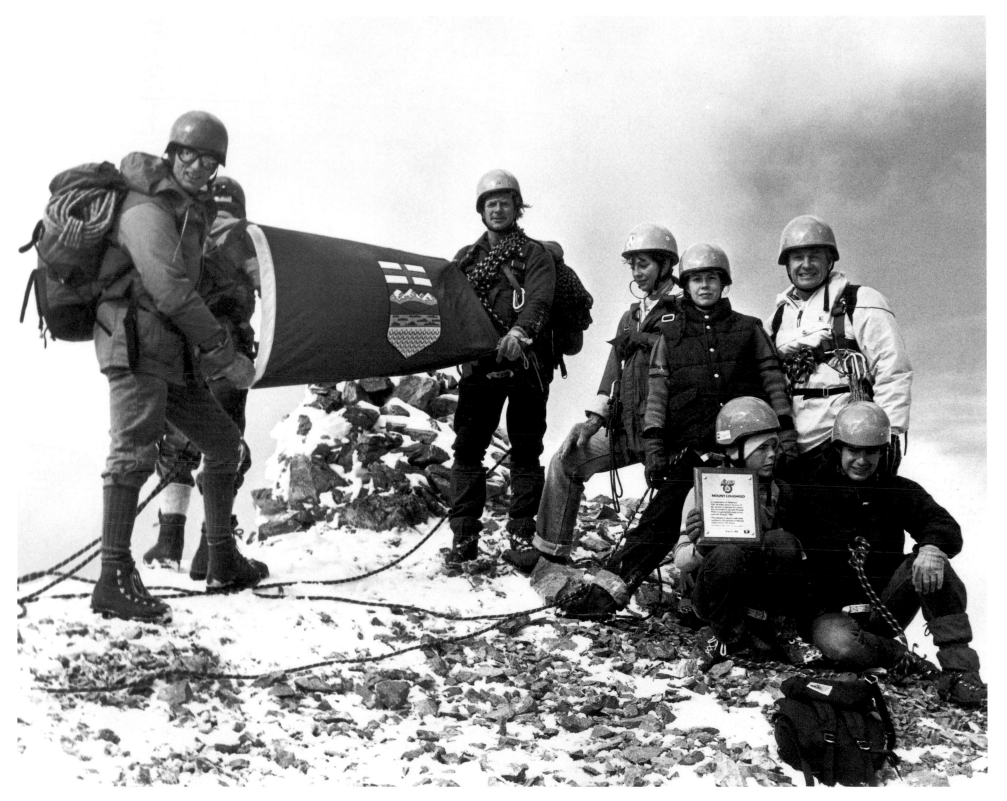

PETER LOUGHEED AND FAMILY ON THE SUMMIT OF MOUNT LOUGHEED
Left to right standing: Bernie Schiesser(ACMG) and Lloyd "Kiwi" Gallagher(ACMG)
holding the provincial flag, Pam Lougheed, Andrea Lougheed, Peter Lougheed.
Seated: Joe Lougheed, Steve Lougheed.

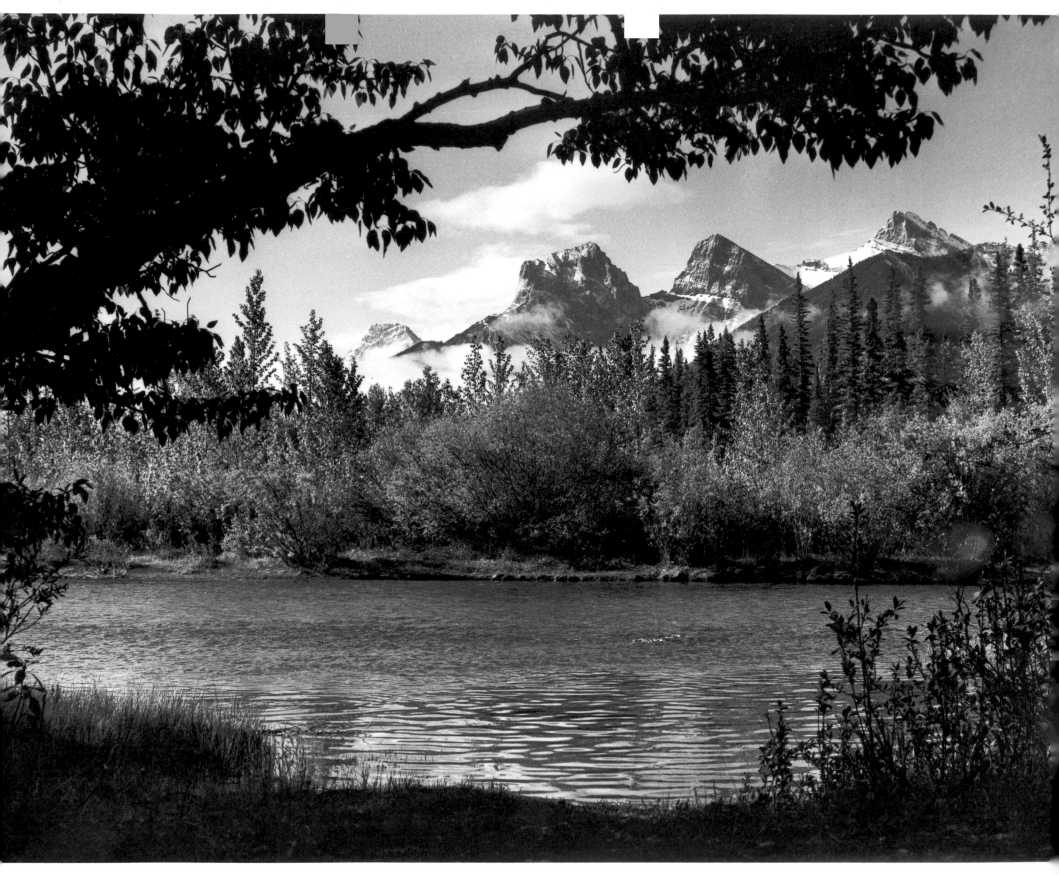

THE THREE SISTERS

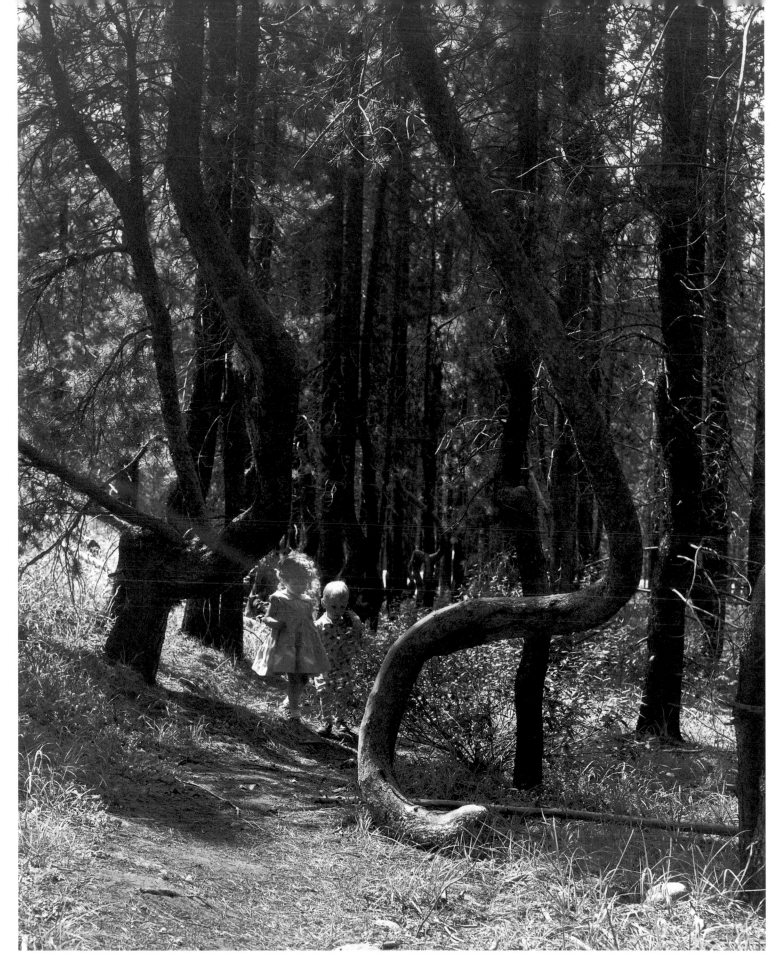

CHILDREN IN THE VALLEY
OF THE CROOKED TREES

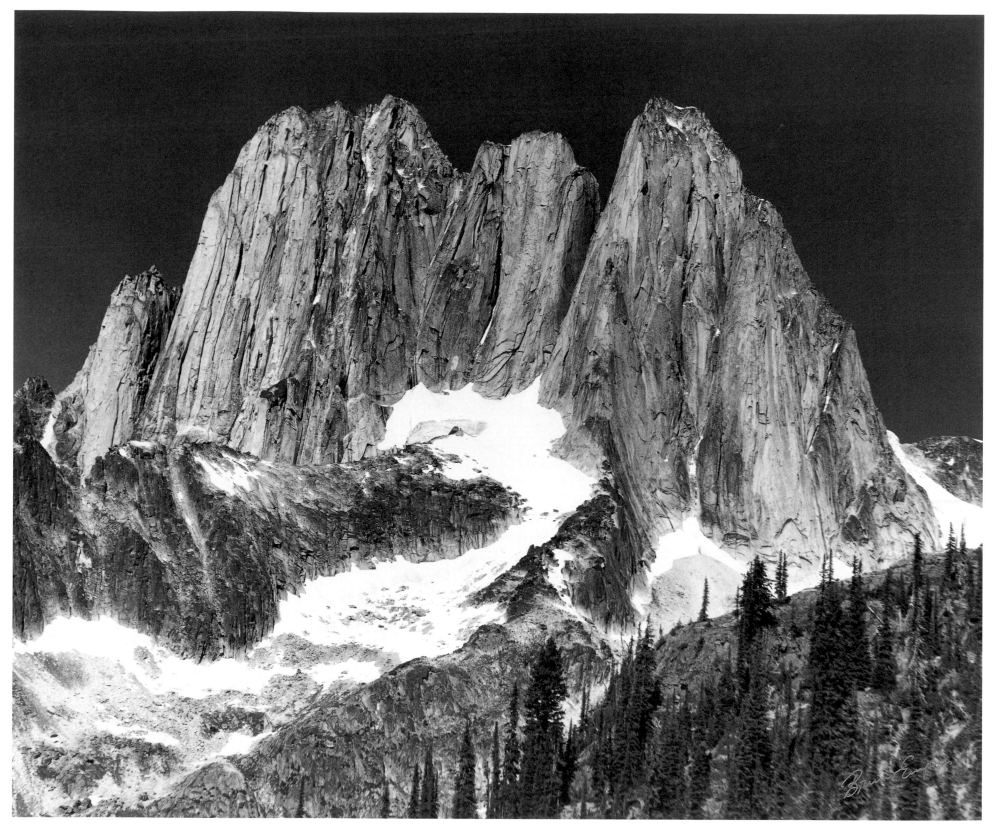

HOWSER TOWERS
The west face of the Howser Towers in the Bugaboos.

OPPOSITE: "THE BIG LEAP"
Climbing East Post, Bugaboos, in 1968.

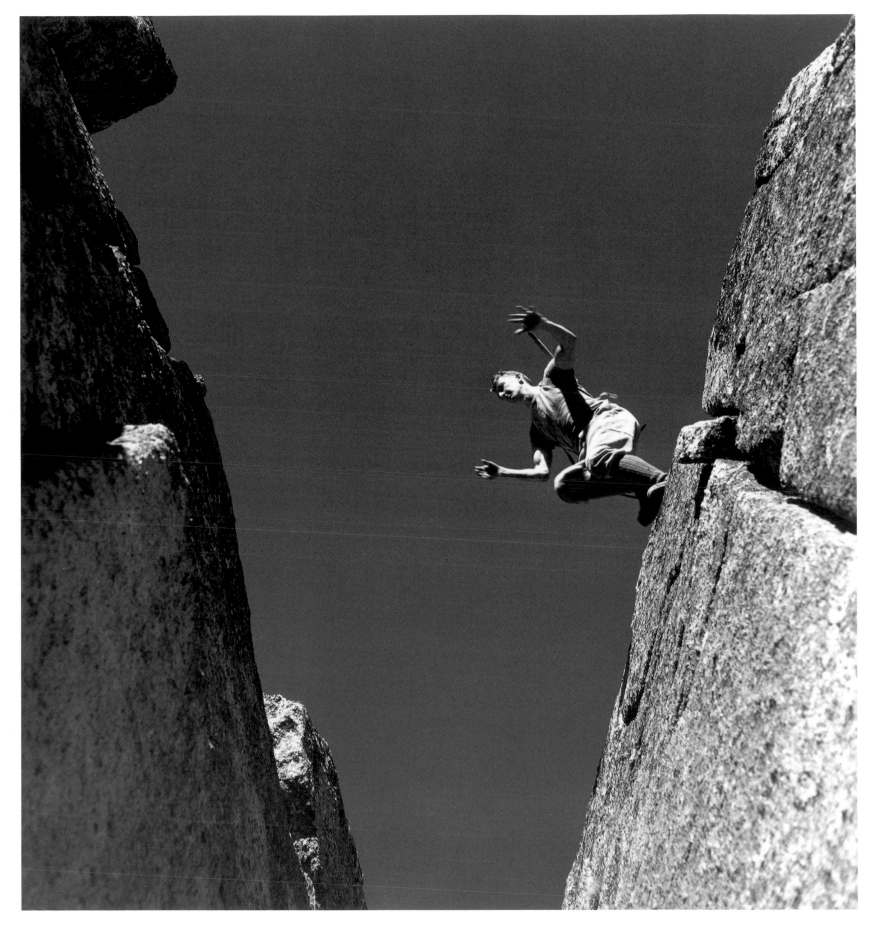

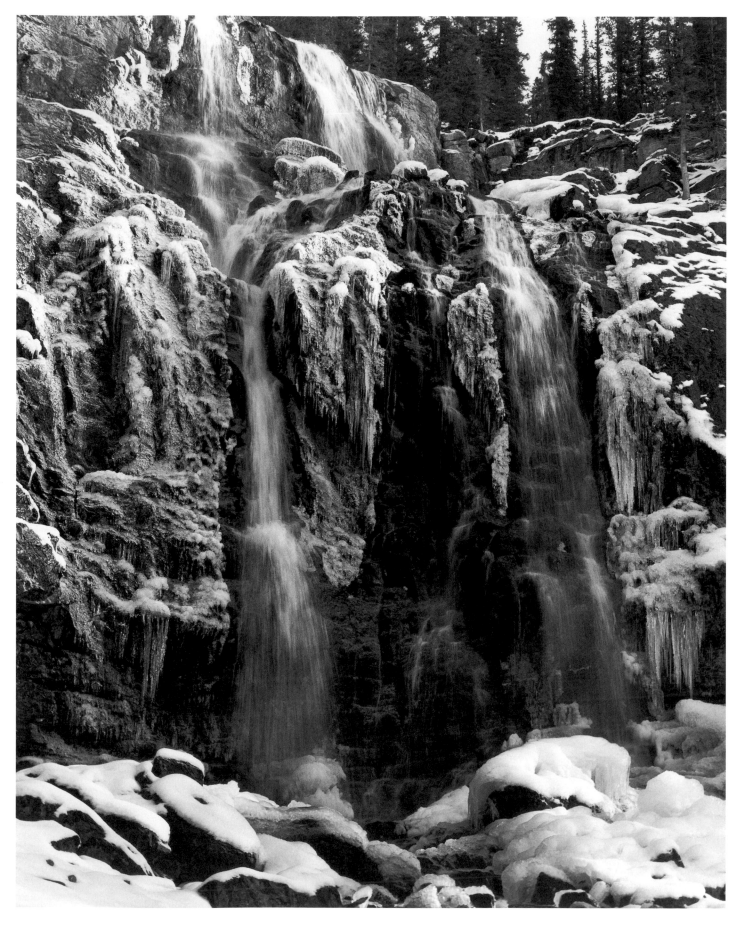

"Tangle Creek freeze up"

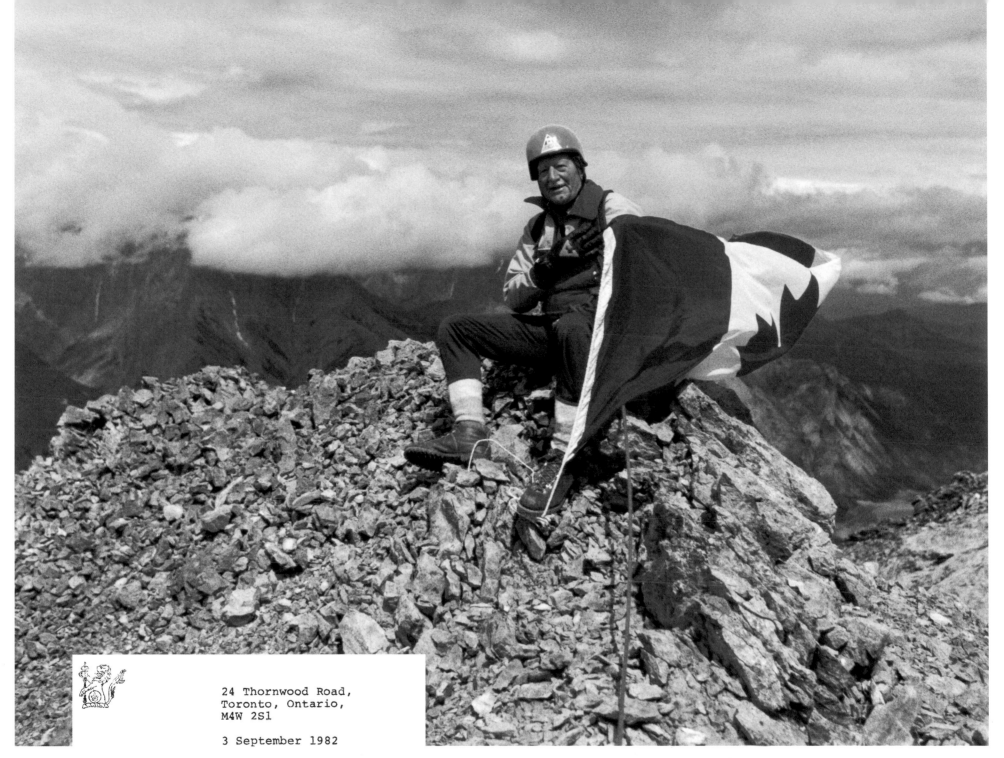

24 Thornwood Road,
Toronto, Ontario,
M4W 2S1

3 September 1982

Dear Bruno,

 I enclose a couple of snapshots from the film which was in my camera on the way up Mount Michener, with the hope that they will stir in your mind the same pleasant memories which they give to me.

yours ever

Roland Michener

GOVERNOR GENERAL ROLAND MICHENER ON THE SUMMIT OF MOUNT MICHENER (2545 M)

Climbing this peak named after him was a major achievement at 82 years of age. Loose rock and talus made the climb quite unstable and some vertical exposure made it a challenge. Sharing a moment on the summit was a joyous occasion for Bruno and Roland, who celebrated with yodelling, laughter and telling tall tales. It was a highlight in the lives of two truly unique individuals. (ACMG guide Lloyd "Kiwi" Gallagher, who with Bruno guided Roland to the summit.)

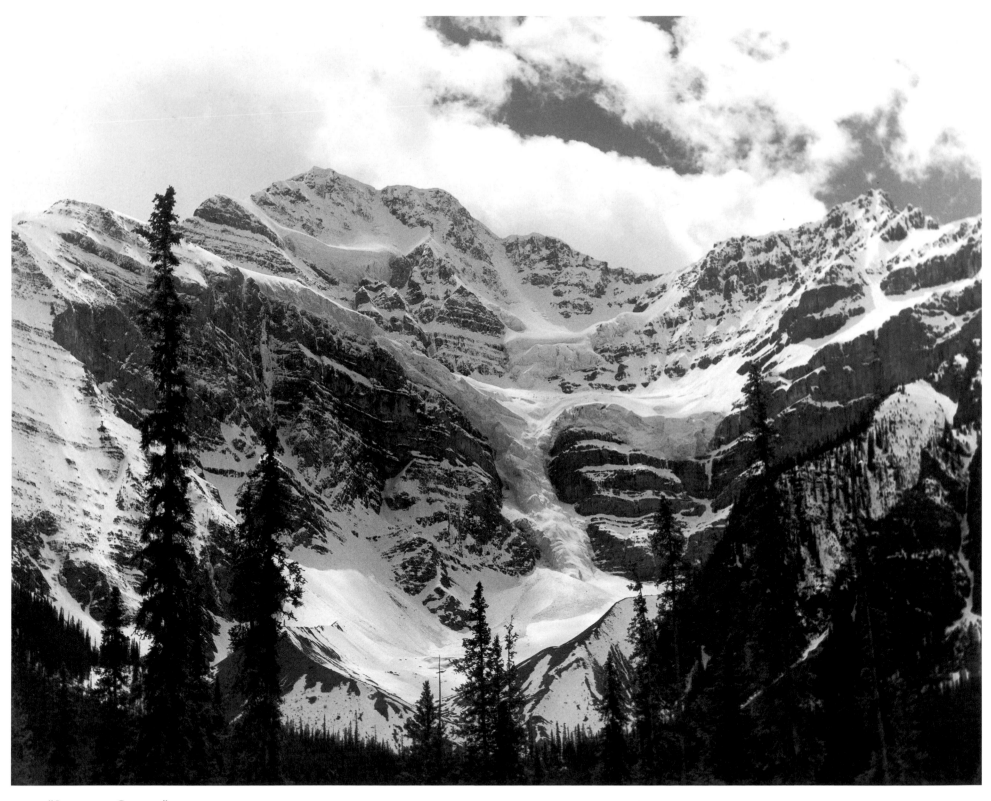

"Snowbird Glacier"
The northeast face of Mount Patterson, 1977.

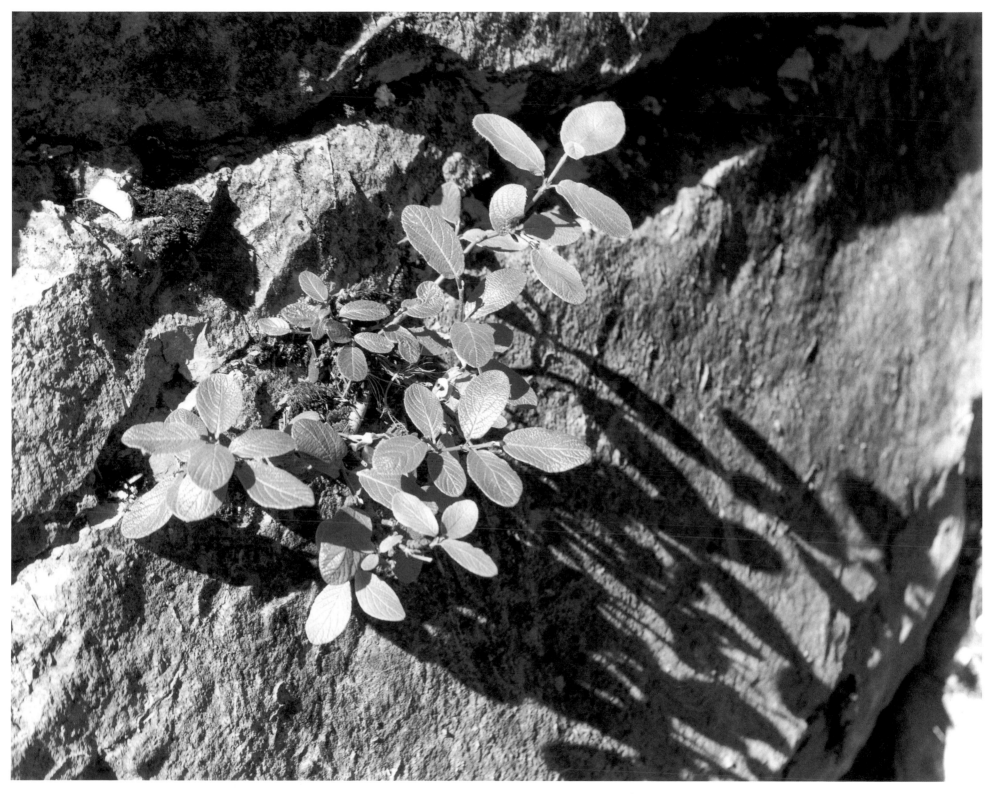

THANKSGIVING PLANT ON ROCK
Dwarf willow.

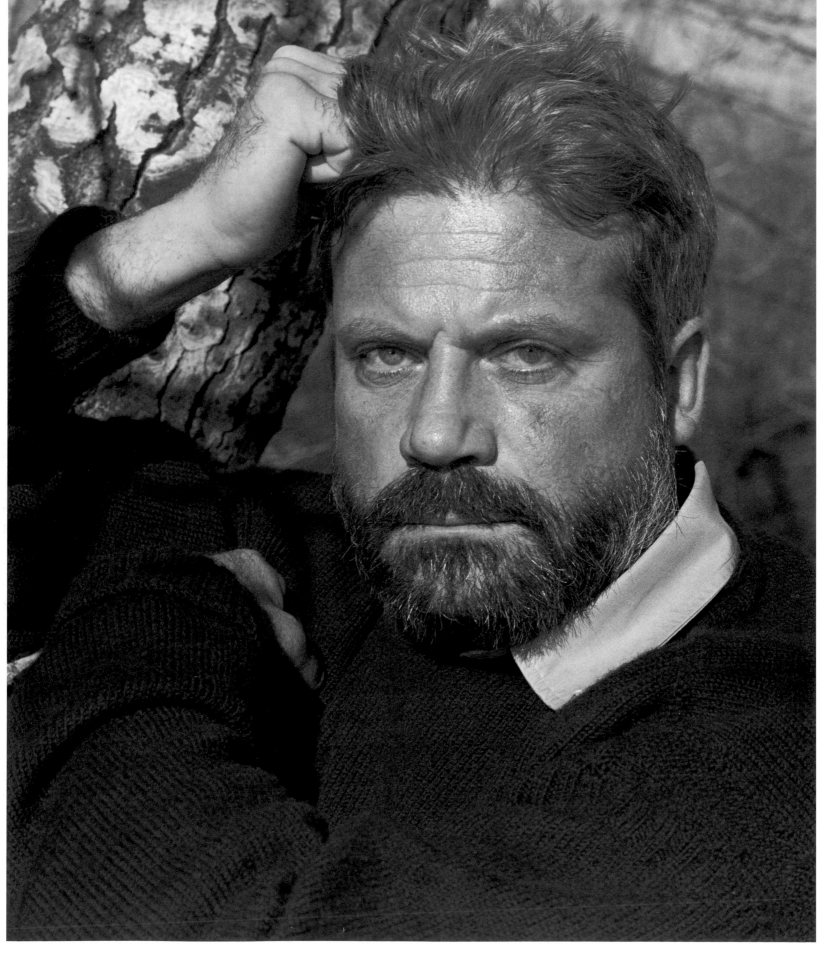

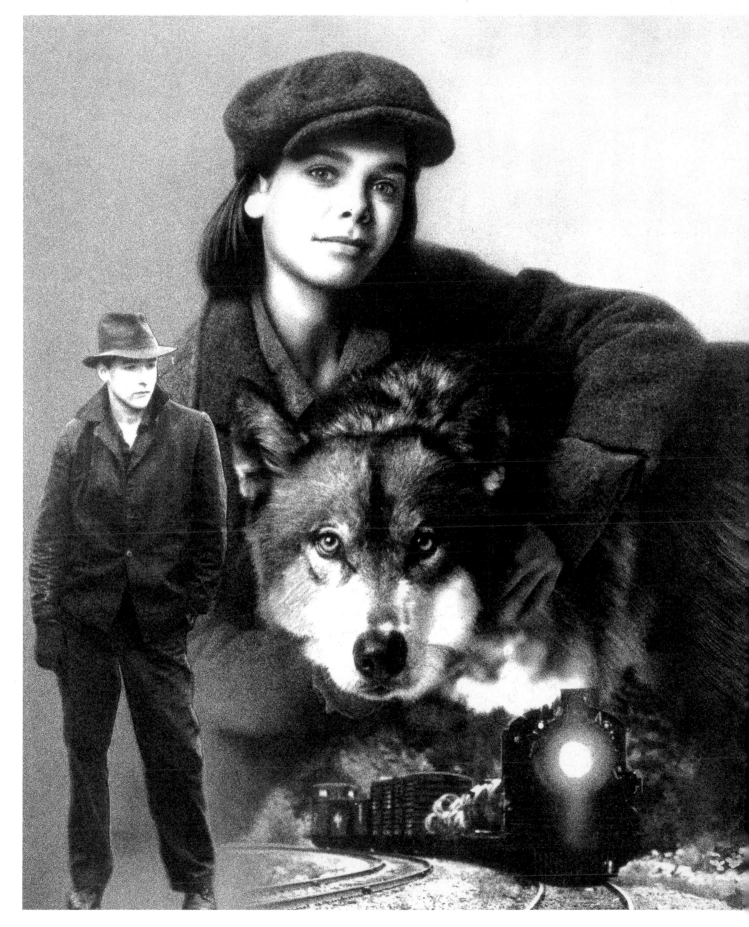

OPPOSITE: ACTOR OLIVER REED
Personal portrait.

RIGHT: "THE JOURNEY OF NATTY GANN"
This 1984 movie was filmed on location in the
Crowsnest Pass and on the lower mainland of
British Columbia. Bruno's photomontage was used
as a poster for the film. Director, Jeremy Kagan.

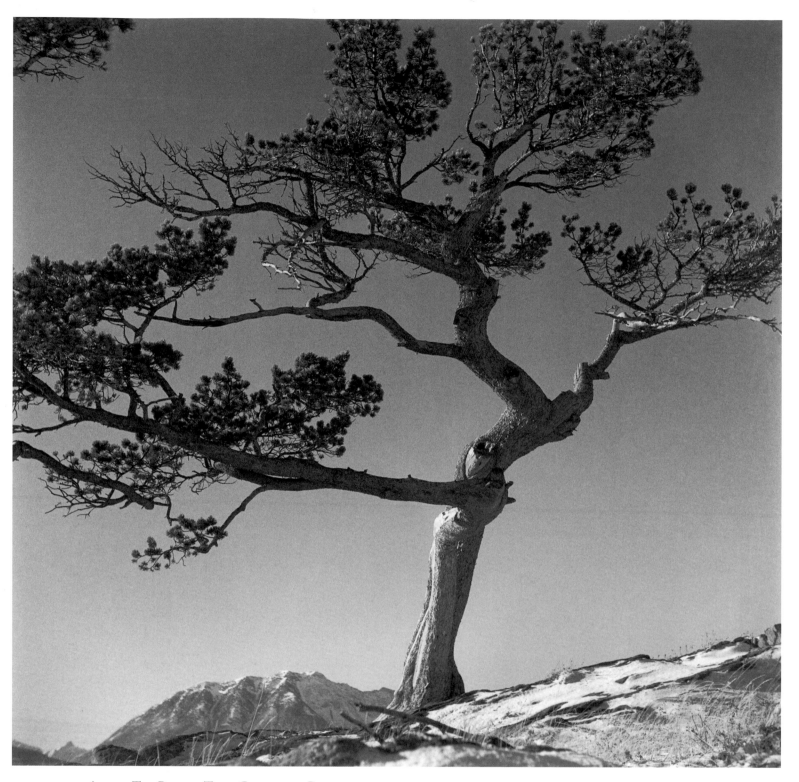

ABOVE: THE BURMIS TREE, CROWSNEST PASS, IN 1950
"When I was young, Turtle Mountain came crashing down and shook the earth,
The wind and dust almost suffocated me,
I have witnessed many cold winters, fierce winds from the past,
I lost my crown when a west wind tried to knock me down."

OPPOSITE: THE BURMIS TREE IN 2000
"I am on top of a rock ridge,
You can see me,
A dry crooked tree, I am old now
And still standing…"

156

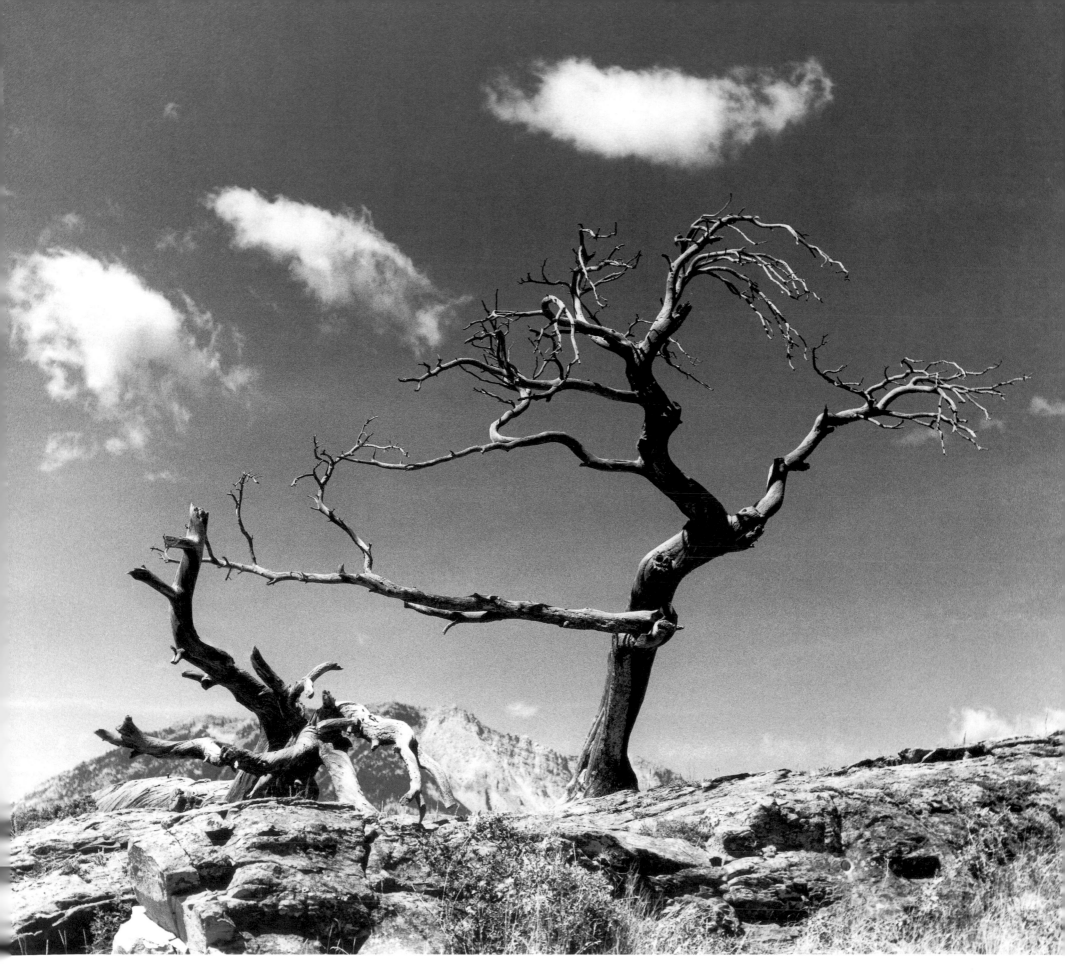

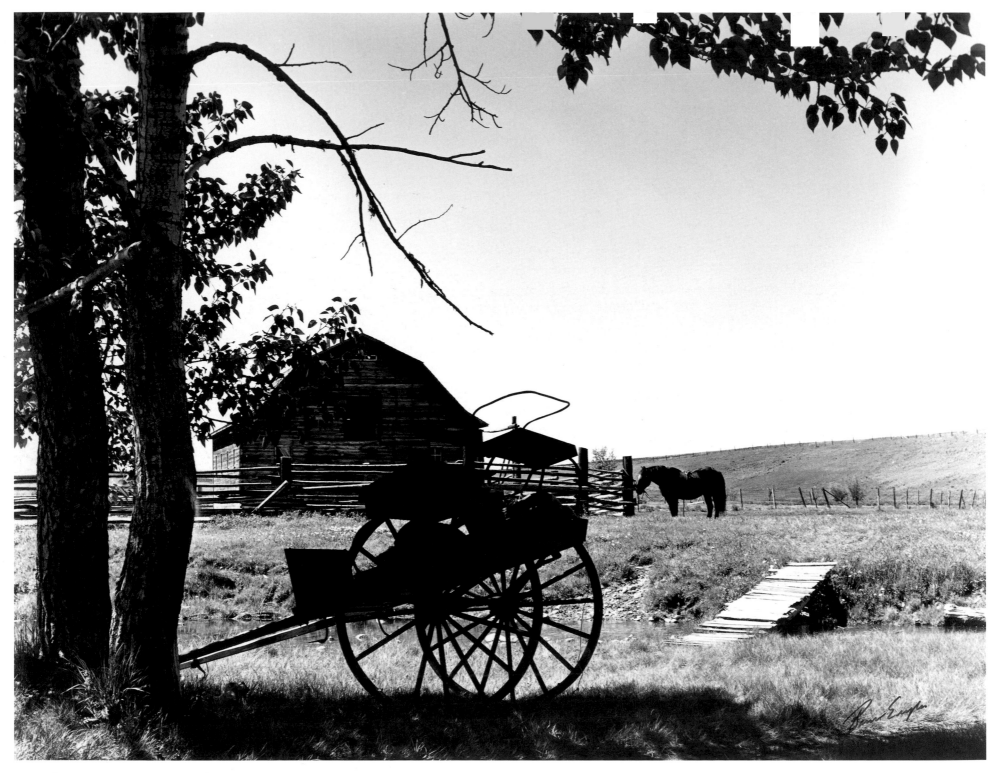

"Old farm near Bragg Creek"

Opposite: "Wheels of Nostalgia," 2000
"Wagon wheels are the symbol of how the west was won a century
or more ago. Wheels and wagons are remembered in songs.
Paved roads have replaced the wagon wheel tracks in the long
grass of Southern Alberta. They are still and silent now."

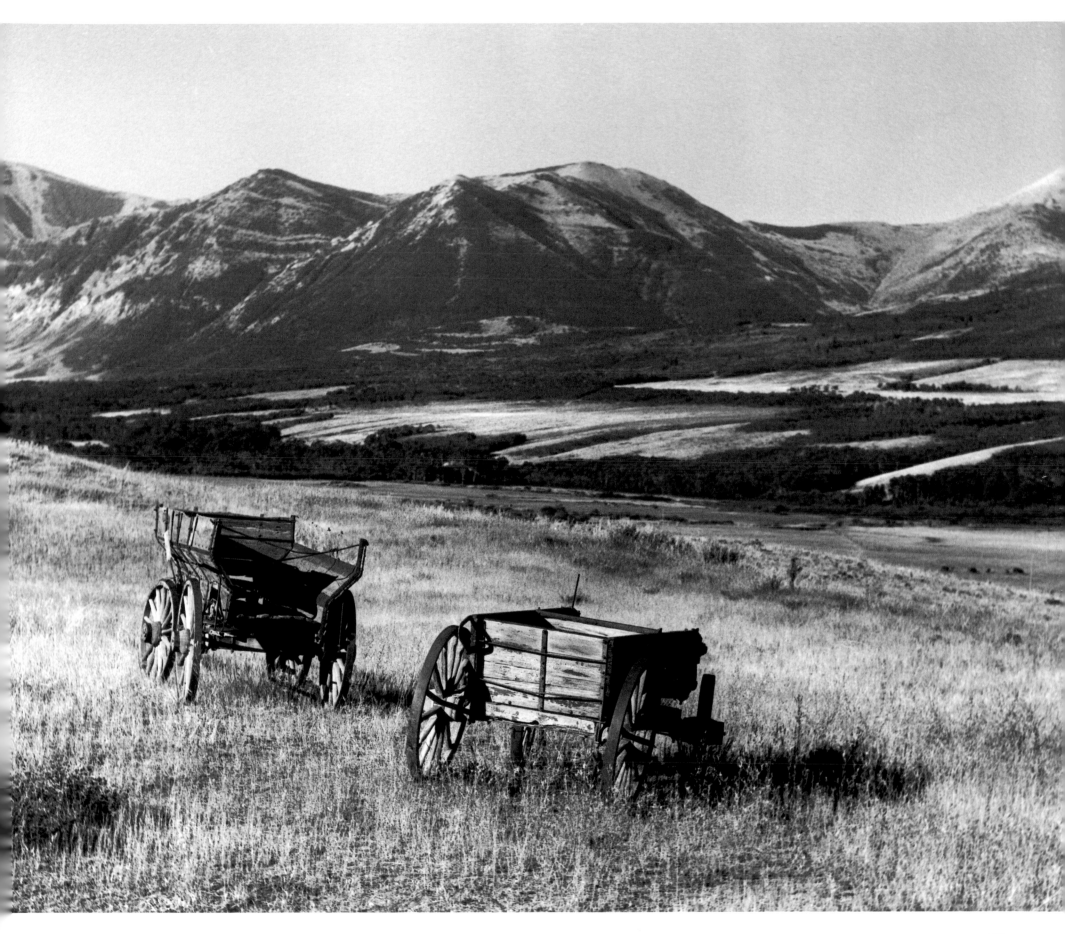

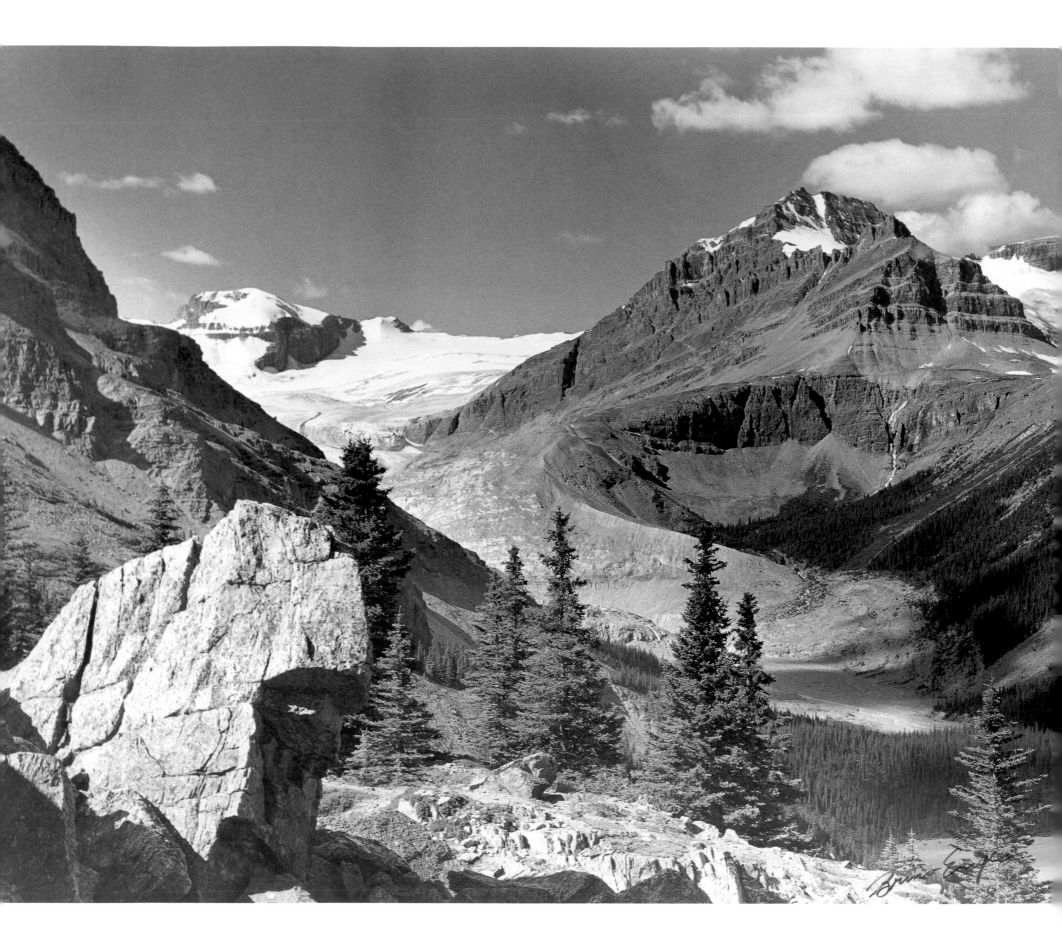

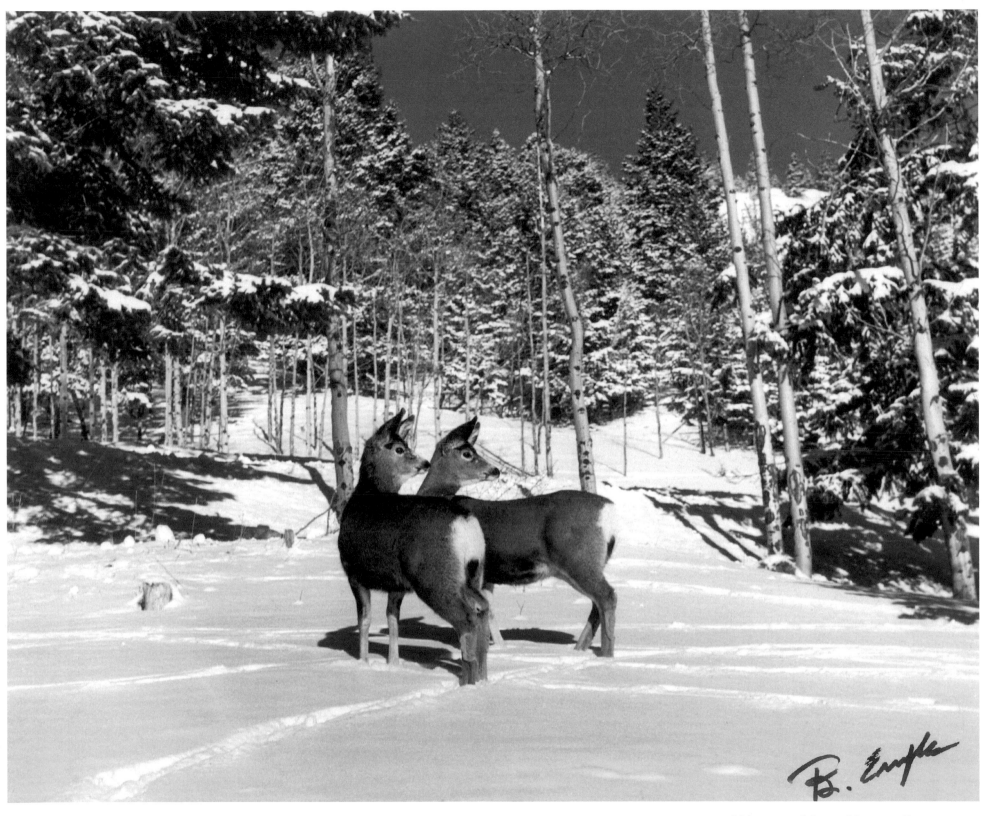

MULE DEER, MOUNT NORQUAY ROAD
Again, Bruno shows his preference for twins!

OPPOSITE: PEYTO LOOKOUT
Mount Rhondda, Peyto Glacier and Peyto Peak.

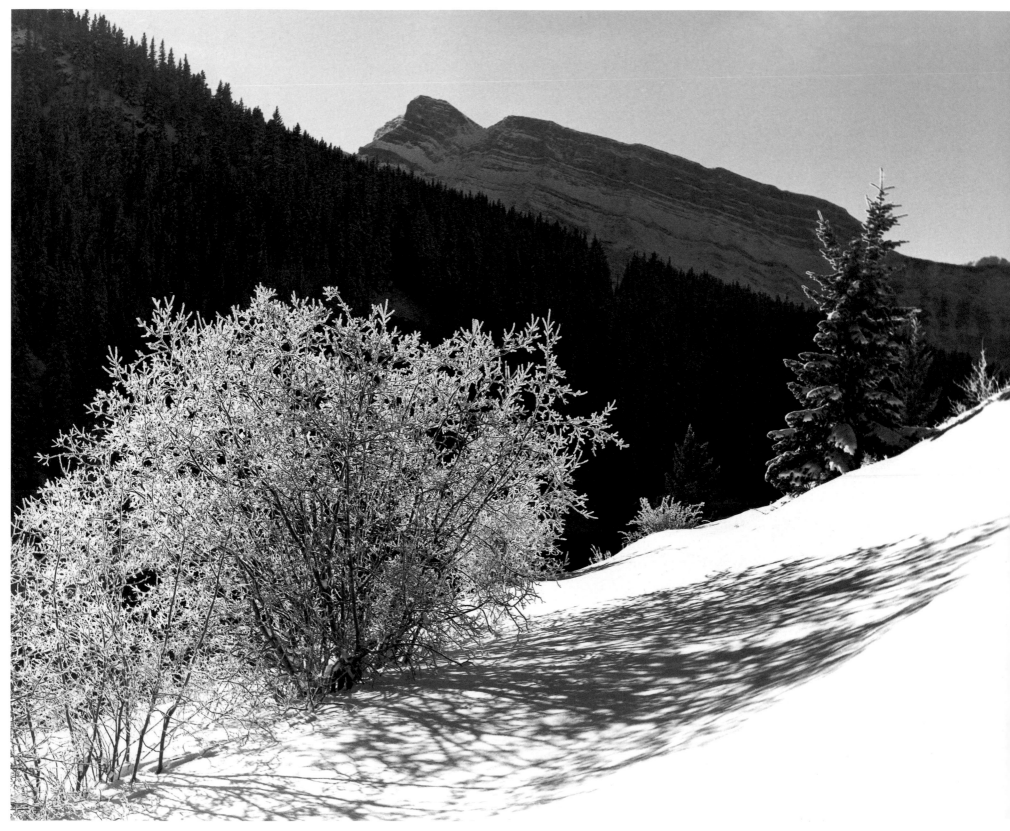

"WINTER LACE"

OPPOSITE: FIRST SNOW, SEPTEMBER, 2000
Elizabeth Parker Hut, Lake O'Hara. This was Bruno's last trip
into the heart of the mountains and he was very happy.
One of Bruno's last photographs.

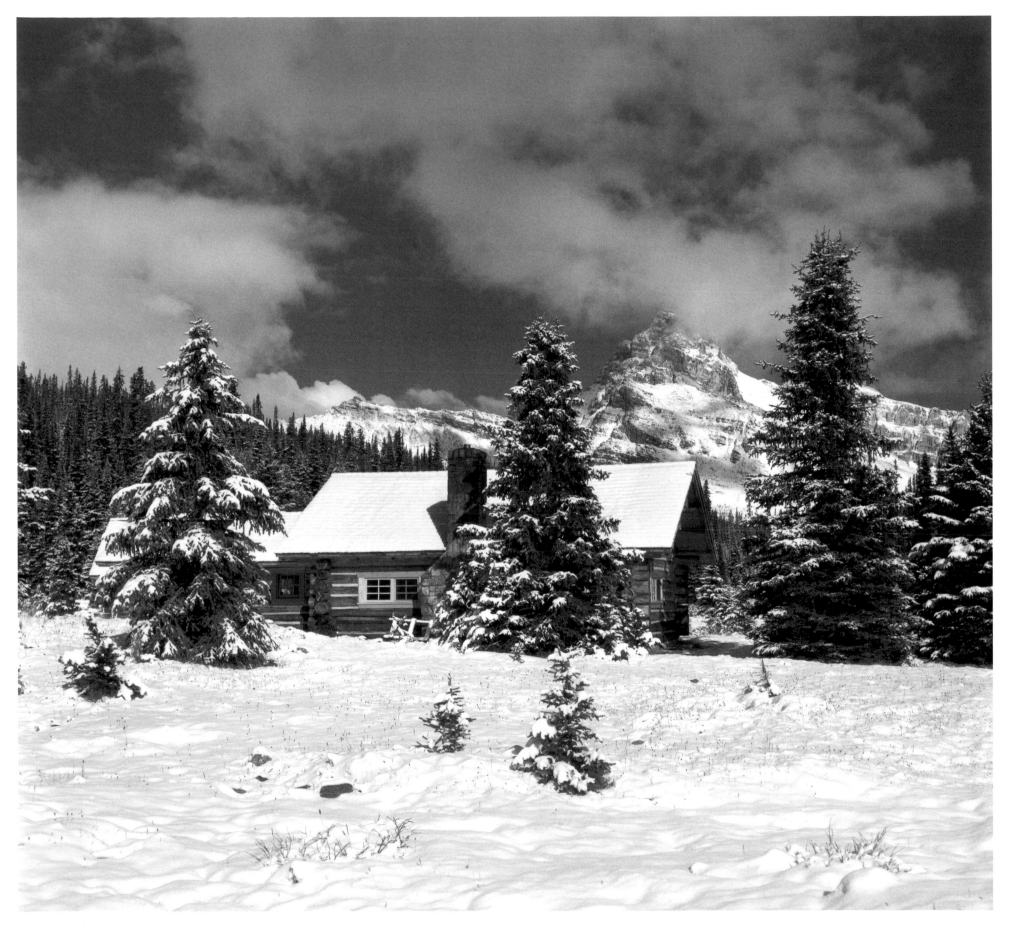

Song for Bruno by Sid Marty

What will you do, now your old guide is gone?
Shoulder your pack and go out to greet the dawn
His pictures and his stories linger in your mind
He left you a stoneman where the rimrock meets the sky
You'll find his track in the deep powder snow
Fading away into the alpenglow

But I don't want to sing any sad song
A real Bruno-ography
Must be played, in a major key.

Oh, didn't he ramble
Didn't he drink the mountain sun like wine?
Life is a gamble,
But he lived it his way most of the time
Didn't he touch everybody he met?
That's the measure of a life well spent
He gave so much of his work away
Only in memory can we, try to repay.

He seemed like one befriended by time
The lines on his face were mostly laughter lines
But he was an artist
Who loved the mountain light
And the stark and subtle beauty
Of immortal black and white

But didn't he ramble
Didn't he drink the mountain sun like wine?
Life is a gamble
But he dodged the snowslides most of the time

Wasn't he innocent?
Wasn't he wild?
Wasn't he truly the mountain's child?
So pay out the rope
And give him some slack
He's led on the crux
Where there is no turning back.
And if you see old tracks
In deep powder snow
Carve some turns for Bruno
In the alpenglow

I know that it sounds like a sad song
I guess that's okay
Since our boy has gone so far away

Gone for a ramble
Drinking the mountain sun like wine
Life is a gamble
But he dodged the snowslides most of the time

Didn't he touch everybody he met?
That's the measure of a life well spent
Wasn't he innocent?
Wasn't he wild?
Wasn't he truly the mountain's child?

What will you do, now your old guide is gone?

"I ALWAYS USED TO RUN INTO THE

MOUNTAINS FOR PEACE.

I FOUND PEACE AND I FOUND MYSELF.

I GOT OUT OF THE CONFUSION.

I BECAME MYSELF AGAIN.

THE MOUNTAINS ARE A LIVING THING

TO ME."

Bruno Engler

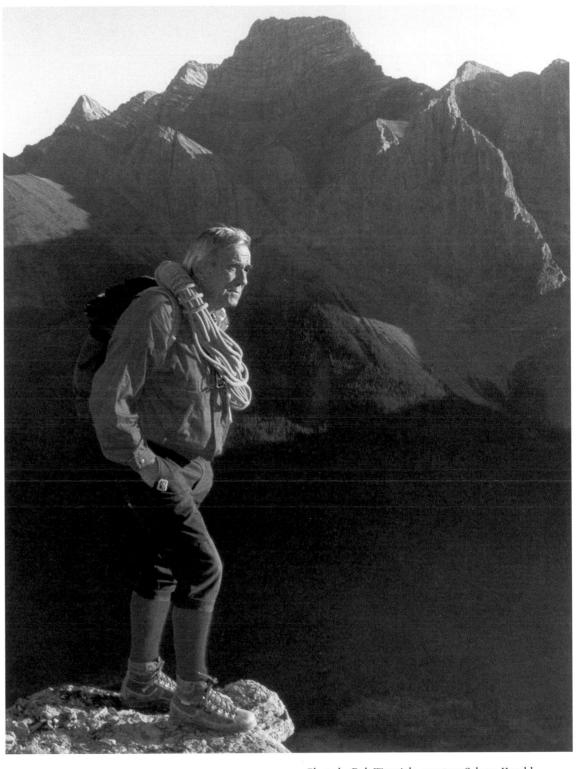

Photo by Bob Warwick, courtesy Calgary Herald.

List of photographs

ACKNOWLEDGEMENTS

Thanks to Wayne McNeil for assistance from the very beginning of this project.

Thanks to everyone who contributed information: Lloyd "Kiwi" Gallagher, Rudi Gertsch, Peter Fuhrmann, Brian Patton, Guy Faucon, Eddie Hunter, Christine Crilley-Everts.

Thanks to Sid Marty for permission to publish "Song for Bruno."

Thanks to Bob Warwick for Bruno's portrait, to Vera's literacy tutor Louise Schulz and to Brian Evans at Miller Thomson.

Thanks to the Alberta Historical Resources Foundation for research assistance and support.

Thanks to David K. Gifford and Heidi R. Wyle.

Thanks to Peak Beverage Group Inc., Network Capital Inc. and the Banff Centre for Mountain Culture.

We also wish to acknowledge the kind help of Tony and Gillean Daffern of Rocky Mountain Books.

And a final thank-you to the many friends of Vera and Bruno Engler.

THE BANFF CENTRE
FOR MOUNTAIN CULTURE

NETWORK CAPITAL INC.